THE PAINTER'S
METHODS
&
MATERIALS

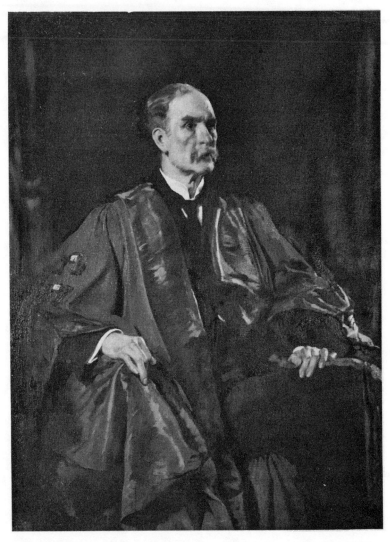

Plate 1. PROFESSOR MATTHEW HAY. By CHARLES SIMS, R.A.

This picture is of peculiar interest as it is a modern example of the 15th century oil tempera technique, the picture having been painted in egg and finished in oil. If the theory developed in the text is justified, this picture should keep up to its present colour-key quite as perfectly as the Van Eycks and other oil tempera pictures of the 15th century.

THE PAINTER'S METHODS

&

MATERIALS

BY

A. P. LAURIE, M.A. (CANTAB.)

D.SC. (EDIN.), F.R.S.E., F.C.S., H.R.S.A.

Dover Publications, Inc., New York

Published in Canada by General Publishing Company, Ltd., 30 Lesmill Road, Don Mills, Toronto, Ontario.
Published in the United Kingdom by Constable and Company, Ltd., 10 Orange Street, London WC 2.

This Dover edition, first published in 1967, is an unabridged republication of the work published in 1960 by Seeley Service and Company, Ltd., 196 Shaftesbury Avenue, London WC 2, England.

International Standard Book Number: 0-486-21868-6
Library of Congress Catalog Card Number: 67-30385

Manufactured in the United States of America
Dover Publications, Inc.
180 Varick Street
New York, N. Y. 10014

PREFACE

THIS book has been written for the craftsman painter in oil, water colour, tempera, and fresco, not for the scientific chemist or the manufacturer. It therefore deals with methods and the properties of materials rather than their chemical description or methods of manufacture. For example, the chemistry of the drying of linseed oil is so complex as to be unintelligible to anyone who is not a student of chemistry. I therefore treat only with the results of these changes.

Those who wish to pursue their studies further may consult, among standard books, Sir Arthur Church's *Chemistry of Paints and Painting* and Hurst's *Painters' Colours, Oils, and Varnishes*, and of modern works, *Varnishes and their Components*, by Dr. Morrell, *Malmaterialienkunde als Grundlage der Maltechnik*, *Die Anorganischen Farbstoffe*, and *Über Fetten Öle*, by Professor Eibner.

For those who wish to study the materials and methods of the Middle Ages to the close of the sixteenth century, the Classic work is still Eastlake's *Materials for the History of Oil Painting* (reprinted in 1960 by Dover Publications, Inc., under the title *Methods and Materials of Painting of the Great Schools and Masters*), to which may be added Hendrie's *Translation of Theophilus*, Mrs. Merrifield's *Fresco Painting* and *Original*

7

PREFACE

Treatises on the Arts of Painting (reprinted by Dover Publications, Inc., in 1967), Lady Herringham's translation of Cennino Cennini, the translation of *Vasari on Technique*, by Louisa Maclehose (reprinted by Dover Publications, Inc., in 1960), and Professor Berger's *Beiträge zur Entwickelungs-Geschichte der Maltechnik.* May I also be permitted to add my *Materials of the Painter's Craft* and the *Pigments and Mediums of the Old Masters?* Students should also consult the *Transactions* of the Tempera Society.

On sitting down to write this book I found so many practical questions arising to which I could discover no answer, that I considered it necessary to carry out a series of experiments in several different directions, the results of which are incorporated in these pages. To the best of my knowledge the experiments on the transparency of pigments in different refractive media and the change in the refractive index of linseed oil in process of drying are new.

In numerous other cases the statements in the text are the results of actual experiments, though no details are given.

A logical order of treatment of the subject proved difficult, and cross-references inevitable. In many cases repetition was found necessary to give completeness to the particular subject under discussion and save trouble to the reader.

Finally, my thanks are due in the first place to Professor Eibner, not only for his help as a correspondent, but also for the assistance obtained from his publications, an assistance which occurs so often that I have

PREFACE

not attempted to acknowledge it in every case in the text. My thanks are also due to Mr. Balsillie, of the Mineralogical Department of the Scottish National Museum; Mr. Batten; Mr. Caw, Custodian of the Scottish National Gallery; Mr. Davidson, of the Cookson Lead and Antimony Company; Mr. John Duncan, R.S.A.; Mrs. Sargant Florence, for permission to reprint her description of "Fresco Painting" from the *Transactions* of the Tempera Society; and to Dr. Morrell; Professor Peddie; Mr. Charles Sims, R.A.; Mrs. Traquair; and the Director of the Rijks Museum and the Staffs of the Physical and Chemical Departments of the Heriot-Watt College.

CONTENTS

11

LIST OF ILLUSTRATIONS

ILLUSTRATIONS

ILLUSTRATIONS

THE PAINTER'S METHODS
& MATERIALS

CHAPTER I

THE MEDIUMS USED IN PAINTING

THE mediums used by artists to mix with their pigments are very much the same to-day as they have been through long periods of time.

For wall-painting the pigments, merely mixed with water, are laid on the wet lime surface of the plaster, the binding medium being the crystallized carbonate of lime, which is slowly formed by the combination of the carbonic acid gas in the air with the lime. Mr. Noel Heaton has shown that this method was used in painting the frescoes in the Palace of Knossos, and the weight of evidence and research is in favour of the same method having been used at Pompeii. The frescoes of the Italian Renaissance were painted by this method. Technical details have varied, but the principle of using the carbonate of lime to form the binding material is very ancient.

Gum-arabic was used by the Egyptians, and is used by artists to-day for water-colour painting, the pigments being ground in this medium.

Size was used by the Egyptians, and by the Greeks and Romans, and throughout the Middle Ages for wall decorations. To-day it is used principally by the house-painter and the scene-painter.

The history of the egg medium is more obscure. Its

17

THE MEDIUMS USED IN PAINTING

use for certain special purposes is mentioned by Pliny (A.D. 23–79) and in manuscripts of the Middle Ages; but it is not till we come to the treatise on Painting by Cennino Cennini, at the beginning of the fifteenth century, that we find a full and detailed description of the use of the yolk of the egg as a painting medium. The pictures of the painters of Italy during the fourteenth and fifteenth century, and probably earlier, were principally executed in this medium.

The first mention of the use of the drying vegetable oils as media for painting occurs in the manuscripts of the eleventh or twelfth century. There is evidence of a long northern tradition in the use of this medium before the fifteenth century, after which it gradually replaced egg and became the universal medium.

Only one medium used in classical times has fallen out of use, namely, beeswax. Pliny tells us how this medium was used. The pigments were stirred in with the melted wax, and the work executed partly with the brush and partly with bronze modelling tools. In order to paint with this medium in a cold climate the panel or canvas must be artificially warmed. Each stroke of the brush must be rapidly put in place and cannot be altered.

Mr. Burns has painted quite successfully in this medium, the canvas being placed with its back to a hot fire. The finished picture, when polished with a cloth, closely resembles an oil painting. Wax is a fairly permanent medium, but readily collects dust and dirt. Mr. Burns tells me that his picture painted twenty years ago is in excellent condition; but owing to the wax accumulating dirt, he varnished it some time ago, quite successfully, with copal oil varnish. This confirms the statement made in the fifth century by the physician Ætius, that wax pictures should be varnished with a drying oil.

THE MEDIUMS USED IN PAINTING

Examples of wax pictures, on the whole in excellent condition, which were found by Professor Flinders Petrie in Egypt, are of about the second or third century, and are to be seen in the National Gallery. With the exception of such pictures preserved by the Egyptian sand, I am not aware of any others. Possibly the examination now going forward of the Russian ikons may reveal some other early examples of wax paintings. Encaustic painting with wax dissolved or emulsified in a volatile medium was at one time fashionable ; it is quite different from the classical technique. An interesting account of the attempts made to revive wax painting will be found in the *History and Methods of Ancient and Modern Painting*, by James Ward.

The Lucca manuscript of the eighth century mentions only two mediums for painting—wax for painting on wood and glue for painting on parchment. I have already stated that the first description of a vegetable drying oil as a painting medium occurs in a manuscript of the eleventh or twelfth century. This suggests the possibility that the use of drying oils for painting was discovered some time between the eighth and eleventh century.

It is sufficient for our purpose that the mediums used by artists to-day have the tradition of centuries of use behind them, and that modern chemistry has not up to the present discovered any other medium, with the exception of casein, that has been found suitable by painters.

Of these mediums the most important is oil, and it might be supposed that after so many centuries of use there would be nothing new to say of the properties of this medium or of its correct use. Unfortunately owing to loss of studio tradition, less is known to-day of some of the properties of this medium and of its correct use than was known to the Van Eycks and their followers, and the

main purpose of this book is to discuss the properties of the oil medium and how it should be used. The drying oils first known to painters were linseed oil, expressed from the seed of the flax, and walnut oil, extracted from the kernels of the walnut. Hempseed oil is also mentioned. Later on poppy oil was added to the list. To-day walnut oil is little used, linseed oil and poppy oil being used in grinding the pigments by the modern artists' colourmen.

Light, the oxygen of the air, and water vapour convert these oils when exposed in thin layers into a tough, elastic, transparent solid which consists principally of a substance which the chemists have named linoxin. We shall have to discuss this drying process in more detail later on, as the conditions of drying must be closely studied to avoid the danger of cracking. The film of dried oil has two properties which are disturbing to the painter. It becomes of a brownish yellow with age, and it apparently has the property of making the pigments gradually more translucent and deeper in tone.

It is to these causes that the lowering of tone of pictures painted in oil is due. It is therefore essential that the artist should have a thorough understanding of how these changes are going to affect different pigments and different methods of painting, in order to avoid serious lowering of tone and serious changes in the whole colour scheme.

The story told by Vasari of the discovery of how to paint in oil by the Brothers Van Eyck has misled artists for generations. So supreme a technical result so quickly arrived at, suggested a secret and lost medium, and Vasari himself hints at such a mystery. But when we realize that Van Eyck was the final expression of craftsmanship to produce a certain æsthetic result, with

THE MEDIUMS USED IN PAINTING

some three hundred years of experience and tradition behind him, we look rather to a study of his methods than of his medium for an explanation of his results.

The main facts are, that, with the exception of an occasional obscure reference or isolated recipe, the account of how to grind pigments in oil and to paint in oil is essentially the same in the writings of Theophilus and Eraclius, in the twelfth century, in Cennino Cennini and other fifteenth-century manuscripts, and in Vasari in the sixteenth century. Chemists may dispute as to refinements, and the results to be obtained by different methods of preparing the oil described in these old recipes ; the extent to which resins were dissolved in the oil ; and what diluents were known. These details we may leave aside for our present purpose.

The accumulation of evidence is in favour of the conclusion that these painters were painters in oil, but probably on a solid under-painting in egg ; the extent to which this solid under-painting was carried being a matter for discussion. A study of these and later pictures, more especially those that are half-finished, reveals a supreme knowledge of the behaviour and properties of the dried oil film. No sharp line can be drawn between the perfection of preservation of the pictures of Van Eyck and his followers, and of some, at any rate, of the pictures of the later painters. More especially is this true of the Dutch school, at a time when the oil medium was undoubtedly firmly established.

There can be no doubt that oil pictures painted on wood are much more brilliant and better preserved than pictures on canvas.

The first step necessary for the student to-day is to learn something of elementary optics before he can understand how to handle the most pliable and, at the same time, the most treacherous of mediums.

CHAPTER II

THE WRITTEN EVIDENCE ON EARLY
PAINTING METHODS IN OIL

In the following chapters I have tried to bring together as shortly as possible such documentary information of which I am aware on early methods of oil painting Before beginning the account of such evidence as I have been able to collect, it is, I think, necessary to state how, in my opinion, such evidence should be used.

In the first place it is probable that the written evidence is both inaccurate and incomplete. The examination of the innumerable recipes published in early manuscripts compels one to the conclusion that in most instances the writers of the manuscripts were merely compilers, and had little practical acquaintance with the methods in use in the studio. Even when the writers are themselves painters, it is notorious that the account of technical processes written by those engaged in using them is often unreliable, and that essential details are omitted owing to the writers' familiarity with them, resulting in irritating obscurities. We must therefore take such information for what it is worth, and not regard it as conclusive.

In the next place it is essential that this information be examined in a purely scientific spirit, without the making of unjustified assumptions. Unfortunately, too many writers on this subject have begun with a pre-conceived theory, and have had to twist historical evidence to prove a particular thesis. Let me give an

example of how I think such evidence should be used. Dioscorides describes the preparation of nut and poppy oil. Oleum Cicinum was also known. These oils were therefore known in his time, but neither he nor Pliny mention their property of hardening into an elastic film, or their use as a medium for painting or the making of varnishes. This being so, until either written evidence is obtained, or the examination of contemporary works of art has proved the use of drying oils for such purposes, we must assume that in the time of Pliny the technical use of such oils for paint mediums and varnish was not known. Any assumption beyond this is mere speculation, and leads nowhere.

So far as I know up to the present, no such use of drying oils has been found in the examination of objects of this or an earlier time. It is true that Greek physicians mention the astringent properties of linseed, but are using the phrase in a medical sense, and it is also evident that a linseed poultice was known in his time, but there is no mention of the extraction of linseed oil.

The first mention of a use of a drying oil is made by Ætius in the fifth century. He describes the preparation of linseed oil, and after describing the preparation of walnut oil, states that it is used by gilders and encaustic painters to preserve their work owing to its property of drying. The first description of the preparation of an oil varnish, by dissolving resins in a drying oil, is found in the Lucca Manuscript, supposed to be of the eighth century, a recipe which is similar to that given in the Mappæ Clavicula.

It is not till we come to the manuscript of Theophilus, supposed to be of the eleventh or twelfth century, and the manuscript of Eraclius, supposed to be of about the same date, that we find an account of the use of a drying oil as a paint medium.

Certain vegetable oils on exposure to the air in a thin film have the property of absorbing oxygen from the air and being turned into an insoluble elastic film. It is impossible to draw a sharp line between a drying and a non-drying oil ; but it is sufficient for our present purpose to note that poppy, walnut, and linseed oils were known as drying oils in mediæval times, and these are the oils used by artists to-day.

The oil as extracted from the seed or nut by heat, pressure, or by boiling with water, is far from pure, and contains mucilage and other impurities. Such an oil dries very slowly. It can be rendered more siccative by the following processes—boiling, passing air through it, and exposure to sun and air. All such processes also purify the oil, many of its impurities separating during the treatment. If the oil is repeatedly shaken up with water and exposed to sun and air, the mucilage and other impurities are separated, the oil is bleached and at the same time becomes more siccative. Such methods of purification are, we shall find, very old, and are practised by some artists' colourmen to-day.

The oil so prepared dries quite sufficiently fast to be used for modern oil painting. There are also modern chemical methods of purification which are used for commercial oils.

If it is required to hasten still further the rate of drying, the oil is boiled, or mixed in the cold and then exposed to light with certain metallic compounds such as litharge and white lead and compounds of manganese and cobalt.

These compounds dissolve to a slight extent in the oil, and render it more siccative.

An oil varnish is a solution of a resin in a drying oil.

These general facts about drying oils will enable us

24

to follow the account which I now proceed to give of the old recipes.

The bleaching of oils by the sun was known in the time of Dioscorides, and the boiling of oils with litharge was known in the time of Galen (A.D. 103–193).

I shall quote in the first instance from the manuscript of Theophilus :—

" Take linseed and dry it in a pan, without water, on the fire. Put it in a mortar and pound it to a fine powder ; then replacing it in the pan and pouring a little water on it, make it quite hot. Afterwards wrap it in a piece of new linen ; place it in a press used for extracting the oil of olives, of walnuts, or of the poppy, and express this in the same manner. With this oil grind minium or vermilion, or any other colour you wish, on a stone slab, without water ; and with a brush paint over the doors or panels which you wish to redden, and dry them in the sun. Then give another coat and dry again. At last give a coat of the gluten called vernition, which is thus prepared."

" Take any colours which you wish to apply, grinding them carefully in linseed oil, without water ; and prepare tints for faces and draperies, as you did before in water colours ; distinguishing, according to your fancy, animals, birds, or foliage with their proper colours."

" All kinds of colours may be ground in the same oil and applied on wood, but only on such objects as can be dried in the sun. For having applied one (coat of) colour you cannot add another until the first be dry, which in images (figures) and other paintings is too long and tiresome."

" All colours employed on wood, whether ground in
oil or in gum (water), should be applied in three succes-
sive coats. The painting being thus completed, place
it in the sun, and carefully spread over it the gluten
vernition. When this begins to flow with the (sun's)
warmth, rub it gently with your hands. Do this
thrice and then let it remain until it is thoroughly
dry.

" There is also a kind of painting on wood which is
called translucid, or by some, golden ; it is produced
as follows : Take a sheet of tinfoil—not varnished nor
tinged with yellow, but in its natural state, and carefully
polished—and line with it the surface which you wish
to paint. Then having varnished the foil, grind colours
very finely with linseed oil, and spread them extremely
thin with the brush ; so let the work dry."

These translations are from Eastlake's *Materials for
a History of Oil Painting*.

It is evident from these quotations that Theophilus
knew how to prepare linseed oil, and how to use it as
a painting medium. At the same time he gives no
description of its purification, and if he did not know
how to purify it, the oil would dry very slowly. His
reference to the slowness of drying may be due to this,
or it may merely be due to his being accustomed to
paint with pigments mixed with egg and size, in which
case oil would seem a very slow drying medium.

The next quotation is from the manuscript of Eraclius,
of which two copies are known, the oldest, formerly in
the library of Trinity College, Cambridge, is of the latter
half of the thirteenth century, and, therefore, the
recipes are at any rate older than this date. These
quotations are also from Eastlake's book, with one
correction :—

" If you wish to paint on a column, or on a stone slab, first dry it perfectly in the sun or by means of fire. Then take white, and grind it very finely with oil on a piece of marble. Spread the white with a brush two or three times over the column, which is (supposed to be) already quite smooth and even, without any cavities. Afterwards prime with stiff white, applying it with your hand or with a brush, and let it remain a while. When it is tolerably dry, pass your hand with some pressure over the surface, drawing your hand towards you, and continue to do this till the surface is as smooth as glass. You may then paint upon it with any colours mixed with oil. If you wish to imitate the veins of marble on a general tint (brown, black, or any other colour), you can give the appearance when the ground so prepared is dry. Afterwards varnish in the sun.

" First plane the wood perfectly, rubbing the surface at last with shave-grass. If the wood is of such a nature that its roughness cannot be reduced, or if you have reasons for not wishing so to reduce it and at the same time are not desirous to cover it with leather or cloth, grind dry white lead on a slab, but do not grind it so finely as if you were to paint with it. Then melt some wax on the fire ; add finely pulverized tile and the white lead already ground ; mix together, stirring with a small stick ; and suffer the composition to cool. Afterwards with a hot iron, melt it into the cavities till they are even, and then with a knife scrape away inequalities. And should you be in doubt whether it is advisable to mix the white lead with wax, know that the more you mix the harder it will be. The surface being smooth, take more white, finely ground with oil, and spread it thinly, with a brush adapted for the purpose, wherever you wish to paint ; then let it dry in the sun. When dry, add another coat of colour as before, rather stiffer,

but not so stiff as to make it necessary to load the surface ; only let it be less oily than before, for great care is to be taken never to let the second coat be more fat (than the first). If it were so, and at the same time abundant, the surface would become wrinkled in drying. And now, not to omit anything that belongs to the subject, I return to the first preparation of the surface of the wood. If, then, the panel on which you intend to paint is not even, cover it with leather made of horse-skin, or with parchment."

Eraclius refers both to linseed and to nut oil. It will be noted that the panel is prepared with white lead ground with linseed and not with gesso.

So far we have not found a recipe for purifying the oil for painting purposes, but we find in Eraclius the following recipe, translated thus from the Le Bègue MS., by Mrs. Merrifield :—

How Oil is Prepared for Tempering Colours

" Put a moderate quantity of lime in the oil and heat it, continually scumming it. Add ceruse to it according to the quantity of oil, and put it in the sun for a month or more stirring it frequently, and note that the longer it remains in the sun the better it will be. Then strain and mix and keep the colours with it."

This is not in the MS. at the British Museum and may have been interpolated.

This method of preparation would result in an excellent oil suitable for grinding colours, and for painting. It would dry somewhat faster than that used for grinding artists' colours to-day. The lime would dry the oil and neutralize any free acids and the white lead would

render it siccative. We have therefore established that, at any rate as early as the thirteenth century, methods of preparing oil were known which would make an excellent paint medium, and that the grinding of pigments in this oil and its use were perfectly well known. There is no need to quote reproductions and variations on these recipes by later writers, and we shall now proceed to the information given by Cennino Cennini on this same subject.

Cennino Cennini is best known as a writer on tempera painting, but he gives us some useful information on how to paint in oil. Taking Lady Herringham's translation on page 78, we find the following information :—

How to Paint in Oil on Walls, Panels, Iron, or whatever you please

" Before we proceed further, I will teach you to paint in oil on walls, or on panels, which is much practised by the Germans, and in the same way on iron or stone. But we will first speak of walls.

" *How to begin painting in oil on walls.*

" Cover your wall with plaster, exactly as you would do when painting in fresco, except that where you then covered but a small space at a time, you are now to spread over your whole work. Make your design with charcoal, and fix it with ink or verdaccio, tempered. Then take a little glue, much diluted with water—a whole egg, well beaten in a porringer, with the milky juice of the fig tree, is a still better tempera, you must add to the said egg a glassful of clean water. Then, either with a sponge or with a very soft brush without a point, go once over the whole ground on which you are going to paint, and leave it to dry for one day at least.

" How to make oil fit for tempering colours, and also for mordants, by boiling over the fire.

" It will be very useful to you to know how to prepare this oil, for many things that are done ; therefore, take one, two, or three, or four pounds of linseed oil, and put it into a new pipkin ; if it is glazed, so much the better. Make a small furnace, and make a round hole into which the pipkin fits exactly, so that the flame may not reach it, because the fire easily catches it, and there would be danger to the oil, and also of burning the house. When you have made your furnace, put a moderate fire in it, and the more slowly your oil burns, the better and more perfect will it be. Let it boil until it is reduced to half the quantity. But to prepare mordants, when it is reduced to half the quantity, add to each pound of oil one ounce of liquid varnish (*vernice liquida*), and let it be very fine and clear ; an oil thus prepared is good for mordants.

" How to prepare good and perfect oil by cooking it in the sun.

" When you have prepared this oil (which is also cooked in another way, better for painting, but not for mordants, for which it must be done on the fire, that is, cooked), take your linseed oil and in summer time put it in a basin of bronze or copper. And in August place it in the sun ; and if you keep it there *until it is half wasted,* it will be exactly right for mixing with colours. And you must know that in Florence I have found the finest and best there can be.

" How to grind colours in oil and to use them on walls.

" Let us return to grinding the colours. Begin and grind colour by colour, as you did when working in fresco, except that where you then ground them with

water, you must now grind them with oil. And when you have ground them, that is to say, all the colours (for every colour can be mixed with oil except bianco sangiovanni), provide small vessels, either of lead or of tin, into which put these colours. And if you cannot find such, get glazed vessels, and put the ground colours into them. Put them in a box that they may keep clean. When you would paint a drapery with three gradations of colour, as I have previously taught you, divide the space, and let each colour be laid in its proper place with a minever brush, uniting one colour well into another, the colours being very stiff. Then stop for a few days and return again to your work, see how the paint covers, and repaint where necessary. And in this way paint flesh or anything you please ; and in this way mountains, trees, and every other work. Provide a vessel of tin or lead (something like a lamp), about the height of your finger, half fill it with oil, and keep your brushes in it that they may not dry."

In this account by Cennino Cennini there is only one obscurity, and that is his description of how to prepare a suitable oil for painting, by exposure to the sun.

In the recipe for preparing a mordant for laying on gold leaf, he says, " Let the whole be boiled till it be reduced to one-half" ("*E fallo bollire per mezzo e sta bene* ").

His recipe for preparing the oil for painting is usually translated, " and if you leave it so exposed till it be reduced to one-half." This makes nonsense of the whole paragraph, as no length of exposure to the sun would result in reducing the volume of oil in this way, and therefore we have to ask whether this is a correct translation, or whether there is some other explanation.

The Italian, as quoted by Eastlake, is as follows, " *il quale, se vel tieni tanto che torni per mezzo, è perfettissimo da colorire.*"

The word "mezzo," to-day, when used as an adjective, may also mean faded, and there is a southern Italian phrase in which "mezzo" is used with the word for colour, which means something that is pale or bleached.

I suggest, therefore, that the correct translation of this recipe is, " *and if you keep it there until it is bleached, it will be perfect for colouring.*"

Oil prepared in this way, although not drying so quickly as the oil prepared according to the recipe by Eraclius, would be perfectly satisfactory for the carrying out of oil painting.

The next recipe of interest is from a manuscript in the Strasburg Library, of the fifteenth century, which is as follows (this translation is taken from Eastlake) :—

How to Temper all Oil Colours

" Now I will also here teach how all colours are to be tempered with oil, better and (more) masterly than other painters; and in the first place how the oil is to be prepared for the purpose, so that it may be limpid and clear, and that it may dry quickly.

" How to prepare oil for the colours : Take the oil of linseed or of hempseed, or old nut oil, as much as you please, and put therein bones that have been long kept, calcined to whiteness, and an equal quantity of pumice stone ; let them boil in the oil, removing the scum. Then take the oil from the fire, and let it well cool ; and if it is in quantity about a quart, add to it an ounce of white copperas ; this will diffuse itself in the oil, which will become quite limpid and clear. Afterwards

strain the oil through a clean linen cloth into a clean basin, and place it in the sun for four days. Thus it will acquire a thick consistence, and also become as transparent as a fine crystal. And this oil dries very fast, and makes all colours beautifully clear, and glossy besides. All painters are not acquainted with it ; from its excellence it is called oleum preciosum, since half an ounce is well worth a shilling ; and with (this) oil all colours are to be ground and tempered. All colours should be ground stiffly, and then tempered to a half liquid state, which should be neither too thick nor too thin.

" These are the colours which should be tempered with oil : vermilion, minium, lake, brasil, red, blue bice, azure, indigo, and also black, yellow, orpiment, red orpiment, ochre, face brown-red, verdigris, green bice, and white lead. These are the oil colours and no more. Here observe that these colours are to be well ground in the oil and at (last) with every colour mix three (that is, a few) drops of varnish, and then place every colour by itself in a clean cup, and paint what you please. With all the above-mentioned colours a small quantity of calcined bone may be mixed, or a little white copperas about the size of a bean, in order to make the colour dry readily and well."

This recipe introduces us to two new processes. One, to use white copperas as a drying agent instead of white lead. I have not found in my experiments that pure dehydrated sulphate of zinc has any value as a drying agent, but it has been suggested that the impure sulphate of zinc available in mediæval times would probably contain manganese, and therefore act as a drying agent.

The other new method is the addition of a few drops of varnish to the colour after it is ground.

EARLY PAINTING METHODS

I have not troubled here to quote the many account-rolls which exist in this country, showing that in the thirteenth and fourteenth centuries painting in oil was common, as these accounts merely confirm what we have already learned, and they are discussed in the chapter on Wall Painting.

We have now brought our account up to and well into the fifteenth century, and it will be noted that there is no indication of any marked change of practice or any historical evidence for the account given by Vasari of the discovery of a new technique by Van Eyck. I therefore omit Vasari's description of Van Eyck's discovery of a new oil technique which has probably no historical basis, and which is too vague to give us any useful information.

Vasari, however, gives a very definite account of the technique of his own time which is as follows, and which is quoted from *Vasari on Technique*, by Louisa Maclehose :—

"I must now explain how to set about the work. When the artist wishes to begin, that is, after he has laid the gesso on the panel or framed canvas and smoothed it, he spreads over this with a sponge four or five coats of the smoothest size, and proceeds to grind the colours with walnut or linseed oil, though walnut oil is better, because it yellows less with time. When they are ground with these oils, which is their tempera (*medium*), nothing else is needed so far as the colours are concerned but to lay them on with a brush. . . . *'Vanno poi macinando i colori con olio di noci o di seme di lino (benchè il noce è meglio perchè ingialla meno) et cosi macinati con questi olii, che è la tempera loro, non bisogna altro quanto a essi, che distenderli col penello.'* "

EARLY PAINTING METHODS

I give the Italian here as Professor Berger suggests that this translation means that Vasari used an emulsion of egg and oil.

Recipes for purifying oil by exposing to air and sun over water come somewhat later. Eastlake quotes one from the compendium of Padre Gesuato (1557), and De Mayerne (1620) gives more than one recipe. The only point to be noted here is that the older recipes I have quoted, in which lime is added, would produce a neutral oil, while an oil purified by washing with water and exposing to air and sunlight is very acid.

It is evident then that from the twelfth century onwards the methods of preparing and purifying oils were much the same as those practised to-day, and there is no indication of any secret processes which would give a different result to those with which we are familiar. It will also be noted that in the earlier recipe no distinction is made between one drying oil and another, but that Vasari tells us distinctly that linseed oil darkens and that nut oil does not darken so badly. I do not think sufficient attention has been paid to this remark by Vasari.

Varnishes

The recipes for varnishes are so innumerable that it would be impossible to quote them, but we can divide them into two groups : the recipes before 1500, and the recipes of the sixteenth century and later.

To deal first with the recipes before 1500. These are all recipes for dissolving resins in oil, spirit of turpentine and alcohol being commercially unknown. While it is difficult to identify the resins referred to, the pine balsams, Venice turpentine, and olio d'abezzo, rosin, mastic, sandarac, and possibly amber, seem to have been used, either separately or mixed together, by

dissolving in boiling oil. The recipes for amber are of three kinds : either the amber is first dissolved in an olio resin like Venice turpentine, in which case it would not have the special properties of a pure amber varnish ; or the amber is fused and then dissolved in oil, which gives a dark and very slow-drying varnish ; or the amber is added to the boiling oil without fusing, in which case it does not dissolve.

It seems very doubtful if varnish made from amber was used in practice. The varnishes made from the other resins, judging by the recipes, contain a much higher proportion of resin to oil than would be used to-day. They would not be regarded by the modern varnish-maker as nearly as durable as varnishes made from copal. They were not thinned with turps, like the modern oil varnish, were very sticky and thick, and were rubbed on warm with the hand.

In the sixteenth century recipes are given for the first time for spirit varnishes, in which the resins are dissolved in spirit of turpentine or alcohol—corresponding therefore to modern spirit varnishes, such as mastic varnish.

EVIDENCE FOR THE USE OF EMULSIONS

It remains next to consider what evidence there is for the use of emulsions of egg and oil or egg and varnish.

Vasari, in his *Life of Alessio Baldovinetti*, says that he experimented with emulsions, yolk of egg and " vernice liquida," and found it unsatisfactory as the colours cracked and peeled off when applied too thickly ; and he refers again to such experiments in his *Life of Antonello da Messina.*

Again, in the Venetian Manuscript in the British Museum, written probably in the first half of the

fourteenth century, there is a recipe for painting on glass by using a mixture of yolk of egg and varnish.

The following is an interesting recipe for a wax emulsion given by Le Bègue :—

" If you wish to make a water proper for distempering all colours, take one pound of lime and twelve pounds of ashes ; then take boiling water and put the whole together, making them boil well ; after which let the mixture settle and strain it through a cloth ; then take four pounds of that water, heat it well, take about two ounces of white wax and put this to boil with the water. Then take about one and a half ounces of fish glue, put it in water and leave until it is well softened and—as it were—melted, when you must manipulate it until it becomes like paste, and throw it into the water with wax and make all boil together. Then add to it about an ounce and a half of mastic, and boil it with the other ingredients. Take some of this water on a knife blade, or piece of iron, to ascertain whether it is done. If it is like glue, it is all right. Strain this water while hot or tepid through a linen cloth, let it settle, and cover it well. With this water you may distemper all kinds of colours."

A similar recipe is given in the Mount Athos MS.

In the Bolognese MS. of the fifteenth century, translated by Mrs. Merrifield, a recipe is given for grinding white lead, lake, linseed oil, and white of egg together ; and later in the same MS. a recipe for a cement made of white lead, varnish, and white of egg.

CHAPTER III

THE WRITTEN EVIDENCE ON EARLY PAINTING METHODS IN OIL

(*Continued*)

ANOTHER matter which requires investigation is how far by exposure to bright daylight or sunlight the tendency of an oil film to darken can be permanently cured.

That such a darkened film can in most cases be bleached by such exposure we know, and there is more than one reference to the exposure of oil pictures to sunlight in the history of painting. Of these the following from a letter written by Rubens is, I think, the most interesting :—

" If I knew that my portrait was still in Antwerp, I would have it detained there, to have the box opened, to see if it has not been injured, or become darkened, as happens often to fresh colours, if they are, as is here the case, so long in a locked box, and not in contact with the air. It may be then that my portrait does not now look as it did originally. Should it really reach you in such a bad condition, the best remedy for that would be to put it often in the sun ; by this means the excess of oil, which causes such changes, is destroyed ; and if, from time to time, it should again get dark, setting it in the sun's rays must be renewed. This is the only remedy against this heart disease."

EARLY PAINTING METHODS

It is evident from this quotation that the pictures as they left the studio of Rubens were not in such a condition as to resist the darkening of the oil if rolled up. If, therefore, he had given them a sun bath, it had not been sufficient permanently to bleach the oil, if that is possible. It is evident also that he does not regard such a bleaching process as producing a permanent result, as he says that if the picture again darkens, it must again be placed in the sun.

This passage has been quoted as proving that it was the practice of painters in the time of Rubens to place their pictures in the sun as part of their painting method, and in this way the tendency of the oil to darken was permanently cured. It is, I think, evident from a careful analysis of this passage that the evidence to be derived from it tends rather the other way.

It is nevertheless a matter for experiment to find how far sun-bleaching of the dried film affects a permanent cure of the tendency to darken. Professor Eibner has shown that exposure to sunlight while drying is most injurious to an oil film.

The two most valuable treatises on the history of painting are Eastlake's *Materials for a History of Oil Painting*, a model of scholarship and research ; and Professor Berger's *Beiträge zur Entwickelungs-Geschichte der Maltechnik*, in which the De Mayerne MS., quoted by Eastlake, is translated in full. Translations of individual manuscripts by Mrs. Merrifield and Lady Herringham, and *Vasari on Technique*, by Louisa Maclehose, can also be consulted.

Having quoted the more important recipes given in the old MSS., it is necessary next to consider critically the conclusions come to by Professor Berger and by Eastlake.

EARLY PAINTING METHODS

At the time when Eastlake wrote, the story of the discovery of oil as told by Vasari still had general acceptance, and no doubt influenced Eastlake throughout.

Modern critical examination of contemporary records about the Brothers Van Eyck have not resulted in producing any evidence as to the truth of this account, and it is certainly remarkable that no mention was made of it on the tombstone of either painter, both of which had inscribed upon them lengthy epitaphs.

Eastlake suggests that the only oil painting known before Van Eyck was in a thickened oil obtained by exposure of the oil to sun and air. If the crude oil is purified by the process so often repeated in old recipes of exposure to sun and air, over water, the first change is the precipitation of the mucilaginous and albumenoid impurities. This is followed by three changes. The oil bleaches and at the same time is partially oxidized and partially polymerized. The partial oxidation makes it dry more quickly; and the polymerism will thicken it in time. The rate at which these two processes will take place is no doubt influenced by temperature and light acting simultaneously, and so different results will be obtained under different conditions.

In practice, at any rate in this climate, there is no difficulty in preparing an oil, pale, limpid, and sufficiently quick drying for ordinary artists' purposes. I worked out the conditions some thirty years ago, and such an oil has been used commercially for grinding artists' colours ever since without the addition of any dryers. Eastlake is wrong, therefore, in assuming that an oil could not be prepared in this way suitable for painters. If the process is continued long enough the oil will thicken and will then be more suitable for use as a varnish.

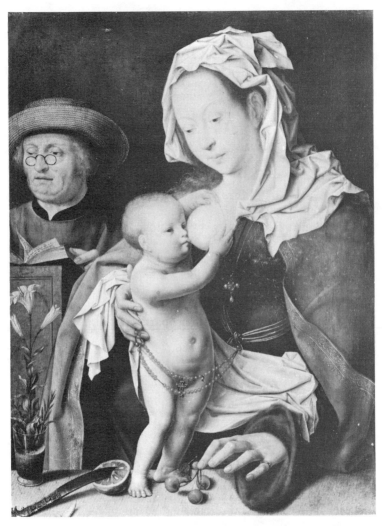

Plate 2. HOLY FAMILY. By the Master of "The Death of the Virgin."

This picture has been selected in preference to the Van Eycks in the National Gallery, because it is in even better preservation than they are, and is a perfect example of the triumph of the technical methods employed by the early painters in the tempera oil technique. The picture seems as perfect as when it left the artist's studio.

In the Hermeneia, instructions are given for preparing an oil by exposure to the sun till it is as thick as honey, and in a fifteenth-century recipe quoted from the Strasburg Manuscript, it is stated that after three days' exposure to the sun the oil boiled with bone ashes and treated with sulphate of zinc becomes thick. The thickening must have been due to the boiling, not to the short exposure to the sun ; and if so, the boiling must have been prolonged. If this recipe is to be taken as conclusive, then in the fifteenth century they ground in a thickened oil, that is, polymerized oil like Stand oil.

The other evidence is supposed to be given by Cennino Cennini. This, I believe, is due to a mistranslation, as I have already stated. Cennino Cennini describes two methods of preparing linseed oil—one by prolonged boiling, for making mordants for cementing on gold leaf ; and another, which he says is the better way for a painting oil, by exposure to the sun and air. As the second recipe makes nonsense as it is usually translated, I have suggested the alternative translation that the oil is exposed until it is bleached.

In this connection there is a passage in Cennino Cennini, Chapter 144, which seems to have escaped attention :—

" If you would imitate velvet, paint the drapery of any colour you please, tempering your colour with the yolk of an egg. Make the pile on the velvet with a minever brush tempered with oil ; shape the pile with thick paint."

This instruction surely shows a manageable oil medium, and it is difficult to understand why, having a method by which a satisfactory painting oil could be

produced, the painters previous to Van Eyck should have gone out of their way to make it too thick.

This question of the use of thickened oils has recently received renewed attention because of the interesting suggestion of Professor Eibner that Van Eyck and his followers used Stand oil, i.e. linseed oil thickened and polymerized by prolonged boiling in absence of air, and also possibly by prolonged exposure to the sun's rays without oxidation. There are chemical reasons for stating that such an oil would produce a very permanent dried film which would not yellow so much as oil prepared in the usual way, and some of the old recipes would give a partially polymerized and partially oxidized oil. Professor Eibner's view differs from that expressed by Eastlake, in that he suggests the use of thickened oils for the perfected, not for the imperfect, method of oil painting. I have tried grinding pigments and painting in this thickened oil. It is sticky and at the same time flowing. Fine work like that of the fifteenth-century painters is impossible with such a medium. If used, the oil was either thinned with oil of turpentine or emulsified with a little egg. Professor Eibner is of the opinion that Van Eyck and his followers must have known and used oil of turpentine or a similar volatile medium, the use of which requires a knowledge of the art of distillation.

The earliest reference to distillation is made by Pliny, who speaks of the distillation of a crude turpentine by heating pine balsam in a vessel covered with a woollen fleece and squeezing out of the wool the condensed vapours. Distillation, as we know it, is first described by Cleopatra, a physician of the third century in Egypt, and must have been a familiar process to the alchemists, and the preparation of turpentine is described by Marcus Graccus in the eighth century. That Van Eyck and his

followers could have used oil of turpentine must therefore be admitted.

In the Advocates' Library, Edinburgh, there is an illuminated manuscript which is known to have been painted between 1465 and 1489, and in which wax has been used as a medium. Pure beeswax has been used, as I have proved by taking the melting point of the substance, so that it is not an emulsion of wax and glue, such as is described by Le Bègue, and the delicate painting could only have been done by dissolving the wax in a volatile medium like turpentine.

This then gives us a date when turpentine must have been known.

It is not likely that this is the only manuscript in which pure wax has been used, and a search for others would enable us to arrive at a conclusion as to when turpentine was known as a medium for artists.

In the meantime the silence of manuscripts before the sixteenth century is against Professor Eibner's view. Sixteenth-century manuscripts contain numerous recipes for the making of spirit varnishes by dissolving resins in volatile mediums. None are mentioned of an earlier date.

The other possibility is the emulsifying of thickened oil with egg. There are two ways in which an egg emulsion can be used. By the addition of the white, but still better with a little of the yolk of egg, to a sticky varnish or sticky balsam, or sticky thickened oil, it is possible to obtain a medium which is crisp and will not flow. By the addition of more egg and water it is possible to obtain a medium which will mix with water and paint out like a size medium and dry dead and flat. All this has been dealt with in detail in the chapter on emulsions.

The theory that egg emulsions miscible with water

43

were used by Van Eyck and his followers, has been developed at great length and with great ingenuity by Professor Berger, and it is necessary, therefore, to look at the actual evidence.

There are, I believe, only three references in ancient writing. One is the reference in Vasari, where he states they were tried and abandoned. Another is the recipe in the Bolognese manuscript of the fifteenth century for grinding white lead, linseed oil, and white of egg together, and the third, in the Venetian Manuscript in the British Museum, of the first half of the fourteenth century, is for grinding yolk of egg and varnish together for painting on glass.

There is no evidence that in either of these two recipes water was also to be added. On such slender evidence does this elaborated theory as to fifteenth-century technique rest.

Against these occasional recipes we have to place the evidence as to the method of painting in oil, which is so often repeated in different manuscripts. In Theophilus, in Cennino Cennini, and in Vasari we find the same simple instruction repeated, to grind the pigments in linseed or walnut oil, and this, as Vasari tells us, is their only tempera.

Eastlake, having done his best to establish an improvement made by the Brothers Van Eyck on the methods of oil painting, comes to the conclusion that their secret lay in the use of an " oleo resinous vehicle."

As has been already seen, the mediæval varnishes were thick, sticky, and slow drying, and quite unsuitable for painting. There is evidence that the addition of a few drops of varnish was made to the oil medium, both in the recipe already quoted from the Strasburg Manuscript, and also in the instructions given by later writers on painting. Such an addition would give a

smoother, harder, and more polished surface than oil alone, and it may very well have been the practice to add a little varnish in this way. Such an addition is often made by modern painters, but it can hardly be claimed that so small a modification would profoundly affect the durability and brilliancy of painting in oil.

The whole question can be approached in another way, and that is the consideration of the pigments which were available, and how far these pigments were permanent or fugitive, and whether, if fugitive, anything could be done to protect them.

Many years ago I published a method of discovering how far oil and varnish films were permeable to moisture by grinding them with ignited sulphate of copper. Sulphate of copper, or blue vitriol, crystallizes in transparent blue-green crystals together with five molecules of water, which can be driven off by heat, leaving an opaque white powder. If this opaque white powder is ground with linseed oil, a white enamel is obtained, and if after drying in dry air it is exposed to water vapour, owing to the easy permeation of the linseed oil film by water, the sulphate of copper combining again with water is converted into a transparent bluish green. Experiments on these lines showed that linseed oil, walnut oil, and the usual oil varnishes were easily permeated, but the balsams and pure resins dissolved in a volatile medium resisted for a long time the attack of water vapour, and therefore it is possible to protect fugitive pigments from change by locking them up in a balsam or a varnish made by dissolving resin in a volatile medium, and it was also found that a very small addition of oil could be made to such a balsam without spoiling its protective value. I therefore suggested that possibly in the case of fugitive pigments such balsams as Venice turpentine or olio d'abezzo were used. Since

then quantitative methods for testing both the absorption of water by oil films and their permeability have been devised, but the main facts remain as I have already stated them.

When engaged in the examination of the pigments used on illuminated manuscripts, I found a green which apparently is a resinate of copper made by dissolving verdigris in a pine balsam and which is permanent. If I am right in supposing that this green was used by Van Eyck and his followers, it may have been used by taking the sticky solution of the green in the pine balsam and emulsifying with a little egg and oil so as to make a workable medium. Such a mixture is opaque when first painted out, but turns transparent on drying. Or the green balsam may have been dried and ground and used as a pigment, so that even if we take the use of this green as proved, it does not prove the use of a balsam varnish in the actual painting.

If we now proceed to consider the pigments available in the fifteenth century, unless we find that fugitive pigments were the only obtainable pigments, there is no reason for us to suppose that any locking-up process was essential. Very large numbers of pigments are described in the various manuscripts, many of which are notoriously fugitive, but the result of my examination of illuminated manuscripts was to show that in most cases at any rate a very limited palette was used— white lead, vermilion, red lead, orpiment, malachite, copper resinate, verdigris, possibly gamboge, real ultramarine, azurite, and a lake.

For the artist's palette painting in oil we must add to this list the yellow oxide lead or massicot, Naples yellow, the oxide of lead and antimony, and probably the oxides of lead and tin, and, of course, the earth colours and the blacks. The oxide of lead and the

oxides of lead and antimony have been removed from the artist's palette on account of the fear of their turning black owing to the action of sulphuretted hydrogen ; but the durability of white lead makes it doubtful if this removal is justified. If we remove verdigris from the list, replacing it by the resinate of copper, the probability is that we can regard this as a permanent palette, with the exception of gamboge and the possible exception of orpiment. Sir Arthur Church condemns orpiment as fugitive on account of some experiments made by Sir Joshua Reynolds, which incidentally confirm the value of a pine balsam as a preserving agent, but the probability is that the orpiment he used was an artificial preparation. In the old manuscripts we find that orpiment is stated to be a bad drier, and that it must not be mixed with pigments containing lead or copper ; but in no case is it spoken of as fugitive, and it has proved to be quite permanent when used on illuminated manuscripts. It has therefore, I think, been too hastily condemned. I have, however, found one example, in a picture by Holbein, of the use of powdered gold and yellow ochre in its place, which looks as if he had regarded it with suspicion.

With reference to the copper carbonates, malachite, azurite, and the artificial varieties blue and green bice, there is sufficient evidence on old pictures as to their permanency as pigments, the only objection to them being their tendency to settle in the oil, and owing to their transparency to suffer excessively from the yellowing of the oil, though in some cases they have turned black.

There still remains for us to consider what lakes were available. The lakes were prepared from Japan wood, kermes and later on cochineal, Indian lac, ivy gum, and madder. All of these, with the exception of madder, are fugitive and recipes for madder are remarkable by

their absence ; but we know that madder was used as a dye, and there are many recipes for extracting the colour from dyed wool to make lakes ; while the permanency of many of the lakes used not only in oil but in tempera is evidence in favour of madder lakes being known.

Finally, the good preservation on the whole of the pigments in tempera pictures, which have no such protection as is afforded even by oil, and which, even if the pictures were originally varnished—which I venture to doubt—have long lost their protective varnish, tends to prove that within a limited range the fifteenth-century painter had a permanent palette, and therefore there was no need for him to resort to the use of pine balsams or of highly resinous varnishes to protect his pigments. I frankly confess that I am here expressing a view which is different from what I have expressed before, but on revising the whole of the evidence available, it seems to me that the verdict is in favour of the use of the oil medium from the Middle Ages onwards, with the proviso that a little varnish may have been added, and also that probably before the introduction of turpentine as an artist's medium, when an artist wished to use a sticky oil or varnish, he mixed it for this purpose with a little egg.

If this view is correct, we are driven to the conclusion that the fine condition of the early Flemish pictures and their high colour key after the lapse of so many centuries, is due in the first place to very careful and methodical painting on a sound wood panel, and in the second place to the thorough understanding and successful use of the combined tempera oil technique.

The next question of interest which arises is how and when the combined oil tempera technique began. The oldest Northern tradition, as given by Theophilus and

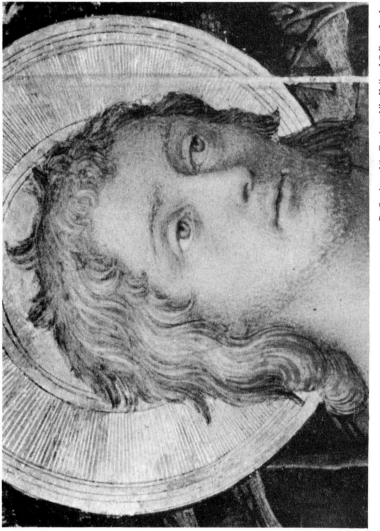

Plate 3. CHRIST AND THE APOSTLES. By FRA LIPPO LIPPI.

This magnified photograph of the head of the Christ is of interest as revealing something of the technical methods of masters of the egg medium, like Fra Lippo Lippi. Owing to the degradation in tone of oil pictures, considerable interest in the possibilities of the egg medium has been taken by modern artists.

EARLY PAINTING METHODS

Eraclius, is to prime the panel with white lead in oil and paint with oil. If we go still further back to the Lucca Manuscript, we find painting in wax. Vasari, in order to heighten the dramatic effect of his story about Van Eyck, tells us that before his discovery, egg was the ancient and universal medium, and this statement has been copied by every subsequent writer on art, but I cannot find that it is based on actual evidence. Eastlake tells us that in certain pictures he examined of the fourteenth century, the draperies were painted in oil and the faces in tempera; and gives as his evidence that the flesh painting is thinner than the painting of drapery. We now know that even sixteenth-century oil painters laid thin paint on the flesh, in order to obtain full advantage of the white gesso below, so that these pictures to which he refers may well have been oil pictures throughout.

It is very difficult to tell by inspection in what medium pictures previous to 1400 were painted, and a chemical investigation of the medium used should yield results of extraordinary interest.

Were egg and wax the two classical mediums, and does the painting in egg continue throughout the centuries, side by side, with the painting in wax which somewhere between 800 and 1200 was replaced by oil? Is the Flemish miracle of the fifteenth century the combination of the two parallel methods for the first time in the hands of a master—not as Professor Berger would have us believe, by mixing egg and oil on his palette, but by utilizing the full optical advantages of both methods in a combined technique? It is in a chemical examination of the pictures painted in the North before the Van Eycks that an answer to these questions will be found.

In the following chapters we shall discuss artists'

49

materials, paper, wood, canvas, pigments, and oils, and the optical principles involved in oil painting and the optical properties of oils and pigments.

We shall then be in a position to discuss early examples of oil technique, and throw further light on the methods used and the scientific principles underlying them.

CHAPTER IV

WOOD PANELS AND PAPER

THE earliest form of paper known in Europe is that prepared from the pulp of the papyrus reed in Egypt. This was used during the time of the Roman Empire, and seems ultimately to have gone out of use and been replaced by vellum, owing to the exhaustion of the supply of the papyrus reed, and consequently we are accustomed to find vellum used for early manuscripts.

The manufacture of linen paper has not been traced further back than the second half of the twelfth century. Specimens of thirteenth-century paper exist, and are in excellent condition. They have been sized with starch, the size used by the Egyptians in preparing papyrus. To-day paper is usually sized with size.

Paper for water-colour painting should be a rag paper, preferably prepared from linen fibre, and should contain nothing in addition but a little size, all such chemicals as bleaching powder, sulphite of soda and alum being absent. In a recent analysis of a high-class water-colour paper, I found that the paper consisted of linen fibres with a little cotton fibre, and was quite free from any oxidizing or reducing agents, whilst the amount of ash was from $\cdot 56\%$ to $\cdot 71\%$, and consisted partly of soluble sulphates and of calcium sulphate.

In the preparation of paper, the rags, having been boiled and thoroughly pulped, are usually bleached by the introduction of a little bleaching solution, the excess of the bleach destroyed by means of sulphite of soda,

the pulp thoroughly washed, and some size incorporated. This size sometimes contains a little resinate of soda and sometimes alum is also added. In the case of water-colour paper, resinates and alum should be absent, as they may act on some of the more sensitive pigments. It is also very important that care should be taken that no fragments of iron or bronze have been introduced in the process of manufacture. This is most apt to happen from disintegration of the teeth of the beaters, and I understand that in making some of the finest qualities of paper in Germany, the teeth of the beaters are made of agate. These tiny particles of iron or bronze will oxidize in time, producing spots upon the paper, and will decompose certain pigments—cadmium yellow, for instance, being decomposed, forming black spots visible to the eye from tiny particles of iron or bronze, which would only have been visible in the original paper under the microscope.

It is to be regretted that it is not possible to obtain a modern water-colour paper in which such powerful bleaching agents as bleaching powder have not been used. The old paper on which the drawings of Raphael and other artists were made, and which has stood so well the test of time, must have been bleached simply by sun, air, and water. We have to-day a bleaching agent, which was doubtless produced under those con-ditions in small quantities, namely, peroxide of hydro-gen. This, strictly speaking, should be the only bleaching agent used in the preparation of water-colour paper. The question of the amount of size in the paper, and consequently the extent to which it is non-absorbent, is one of great interest to the water-colour painter. It is fully discussed by Mr. Rich in his book in this series on *Water-colour Painting*.

WOOD PANELS AND PAPER

Wood Panels

Well-seasoned panels of wood form an excellent support for pictures. At the same time wood has certain obvious defects ; it tends to warp and crack, and is apt to be attacked by the wood beetle. It is necessary, therefore, in the first place to select a suitable variety which is least likely to warp or crack. It should be free from resin and gums, and wood grown on poor soil in temperate climates and felled in winter is the best. In Italy the white poplar was largely used, while the Flemings used oak. To-day mahogany is used, and is a most satisfactory wood for the purpose, being much less likely to crack than oak.

In order to understand the seasoning process through which wood has to go, it is necessary to know something of the microscopic structure of wood. Wood consists of cells which in the greenwood are more or less full of water, and the lining of these cells also consists of material by which water is absorbed, and is more or less loosely combined, and which is able to take in or give up water according to the amount of moisture in the air.

Starting from the central pith, a fresh layer of wood is formed each year surrounding that of the previous year and lying underneath the bark, and so year by year a fresh ring is added to those already formed. As this process continues the inner or older rings cease to constitute part of the living portion of the wood body of the tree, becoming a central column of support, and acting as a storehouse for water. Surrounding this central heart-wood, which is sometimes darker in colour, is a zone of wood consisting of a varying number of year rings, usually lighter in colour than the heart-wood, and is called the sap-wood. This sap-wood is

53

WOOD PANELS AND PAPER

still alive, and takes part in conducting water from the roots to the leaves. Between the outermost year ring and the bark is a ring of actively growing tissue called the cambium.

It is evident from this account that when the trunk is cut tangentially into planks, the condition of the cells is different on the two sides of the planks, and consequently, from the difference in the condition, there is a tendency to warp. The best way to cut timber to avoid warping is radially. In most varieties of timber the warping takes place almost entirely at right angles to the direction of growth.

We may have warping, therefore, due to the different properties of the cells on each side of a panel, and due to difference in the amount of moisture in the air on the two sides of the panel. Prolonged and careful seasoning diminishes the danger of warping from both these causes, and the thoroughness of the seasoning can be tested by a method shortly to be described. What is known as ply-wood is prepared by cutting spirally round and round the tree a thin shaving and then glueing the shavings together with casein, with the grain of each piece at right angles to the last piece. Plywood differs very much in quality and tendency to warp according to the care with which the wood has been seasoned and the kind of wood selected.

When the wood is allowed to dry, the cell water first disappears, and then the cell walls begin to lose water more and more slowly. They never lose the loosely attached water completely until the wood is heated to a temperature at which it begins to decompose. The seasoning, therefore, of timber is the reduction in the amount of water it contains to an average, and as long as this average is sustained afterwards the wood does not warp or crack.

WOOD PANELS AND PAPER

The process of seasoning is a slow one, and after seasoning in bulk and being cut up it requires to be seasoned again. There are now rapid processes in use for seasoning with the assistance of hot air and steam, but they have yet to be proved to be reliable for picture panels. Cennino Cennini recommends boiling in water and then drying afresh. Sir Arthur Church advises soaking in water heated to 50° C. and then steaming. When dry he washes both sides with a solution of corrosive sublimate and again dries and seasons in a warm air chamber, and finally protects the back of his panel with oil paint.

As I have stated, wood is never dry. It retains a certain amount of moisture, and, in the presence of dry air, gives off moisture and shrinks and, in the presence of moist air, takes up moisture and expands. With well-seasoned wood kept under proper conditions, actual cracking from shrinkage of the whole of the wood should be impossible, but the wood is necessarily not exposed to the same conditions on both sides when hanging on the wall of a gallery, and, consequently, it will warp more or less, and the warping will vary from hour to hour and day to day, as the conditions of moisture on the two sides of the panel change, a warping, which even if not perceptible, is loosening the hold between the priming and the wood. To get more information about this, I made the following experiments.

The panels tested were 12 in. each way, and I had a tin box made 11½ in. by 11½ in. and 4 in. deep with a broad brass flange attached around the top. I then took a sheet of rubber 14 in. each way, cut out the centre, and cemented the rubber strip on to the edge of the panel, just as one would mount a water-colour picture on to a cardboard mount. The panel with this

rubber strip was then laid on the top of the box, another brass flange laid on the rubber and the two flanges pressed together with brass screw clips. The box was thus closed by a lid, the panel, the rubber margin, and the brass flange resembling a picture, mounted on a mount, and surrounded by a frame and the wood was free to expand, contract, and warp in any direction. The diagram makes the whole arrangement perfectly clear.

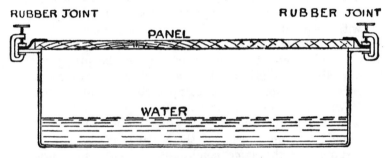

RUBBER JOINT RUBBER JOINT

PANEL

WATER

APPARATUS FOR TESTING THE WARPING OF PANELS

Fig 1.

Water was put inside the tin box so that the lower surface of the panel was exposed to air saturated with moisture, while the upper surface was exposed to the air of the room. After exposure for about twenty-four hours to moisture the panel was taken out, placed on a sheet of plate glass, and the amount of warp that had taken place measured with a steel rule. Readings with a wet and dry bulb thermometer placed above the box showed no very great change in the amount of moisture in the atmosphere during the experiments.

The first experiment was made with a white wood panel supplied by a reputable artists' colourman, and,

WOOD PANELS AND PAPER

The process of seasoning is a slow one, and after seasoning in bulk and being cut up it requires to be seasoned again. There are now rapid processes in use for seasoning with the assistance of hot air and steam, but they have yet to be proved to be reliable for picture panels. Cennino Cennini recommends boiling in water and then drying afresh. Sir Arthur Church advises soaking in water heated to 50° C. and then steaming. When dry he washes both sides with a solution of corrosive sublimate and again dries and seasons in a warm air chamber, and finally protects the back of his panel with oil paint.

As I have stated, wood is never dry. It retains a certain amount of moisture, and, in the presence of dry air, gives off moisture and shrinks and, in the presence of moist air, takes up moisture and expands. With well-seasoned wood kept under proper conditions, actual cracking from shrinkage of the whole of the wood should be impossible, but the wood is necessarily not exposed to the same conditions on both sides when hanging on the wall of a gallery, and, consequently, it will warp more or less, and the warping will vary from hour to hour and day to day, as the conditions of moisture on the two sides of the panel change, a warping, which even if not perceptible, is loosening the hold between the priming and the wood. To get more information about this, I made the following experiments.

The panels tested were 12 in. each way, and I had a tin box made 11½ in. by 11½ in. and 4 in. deep with a broad brass flange attached around the top. I then took a sheet of rubber 14 in. each way, cut out the centre, and cemented the rubber strip on to the edge of the panel, just as one would mount a water-colour picture on to a cardboard mount. The panel with this

55

rubber strip was then laid on the top of the box, another
brass flange laid on the rubber and the two flanges
pressed together with brass screw clips. The box was
thus closed by a lid, the panel, the rubber margin, and
the brass flange resembling a picture, mounted on a
mount, and surrounded by a frame and the wood was
free to expand, contract, and warp in any direction.
The diagram makes the whole arrangement perfectly
clear.

APPARATUS FOR TESTING THE WARPING OF PANELS

Fig 1.

Water was put inside the tin box so that the lower
surface of the panel was exposed to air saturated with
moisture, while the upper surface was exposed to the
air of the room. After exposure for about twenty-four
hours to moisture the panel was taken out, placed on a
sheet of plate glass, and the amount of warp that had
taken place measured with a steel rule. Readings with
a wet and dry bulb thermometer placed above the box
showed no very great change in the amount of moisture
in the atmosphere during the experiments.

The first experiment was made with a white wood
panel supplied by a reputable artists' colourman, and,

it may be taken as consisting of what is regarded as properly seasoned wood. The amount of warp amounted to 12 millimetres or approximately ½ in., the thickness of this panel being 5 millimetres.

The next experiment was with a mahogany panel, 3 millimetres thick, cut from a piece of mahogany which had been cut and seasoned for some three years. The amount of warp in this case amounting to 9 millimetres. As this panel was thinner and therefore should have warped more than the white wood panel, this showed superiority of the mahogany over the white wood.

The next experiment was made with a mahogany panel also 3 millimetres thick, and cut from an old piece of second-hand mahogany, at least twenty years old. The warp in this case only amounted to 5·5 millimetres, showing the superiority of this old mahogany and therefore the length of time that is required for a piece of wood to become thoroughly well seasoned. It is usually stated in the text-books that the seasoning of wood is merely a matter of the drying out of sap, but I do not think this is all the story. Apparently by long exposure to air the wood cells become less sensitive to changes in the moisture of the atmosphere, losing probably their hygroscopic properties.

My third experiment was made with a piece of three-ply wood 5 millimetres thick, supplied by the Venesta Company and made from alder wood. This only warped 2½ millimetres, showing a superiority even to the old mahogany.

These experiments had been made in each case by saturating the under surface of the wood by moisture. It seemed, therefore, interesting to see what would happen when the conditions were reversed, by putting dry calcium chloride inside the box so as to expose

the under surface of the panel to dry air. When this experiment was tried on the three-ply panel it warped 5·5 millimetres, showing that with the balance of moisture which it contained, it was more sensitive to drying than it was to wetting.

The next question which I proceeded to investigate was the relation between the amount of warping and the thickness of the panel. For this purpose I had two other panels cut from the same piece of old mahogany, one 6 millimetres and the other 12 millimetres thick. The amount of warping was 3·5 millimetres and 2·5 millimetres, so that if we arrange these in order we have for the 3 millimetres thick a warp of 5·5 ; for the 6 millimetres thick a warp of 3·5, and for the 12 millimetres thick a warp of 2·5. Assuming that a piece of wood is thoroughly seasoned it is evident that there is much less curvature in a thick panel, which confirms the mediæval practice of using a panel for even small pictures at least 1 in. thick.

Finally, to get a good comparison between ply-wood and old mahogany I tested a five-ply birchwood panel from the Venesta Company of 12 millimetres thickness. The warp in this case was ·5 millimetres. This is the ideal panel for artists' purposes.

The next question investigated was the protective value of different treatments in order to reduce warping, and for this purpose the white wood panels were used. Saturation of a panel on both sides with a weak solution of resin caused very little improvement. A panel sized and then coated on each side with one coat of Ripolene enamel, only warped 5 millimetres instead of 12 millimetres, showing the protective value of a coat of oil or varnish paint.

An interesting question here arises as to how far a coat of varnish or paint on one side is beneficial, the

WOOD PANELS AND PAPER

other side being exposed to moisture. It is quite possible that coating on one side is beneficial as it will tend to cause the wood to get evenly saturated with moisture throughout. Another of the white wood panels was therefore treated with enamel paint on one side only, and the other unprotected side exposed to moisture, with the result that it warped 8 millimetres instead of 12 millimetres.

From these experiments we can draw the following conclusions :—

That even for a small picture a panel should not be less than ½ in. thick ; the mediæval panel for a small picture being often over 1 in. in thickness. That either a good quality of five-ply birch or an old well-seasoned mahogany is best. That the panel should be sized and painted on both sides with oil or varnish paint."

The advantage shown by these tests of painting both sides of the panel at once raised the question of the use of such a panel for tempera painting or oil painting on a gesso ground. I found for this problem the following solution :—

A panel was sized and coated with one coat of Ripolene enamel. When dry the surface of the Ripolene was sandpapered and unprimed canvas attached to the surface, in one case with a strong carpenter's glue and in the other case with casein. In both cases the canvas was found to be firmly attached, and on being forcibly torn off left the glue and the casein attached to the Ripolene surface. Such a canvas so attached gives a capital curface for a gesso priming of either size or casein. This combination of wood and canvas is the most reliable backing for a picture which we can obtain out of known materials.

WOOD PANELS AND PAPER

When a large panel is required the planks should be tongued and grooved and cemented together with good glue or casein. Panels are much strengthened by the process of cradling. Strips of wood, slotted out at intervals, are glued on the back the way of the fibre, and cross-pieces slipped into the slots.

CHAPTER V

PRIMING OF PANELS AND CANVAS

The Priming of the Panel

THE best account is that given by Cennino Cennini in his *Treatise on Painting*. He begins by telling us how to prepare glue. For the cementing of the portions of a panel together he recommends a mixture of cheese, well washed with water, and lime, and he describes a fish glue corresponding to our modern isinglass, and a glue, " colla di spicchi," which is made from sinews and clippings of goat skins, boiled with an equal quantity of water till reduced to one-half; allowed to solidify, cut into slices and put in the wind to dry. He also describes a glue made from shavings of the skins of sheep and goats, which are softened in water for twenty-four hours and then boiled down till the water is reduced to one-third, which can be used in place of " colla di spicchi " for mixing with the grounds of the picture ; and finally a glue made from parchment clippings, boiled till the water is reduced to one-third, which he uses as a tempera for pigments. He does not consider this glue strong enough for the gesso with which the panel is to be covered. All these materials and directions correspond very closely with modern methods of glue manufacture.

He fills in hollows and knot-holes with glue and sawdust. He first treats the panel with a thin wash of parchment glue and then two coats of strong glue. I

have often found on examining old panels a very obvious layer of glue under the gesso. He next covers the panel with strips of old linen soaked in glue. I have only very occasionally found old panels prepared in this way with linen, so it evidently was not a universal practice and was not always followed by Cennino Cennini, because in the next sentence he tells us when the panel is dry to rasp it with the point of a knife. His meaning is somewhat obscure, as he tells us to make it quite even. It is, I think, obvious that a slightly roughened or rasped surface will make a better tooth for the gesso.

I found on an old Egyptian coffin lid that the fibre of the wood had been torn up, and then covered with a layer of glue and sand on which the gesso was laid. Obviously an excellent practice.

The gesso used by Cennino Cennini is made from plaster of Paris, and is used in two conditions. For the first layer he uses plaster of Paris ground with glue water and laid on with the spatula. After two or three days to dry it is rubbed down with a rasp. This is called " Gesso-Grosso."

For the final coat of gesso, he mixes plaster of Paris with an excess of water, stirring repeatedly, and keeps it wet for a month before use. This slaked plaster of Paris he calls " Gesso-Sottile." The first coat having been rasped and polished, the dried cakes of Gesso-Sottile are allowed to soak up water, then ground on a muller, mixed with glue and laid on the panel with a brush, and rubbed with the fingers into the first gesso, giving eight coats, and allowing it to dry a little between each coat. The whole must dry for two or three days, and is then rubbed and polished with iron rods till it " looks like ivory."

I have omitted details for the making of raised

surfaces by moulding. For these the reader had better consult Lady Herringham's translation.

It is evident that a glue corresponding closely to our modern carpenter's glue is used, but the amount of glue added cannot be estimated, and it is therefore not clear whether the finished surface is absorbent or non-absorbent.

From one of his remarks Cennino Cennini evidently does not consider the use of Gesso-Grosso essential. The whole can be executed in Gesso-Sottile. Finally, I have in many old panels found that whiting has replaced plaster of Paris, and that in some cases oil or varnish has been mixed with the gesso. The necessity for a non-absorbent panel in the case of oil paintings is obvious, as the oil would deeply stain the gesso and destroy its brilliancy ; and in the case of oil Cennino Cennini gives definite instructions to that effect. It does not seem to be so essential in the case of yolk of egg, but Lady Herringham found it advisable to wash over the gesso with a thin egg water.

Some time ago I obtained possession of a panel which had been covered with comparatively modern painting, and which on cleaning off the modern paint was found to be an unfinished oil picture of the Holy Family, judging by the style, of the sixteenth century. In this case the gesso had been made non-absorbent, but a very thin coat of absorbent gesso had been laid over it to act as a key for the oil. The lower gesso was composed of whiting laid over with a very thin absorbent coat of plaster of Paris.

Parchment glue from parchment clippings is easily prepared and is still used by some gilders ; but excellent glues are now manufactured for the use of carpenters, and a very fine colourless and pure glue can be obtained by taking the gelatine sheets which are pre-

pared for bacteriological purposes and dissolving them in water.

Where gilding is required, the gesso is coated with a thin layer of bole and the gold leaf cemented on with the white of egg, the surface having first been polished. The white of egg is thinned with water, and the panel is wetted and three or four coats of bole as thin as water are laid on with a soft brush, and the bole burnished with a coarse linen rag.

It is of interest to compare this account with the practice of Mr. Duncan, R.S.A., a tempera painter of to-day. Well-seasoned mahogany is used for the panel, and the refined gelatine used for micro-cultures is used for the glue. Eight sheets of this gelatine are dissolved in a pint of warm water as quickly as possible, care being taken not to boil the solution. The panel is wetted and a piece of muslin glued on to it. The Gesso-Grosso is prepared by mixing plaster of Paris with this glue to a consistency which can be plastered over the panel with a trowel. This is given two days to dry and is then scraped down with the edge of a three-cornered file. The Gesso-Sottile is prepared by mixing thoroughly one pound of plaster of Paris with one gallon of water. This is frequently stirred at first and then kept for a month. The water is then drained off and the gesso collected in a cloth, the water squeezed out, and then mixed with the glue in about equal volumes. Eight thin coats of this are laid on with a brush and the panel left to dry for four days. The surface is then rubbed down with fine sandpaper, and in some cases it is burnished with an agate—a tedious but excellent practice, as the more carefully the gesso is prepared, and the more it is polished, the easier and more successful the subsequent painting. It is then coated with two or three coats of weak size to make it

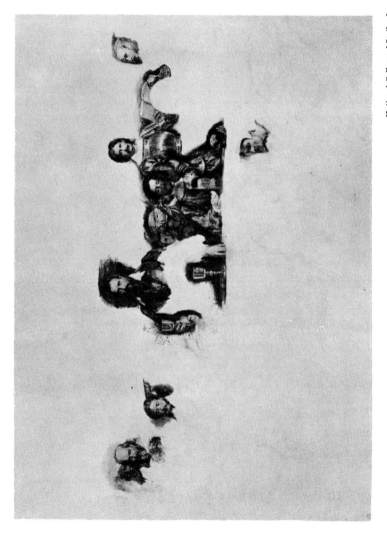

Plate 4. UNFINISHED PICTURE. By Sir David Wilkie.

Sir David Wilkie's pictures, except when he was led away, more especially in his later work, by the fascination of asphaltum, are remarkably well preserved. He followed closely the Dutch tradition. This unfinished picture is on a dazzling pure white ground.

non-absorbent. The back of the panel is also roughly coated with gesso.

In the recipes given by Cennino Cennini, it will be noted that there is no mention of any other substance than plaster of Paris. As an actual fact, the examination of old panels shows that whitening was frequently used instead of gypsum.

If the gesso is to be applied to canvas, he advises adding a little starch or a little sugar (Chapter 162), doubtless to make it more flexible; and in his recipes for oil painting (Chapter 94), he says, " and in the same manner you may work on iron, or on any panel, always sizing first "; and in his recipes in Chapter 90, for painting in oil on walls, he states that the surface is first to be sized or treated with the whole egg mixed with the juice of the fig tree. The surfaces, therefore, were probably non-absorbent.

The early oil pictures, like the tempera pictures, were painted on panels carefully coated with pure white gesso. This gesso was evidently prepared so as to be either non-absorbent or with a very thin absorbent layer on a non-absorbent surface, and on this the drawing of the picture was made. This is clearly shown in the unfinished Van Eyck in the Antwerp Gallery. In this picture the blue sky has been painted in, but the rest consists of a very fine drawing on the white gesso. Over this, according to Van Mander, a thin flesh-coloured priming through which the drawing could be seen was passed. This priming was of oil.

CANVAS

To begin at the beginning, the canvas itself should be woven of pure flax fibre, unbleached or very slightly bleached, so as to secure the greatest possible durability

of material. The test of time has shown that a linen canvas is very durable, pictures painted on canvas of the fifteenth century being in existence to-day. They have had to be relined, that is, backed by another canvas in most instances; but this has been due to defects in the priming, resulting in the crumbling and separating of the paint. Linen canvas of unbleached and partly bleached flax can be obtained from the artists' colourman.

Canvas has two great defects. In the first place it does not protect the back of the paint film from the attack of air and moisture. In the second place it is always changing, owing to the fibres readily absorbing moisture from the air. This movement is caused either by change of temperature, which alters the saturation point, or by change in the amount of moisture in the air. This constant movement tends to crack the paint and to loosen the priming from the canvas, and is probably the reason why relining is so often necessary. It also vibrates mechanically.

Having obtained a suitable canvas, the next problem is how to prime it. There can be no doubt that the earlier canvases in the fifteenth and sixteenth century were primed with gesso, the gesso priming being gradually replaced by an oil priming. The accounts given by Vasari and by later writers of how to prime in oil are too vague to be of much practical use. When priming with gesso, Cennino Cennini advises introducing a little honey to make the canvas more flexible —a very doubtful practice. The objection to gesso priming is that it is apt to crack off when the canvas is rolled up, and is easily caused to peel off by exposure of the back of the canvas to damp. A very thin priming is safest, as it is less apt to crack off.

If picture restorers are to be believed, such gesso

primings were long used after the introduction of canvas, and were usually treated with a sufficient proportion of size to make them non-absorbent.

Vasari gives an account of how to prepare both panel and canvas either with a gesso or an oil priming (*Vasari on Technique*, translated by Louisa Maclehose):—

How to Prime the Panel or Canvas

" I must now explain how to set about the work. When the artist wishes to begin, that is, after he has laid the gesso on the panels or framed canvases, and smoothed it, he spreads over this with a sponge four or five coats of the smoothest size, and proceeds to grind the colours with walnut or linseed oil, though walnut oil is better, because it yellows less with time. When they are ground with these oils, which is their tempera (medium), nothing else is needed, so far as the colours are concerned, but to lay them on with a brush. But first there must be made a composition of pigments which possess siccative qualities, as white lead, driers, and earth, such as is used for bells, all thoroughly well mixed together and of one tint, and when the size is dry this must be plastered over the panel and then beaten with the palm of the hand, so that it becomes evenly united and spread all over, and this many call the ' imprimatura ' (priming)."

This account is very difficult to follow. In any pictures I have examined, the paint lies directly on the white gesso. There is some doubt as to the nature of the " earth for bells."

Then follows another recipe for preparing canvas with oil priming which is as follows :—

PRIMING OF PANELS AND CANVAS

PAINTING ON CANVAS

" In order to be able to convey pictures from one place to another, men have invented the convenient method of painting on canvas, which is of little weight, and when rolled up is easy to transport. Unless these canvases intended for oil painting are to remain stationary, they are not covered with gesso, which would interfere with their flexibility, seeing that the gesso would crack if they were rolled up. A paste, however, is made of flour and of walnut oil, with two or three measures of white lead put into it, and after the canvas has been covered from one side to the other with three or four coats of smooth size, this paste is spread on by means of a knife, and all the holes come to be filled up by the hands of the artist. That done, he gives it one or two more coats of soft size, and then the composition of priming. In order to paint on it afterwards, he follows the same method as has been described above for the other processes."

" The composition of priming " is probably the one given in the former recipe.

Giovanni Battista Armenini was born in Faenza about 1530, and was trained as a painter, but ultimately became a monk. In 1587 his treatise, *De Veri Precetti della Pittura*, was published. He states that before sizing, the holes in the canvas can be filled up with flour paste and one-third white lead, and that the canvas should be sized both back and front. This is apparently, therefore, different from Vasari's statement, though it looks suspiciously like the same recipe incorrectly described either by the one author or the other. The priming is to be composed of white lead, with giallolino and terre de campane, or with verdigris

and umber. The additions of verdigris and umber are as driers, and the amount added may have been very small so as merely to tint the white. He himself advises a priming of a light flesh or flame colour, which he brings about by the addition of varnish. He states that pictures with dark grounds ultimately darken, and that the oil in the ground darkens and sullies the colours and therefore those who wished to prevent change made their grounds of white lead with one-sixth part varnish and a little red.

With these recipes may be compared some given by De Mayerne :—

" After spreading your canvas on a frame, give it some glue of scrap of leather or size. . . . When the glue is dry, prime quite lightly with brown-red or dark English red. Leave to dry ; smooth with pumice stone. Then prime with a second and last layer of white lead, carefully chosen charcoal, small coals, and a little umber, that it may dry more quickly. A third layer may be given, but two are sufficient."

This would doubtless produce a grey priming. It is evident from the introduction of moulding clay by Vasari, and the use of a red-ochre clay by Wallon, who supplied this recipe, that there was some fear of a pure white lead priming, at any rate in direct contact with the size.

Abraham Latombe, of Amsterdam, supplies this recipe to De Mayerne :—

" Canvases must first be glued with calf or goat-skin glue ; the whole artifice consists in this. For if the glue is too strong, the canvas easily splits and tears. After putting the glue on the canvas, lay it while still damp on the marble, flatten with the rubber all joints

and knots ; then let it dry. Then prime with white lead and a little umber. One priming is sufficient, but if you give two layers the canvas will be more even. In painting landscapes let your priming be very light in colour. A siccative oil prepared with litharge should be used."

De Mayerne comments on this, that he found the colour separated from the canvas in a picture by this artist which had been hanging on a damp wall. He therefore objects to size and also to umber. In another part of the manuscript, which contains the recipe of " the little painter of M. de St. Jehan "—

" after sizing we are directed to prime with bole, $\frac{1}{2}$ lb., and umber, 2 oz., ground in oil. Smooth with pumice and finally prime with white lead, 1 lb., and umber, 1 oz."

Similar recipes are given by other writers.

It is evident from all these recipes that the canvas was first prepared with size ; that sometimes the holes were filled up with flour paste and white lead, or flour, white lead, and oil (some obscurity here) ; that the priming was white lead with a drier like umber, and sometimes varnish, either mixed with a clay-like substance (Vasari, Armenini) or underlaid with a priming of a clay-like substance (bole, De Mayerne) ; that the priming was white, light grey, or brightly tinted, of a flame colour ; that Armenini regarded the white as of great importance. It also seems that the white lead and oil alone in direct contact with the sized canvas was not considered safe. Some modern recipes consist of mixtures of white lead and china clay, probably a very sound practice.

PRIMING OF PANELS AND CANVAS

It is evident that no very clear and definite information can be obtained from these recipes, and I know of no others that are any better.

In conclusion, the following account by Mr. Holman Hunt of the method followed by the Pre-Raphaelite Brotherhood is interesting :—

" Select a prepared ground originally for its brightness, and renovate if necessary with fresh white when first it comes into the studio ; white to be mixed with a very little amber or copal varnish. Let this last coat become of thoroughly stone-like hardness. Upon this surface complete with exactness the outline of the part in hand. On the morning for the painting, with fresh white from which all superfluous oil has been extracted by means of absorbent paper, and to which again a small drop of varnish has been added, spread a further coat very tenderly with a palette-knife over the part of the face work, and of such a consistency that the drawing should faintly shine through. In some cases thickened white may be applied to the pieces needing brilliancy, with a brush and the aid of rectified spirits. Over this wet ground the colours, transparent and semi-transparent, should be laid with light sable brushes, and the touches should be made so tenderly that the ground below shall not be worked up, yet so far enticed to blend with the superimposed tints as to correct the qualities of thinness and staininess which over a dry ground, transparent colours used, would inevitably exhibit.

" Painting of this kind cannot be retouched except with an entire loss of luminosity."

Before coming on to consider further the question of priming, Mr. Holman Hunt's account of the method of painting of the Pre-Raphaelite Brotherhood is worthy of some discussion.

PRIMING OF PANELS AND CANVAS

In the first place it will be noted that these pictures are painted on a white lead oil or rather white lead oil copal priming, in which the amount of medium was reduced as much as possible, so as to have as little yellowing of the ground in the course of time as possible, and evidently plenty of time was allowed for the oil in the first priming to get thoroughly oxidized, for he says keep it until it is stone hard. On this, before painting, another very thin coat of white lead with a minimum of oil and copal is laid, and transparent pigments are glazed on to this wet surface.

We have here, then, in so far as the use of a white ground and transparent pigments are concerned, the sixteenth-century oil technique, while, as we shall find when we study the properties of drying oils, the painting on to the sticky and still wet or partially wet paint is a perfectly sound and safe thing to do. the danger of cracking coming later when the oil has surface dried.

How the Pre-Raphaelite Brotherhood evolved this particular technique I do not know ; but it will be evident from what we will learn, both about the optical properties of oil and pigments and the properties of oil in drying, that they followed a sound method which accounts for the excellent condition and brilliant luminosity of their pictures.

If we wish to paint in tempera or in a tempera oil technique we require a gesso ground. A gesso ground has not got the elasticity of an oil ground, and consequently is more affected by the expansion and contraction of the canvas with changes in the moisture of the air, and by the vibration of the canvas, so that even if protected from damp it is doubtful if it will stand the test of time. Cennino Cennini's suggestion of adding honey is a doubtful expedient, as that means that a gesso will always be slightly moist. If he had suggested a certain

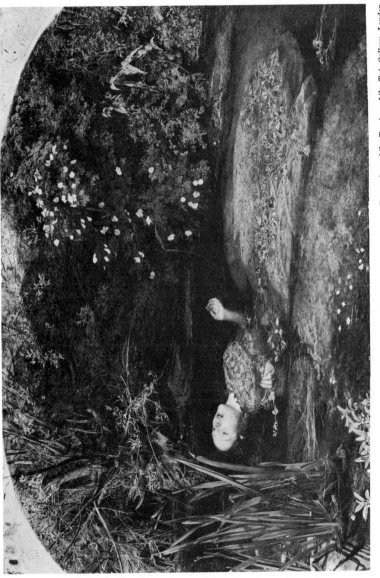

Plate 5. OPHELIA. By MILLAIS.

This is a perfect example of the Pre-Raphaelite School. Their method of painting and the scientific explanation of how the method has given such luminous and durable results is fully dealt with in the text.

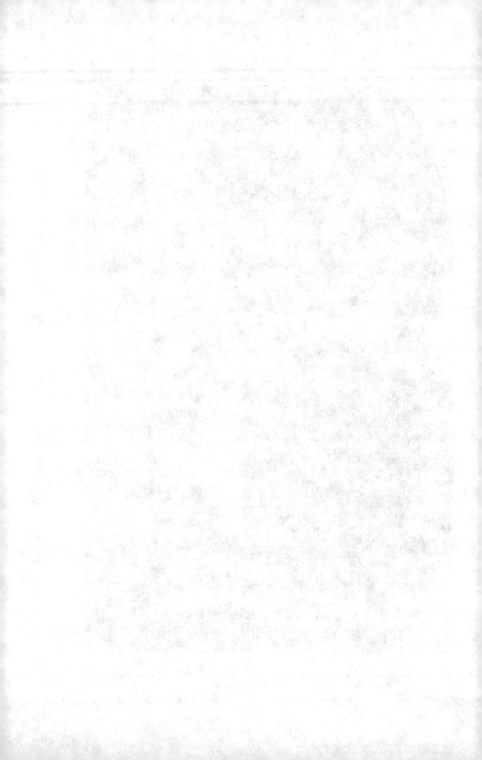

amount of lime instead of gypsum with the honey, there might have been something in it, as the use of sugar mixed with lime to produce a very hard and durable mortar is well known in India. Size is not the only material which can be used to make a gesso ground, and many painters to-day prefer casein. Mr. Batten has used it now for a long time to prepare his grounds, and has found it reliable.

The following is the account given by Mr. Batten in the *Transactions* of the Tempera Society for 1901–1907, of how to prepare a tempera ground with casein :—

" To Prime the Canvas.—Choose an oil-primed canvas of good texture. Pin it face downwards on a board or on the floor. Use plenty of drawing pins and push them well in. Allow a margin on all sides of 1½ or 2 in. beyond the ' sight ' measure of the picture. See that the back of the canvas is clean and free from dust. Rub it lightly with a benzined rag to remove any superficial grease. To prime 8 sq. ft. of canvas, put one ounce of casein[1] into eight ounces of water, and stir for a quarter of an hour with a wood or bone spoon. Then add strong ammonia drop by drop—stirring all the while—till the casein dissolves in the water and forms a strong size. Keep on stirring till the size has the consistence of a thick honey and flows from the spoon without clots.

[1] Samples of casein differ very much in strength, so the proportion of one of casein to eight of water cannot always be relied on. It is well to test each fresh purchase of casein so as to ascertain the right proportions.

I have tried using lime in place of ammonia in making casein size, but I did not find any advantage in so doing.

For Cheese glue see *Cennino*, chap. 112, and *Theophilus*, Book I, chap. 17.

A method of priming with casein size and zinc white is described in Vibert's *Science de la Peinture*. If zinc white is used it is necessary to add a little glycerine to the size.

PRIMING OF PANELS AND CANVAS

The size ought not to be diluted with water after it is made.

" Take plaster of Paris that has been slaked in water for more than three weeks and squeeze it tightly in a linen cloth. Of this take a lump nearly equal in bulk to the casein size. Mix it thoroughly with the size, and work it with a spoon through a hair sieve. Take a large hog's hair brush and lay this priming on the canvas, working it well in. If a rough surface is wanted a second coat may be dabbed on before the first is quite dry. If a smooth surface is wanted, let the first coat dry and then sweep on another. The priming is better for drying fairly quickly, so if the weather is damp a good fire should be kept in. Undue inequalities of the surface may be scraped down with glass paper, or with a knife, after the priming is perfectly dry.

" To make a backing for the canvas.— Take one or more sheets of ' wire-wove roofing '[1] cut to the size of the picture and fasten on to a wooden frame or stretcher by means of brass screws and copper nails. Mix equal quantities of Venice turpentine and oil-copal varnish (commercial). Add white lead in powder and grind into a putty of such consistence that it can be spread with a palette-knife, but is too thick to lay on with a brush. With a palette-knife spread a fairly thick coat of putty over the surface of the ' wire-wove roofing ' as evenly as possible. Roll up the prepared canvas with the oil-primed surface outwards. Do not cut off the margin yet.

" Apply the roll of canvas to one edge of the puttied surface and unroll slowly, pressing the canvas down with a photographer's roller squeegee. Work from the

[1] " Wire-wove roofing " is millboard enclosing a mesh of iron wire. It can be obtained of the W.W.R. Company. As it is difficult to cut, it is well to be careful to order the exact size.

middle outwards, so as to avoid enclosing bubbles of air. If any air should have been enclosed prick the blister with a needle and press again with the squeegee.

" If after a few days it is found that any part of the canvas is not stuck down firmly, it can be pressed down with a hot iron.

" Cut off the margin of the canvas."

As it is hygroscopic, the exclusion of glycerine, which is given in Vibert's recipe, is wise, as also is the exclusion of oil which is found in other recipes. The introduction of oil in the presence of alkali, whether soda, potash, or ammonia, means saponification of the oil, and the behaviour of such a blend would require very careful investigation.

I find that Mr. Batten's grounds are very firmly attached, but they are not so flexible as an oil ground, and here it may be plainly stated that for painting in tempera, where some form of gesso is essential, canvas without backing and support is unsuitable.

The preparation of a wood panel has already been fully described.

Canvas can, of course, be glued to a wood panel, which is only a revival of the best ancient practice.

In the case of a picture to be painted throughout in oil, there is not the same need for a gesso ground. No doubt a gesso ground is preferable to an oil priming from the optical point of view, as it will be, and will remain, whiter; but in the case of a tempera picture we must have a size or casein preparation, as it must be a preparation to which an egg or size film will attach itself.

In accepting an oil ground for a picture painted in oil throughout, we at once accept a lower colour key from the beginning, and one which will become still

lower with time. On the other hand, we have the advantage of the light, easily handled canvas on its stretcher. The traditional preparation, sizing and then priming with oil and white lead or with a mixture of white lead with other pigments, seems perfectly sound.

The attainment of a firmly adhering coat depends on three things.

The size must be sufficient to protect the fibre from the oil, but not more than sufficient. It is a good plan to roughen up the surface. The white lead should be a good stack lead, and the proportion between oil and white lead requires careful adjustment so as to ensure a firmly adhering and sufficiently elastic surface which at the same time contains a minimum of oil. The paint must be well stubbed and worked into the canvas, a little at a time, with two or three weeks between each treatment to allow it to dry. Some prefer to use pure white lead, others, to begin with, white lead and china clay.

An excellent mixture is white lead containing some 10 per cent of barytes. This would be less likely to crack, and will give a tooth to the canvas.

The next question is the selection of the oil. If we take a sample book of primed canvases, and cutting off one-half of each expose them to light while placing the remainder in the dark, and we then compare the two halves after six months, it will be found that the amount of yellowing differs very much on different canvases, showing very different methods of preparation or very different oils used by the same firm. The cause of these differences is well worthy of the investigation of artists' colourmen.

No doubt, if poppy or walnut oil has been used, a priming would be obtained which will yellow less than linseed oil, but in the light of Professor Eibner's re-

searches it is obviously safer to use linseed oil for priming.

Of linseed oil the best is Dutch Stand oil. This has been clearly brought out both by Professor Eibner's researches and by my own experiments on the darkening of oil films. There are obvious objections to using it to paint with, but it could be, and should be, used for priming. It is too sticky to grind sufficiently stiff with the pigment alone, and requires thinning with turpentine.

The amount of thinning with turpentine requires to be tested by experiment, so as to obtain a sufficient bind with a minimum of oil. The amount of oil required to bind a pigment is much less than the amount required to grind a pigment, especially with thick and sticky oils. For example, from experiments with boiled oil and lithophone I found that 5 grammes of lithophone was bound by ·5 grammes of oil, but the same quantity of lithophone required 1 gramme of oil to grind it.

The proper dilution with turps having been found, the canvas can then safely be primed with Stand oil and stack white lead. The following proportions will not be found very far from correct : 20 parts of white lead, 2 parts of barytes, 1 part of Stand oil, and sufficient turpentine to make quite a thin paint for the first application, the turpentine being reduced in future coats so as to give the paint a stiff consistency when applied. A sound copal varnish would do excellently well, or probably still better a Stand oil in which a resin had been dissolved.

The canvas having been primed on the face should now be turned over, and the back treated with a wash of tannic acid or formalin to make the size insoluble.

The experiments described elsewhere on the yellowing of the oil have shown the importance of protecting the

canvas from the back. Professor Oswald has suggested an excellent method of doing this. The canvas is covered with tin-foil cemented on with gold size. Tin-foil is practically indestructible, and has been used from the earliest times in the decorative arts, and will make the back of the canvas impervious to moisture.

The other method is to coat it with beeswax and resin. Beeswax and resin is the oldest varnish of which we have a record, having been used by the Greeks to varnish their ships. It is remarkably resistant to the passage of moisture or injurious gases. If we dissolve some size in water, colour it with neutral litmus and paint it out on sheets of glass, and when dry, varnish with different materials, and then place the varnished glass sheets under a bell jar with a strong solution of hydrochloric acid, the moist hydrochloric acid gas, when it has succeeded in penetrating the protective coating, turns the litmus red. If the surface is painted with beeswax in turps and then polished, the litmus turns red in four or five minutes. If coated with mastic varnish it resists some three or four hours. A layer of beeswax and resin, 3 to 1, less than $\frac{1}{16}$ in. thick resists for several days. Beeswax is slowly oxidized in time, and is not so resistant to chemical change as paraffin wax, but it has the advantage of being sticky and yielding to expansion and contraction without cracking. To protect with beeswax and resin melt them together and lay on the melted mixture freely on the back of the canvas with a brush and distribute with a steel palette-knife. While it is still sticky, lay on it strips of canvas and press them home with the palette-knife. Cover the surface with a further supply of the melted wax, and distribute over the surface with a steel knife as before. This makes an excellent and permanent backing to a picture.

PRIMING OF PANELS AND CANVAS

The canvas when primed should be kept six months before it is painted on, to enable the oil thoroughly to dry, and before used should be rubbed over with fine sand-paper.

If a painter wishes to use a gesso priming, the safest way is as follows : Take an oil-primed canvas ; cover the oil-primed surface with tin-foil or resin, wax and canvas, and prime the raw canvas surface with a *very thin* priming of prepared plaster of Paris and gelatine or casein.

If the canvas is purchased ready primed, it should in the first place be vigorously worked between the hands to see that the priming is properly attached.

Primed canvases differ very much in the extent to which they yellow with time. This can be tested, as mentioned on a previous page, by obtaining a booklet from the artists' colourman, cutting a little piece off each piece of canvas and attaching them to a sheet of glass, which is put in a window, and putting away the booklet wrapped up in dark paper in a drawer. After three months the exposed pieces can be compared with the pieces in the booklet, and the priming which changes least in colour selected. Keep the primed canvas six months before painting on it to ensure the thorough drying of the oil priming.

CHAPTER VI

THE PIGMENTS USED IN PAINTING

Whites, Blacks, the Earth Pigments, Vermilion, Cadmium, and the Yellows

I do not propose to follow any logical order in describing the pigments used by the painter, but rather to discuss them in the way which seems easiest to bring out their properties. The subject is a difficult one, because the pigments are derived from so many sources that for their complete understanding the whole range of chemistry is required. The painter is interested in their properties, but not in their origin, and yet some account of their origin is necessary in order to understand their properties.

For fuller details than are given here the reader is referred to *Chemistry of Paints and Painting*, by Sir Arthur Church. The most important of the pigments are Whites. We shall begin, therefore, by discussing the various white pigments available for use.

White Lead

Of these the first is white lead, known to the painter as flake white, Kremnitz white, and silver white. This pigment, known in the time of Pliny, has been used by painters from classical times, and the best white lead is still made by the process described by Pliny, namely, the exposure of sheets of lead to the vapour of acetic

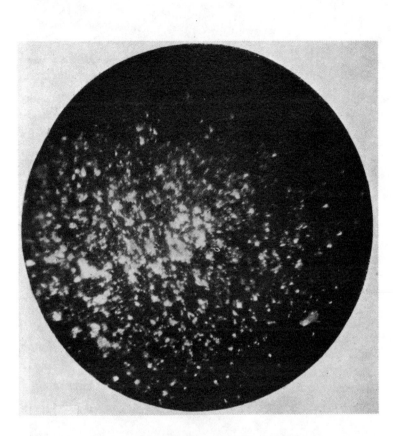

Plate 6. MICRO-PHOTOGRAPH OF PARTICLES OF WHITE LEAD GROUND IN
BROMONAPHTHALENE BY TRANSMITTED LIGHT THROUGH CROSSED NICOLS.

This photograph proves conclusively the transparency of white lead, and also that it consists of
doubly refracting crystals, otherwise no light could have penetrated through the crossed nicols of the
polarising microscope.

Plate 7. THOMAS STEWART TRAILL, M.D. By JOHN LONSDALE.
(Roscoe Collection, Liverpool.)

This picture has been selected to show the danger of the use of asphaltum in an oil picture. This pigment has evidently been freely used in the collar of the coat and the waistcoat, and, probably to a less extent, in the background.

Whether and to what extent it was used by the Old Masters is disputed, but it is evident that if used by them they had discovered some method of preventing it from creeping about the picture and tearing the oil film.

acid, little pots of acid and the grids of lead over them being packed round by spent tan in a state of fermentation. Under these conditions, by a somewhat complex series of reactions, metallic lead is converted into a white friable mass which we know as white lead and which is probably a combination of lead carbonate and lead hydrate. It is separated from the unattacked lead, washed and ground and dried and is then ready for the market. It is a pigment of excellent body and covering power, and enters into a partial saponification with the oil, which results in a paint which has proved most durable under the test of time.

There are other methods of preparing it, such as the precipitation of a pure carbonate of lead, but these preparations have not the body of white lead made by the old process, and do not enter into such intimate connection with the oil. On the other hand, they have the advantage of not yellowing the oil quite so much as the lead made by the old process.

The artists' colourman usually uses Kremnitz white, which is a very pure white. It is named after a town in Czecho-Slovakia, and is prepared by the action of acetic acid vapour and carbonic acid gas on litharge.

White lead has two defects. In the first place it is very poisonous, and while such cases are rare, it has not been unknown for artists to get poisoned by white lead. Care should be taken, therefore, to remove white lead by thorough washing of the hands after handling. It is much more poisonous in the form of powder, but the painter as a rule only handles it ground in oil.

The other defect is the susceptibility of white lead to sulphuretted hydrogen gas, which turns it black, forming sulphide of lead. Fortunately, this compound is decomposed on exposure to a bright light, forming the white lead sulphate, and also can be bleached by

peroxide of hydrogen. Peroxide of hydrogen can be applied in water solution to an oil picture and dissolved in ether to paintings in gum or size, like some of our old water-colour paintings. In modern cities this gas is not prevalent, and the conditions of pictures of all ages painted in white lead show that in practice there is not much danger from this source in the atmosphere of a private house or gallery. It has now been rightly excluded from the water-colour palette, being replaced by zinc oxide, but still remains the best pigment for painting in oil. It is usually described as an amorphous opaque pigment, but as an actual fact consists of doubly-refracting transparent crystals, as can be seen by grinding it in bromonapthalene, and owes its whiteness to its high refractive index, just as we find in another chapter that powdered glass is apparently an opaque white body. Students interested in the microscopic examination of pigments are referred to the article in *Chemical and Metallurgical Engineering*, by Henry Green, (January 10, 1923), where the crystalline character of white lead and zinc white is described. Possibly owing to slow saponification, but more probably owing to the increase in the refractive index of oil with time, a layer of white lead becomes gradually more transparent, the particles of white lead in oil in the Rokeby Venus, when examined under the microscope, appearing much more translucent to light than freshly ground white lead of to-day. The importance of this in helping towards the lowering of tone of oil pictures will be dealt with later. It is essential for artists' use that it shall be quite free from lead acetate, which is sometimes present as an impurity, owing to the method of manufacture. It not only causes the white lead in oil to yellow badly, but may cause darkening of mixtures of white lead and ultramarine, cadmium yellow, and vermilion. Eibner

has shown that these pigments ground in oil, when pure and mixed with pure white lead, do not change.

ZINC WHITE

The next white pigment of importance is the oxide of zinc or zinc white, which is known to the water-colour painter as Chinese white. It is preferred by some artists to white lead, on account of the fact that it is not affected by sulphuretted hydrogen, and it is an excellent pigment, but does not form so flexible a coating in oil as white lead, and is considered by some to be more apt to crack, although I have no positive evidence of this, and am disposed to think that the cracking is due to the use of poppy oil to grind the pigment. It has the defect that it requires a much larger proportion of oil to grind the pigment than white lead, and consequently while not changing in colour itself, is more likely to go down in tone, owing to the yellowing of the oil, than white lead. The proportion of oil required to grind white lead as compared with zinc white being as follows : for white lead, 100 parts take 15 parts of oil, and zinc white, 23 parts of oil, according to figures supplied by Messrs. Winsor and Newton to Sir Arthur Church. The amount varies a little according to the practice of the grinder, but may be taken roughly to be at least double the amount required for white lead. Ground in bromonaphthalene it is seen to consist of transparent particles.

LEAD SULPHATE

Lead sulphate and zinc oxide and barium sulphate are among the other permanent whites supplied by the artists' colourmen. A new white, titanium white, has recently been introduced. More experience in the

behaviour of this pigment is required before introducing it into the artists' palette.

BLACKS

LAMP BLACK, CHARCOAL BLACK, IVORY BLACK. All the blacks usually used by artists owe their pigmentary value to carbon, though other blacks are known. Carbon is the residue left on raising to a red heat various organic substances. We have, for instance, charcoal black, best prepared from vine clippings ; lamp black, from the burning of oils and fats without sufficient air ; and ivory and bone black, from heating ivory and bone fragments. Charcoal and lamp black are almost pure carbon. Ivory and bone black contain as well as carbon, phosphate of lime of which the bone is composed. They are all permanent, and all that is necessary for both the ivory black and lamp black is that they should be quite free from greasy and tarry material which will prevent their drying properly and also is apt to cause cracking. I have so frequently seen fine cracks appear in lamp black when painted in oil over white, that in my opinion ivory black is preferable. Whether this cracking is due to the physical properties of lamp black, or to the presence of greasy material which could be removed by washing with petroleum before grinding, is worthy of investigation.

Very dense and pure blacks are now obtainable from the burning of natural gas, obtained in the oil regions in America, with a limited supply of air. They are used in the paint trade and are the finest blacks on the market, but have not yet, I believe, been introduced by the artists' colourmen.

Graphite, another variety of carbon, is also obtainable as a pigment, and is absolutely permanent.

THE PIGMENTS USED

YELLOW AND RED OCHRE, RAW AND BURNT SIENNA, VENETIAN AND INDIAN RED, TERRE VERTE, RAW AND BURNT UMBER. Having dealt briefly with the whites and the blacks, the next group of the greatest interest to the painter is the red and yellow ochres, terre verte, and the siennas. These pigments, which are obtained by mining, grinding, washing and floating, may be roughly described as clay stained with compounds of iron. The hydrated oxide of iron is yellow, or sometimes, in the case of certain compounds, green, as we find in terre verte ; while, if these yellow bodies are heated, we get the red ochres which owe their colour to the anhydrous oxide of iron.

The yellow ochres are quite permanent, and can be safely mixed with other pigments, though the choice of the right yellow ochre for use in *Buon-Fresco*, as is stated in the chapter on that subject, is a little open to doubt. It will be seen from the table in Chapter IX that French yellow ochre is one of the least transparent of pigments, and therefore will not be very much affected by the optical changes in linseed oil. Ground in methylene-iodide saturated with sulphur, it is seen to consist of translucent isotropic particles. The red ochres, light red, Venetian red, and Indian red are either found in nature or are produced by roasting the yellow ochre, or by heating in a retort certain compounds of iron, like green vitriol (iron sulphate), in which case they are practically pure oxide of iron. Care should be taken in the case of the artificially prepared oxides that they are free from partially decomposed sulphate of iron. All these red oxides are absolutely permanent, and are the only pigments, as

85

can be seen in the table in the chapter on Oil Painting, of those tested which have proved to be opaque.

The Mars yellows and reds are artificially prepared yellow and red oxides of iron compounds, and are also permanent.

SIENNA. Raw sienna also owes its colour to the presence of compounds of iron and manganese, but is more transparent than the ochres, coming between pigments like madder lake and chrome yellow in transparency. It is a permanent pigment, but owing to its transparency and the rise in refractive index of linseed oil, gets deeper in tint in course of time, which accounts for the suspicion with which it has been regarded by artists. On roasting this pigment we obtain burnt sienna, which is also a permanent pigment.

UMBERS. Umber owes its colour to the presence not only of compounds of iron, but also of compounds of manganese. There are two varieties : raw umber, as it is obtained from the mine ; and burnt umber, which is produced by roasting raw umber. These pigments are quite permanent.

There are other browns to be found in the list of artist's colours, such as vandyke brown. Unfortunately vandyke brown is a name applied to pigments from different sources, some of which are fugitive to light. A vandyke brown, therefore, should be carefully tested by exposure to light before being used. Owing to the presence of manganese, which is a powerful drying agent for linseed oil, pigments ground in umber will be found to dry faster than pigments in other media.

We have now dealt with the earth colours, and shall go on to consider the more important of the artificial colours in their order in the spectrum.

According to Eibner the yellow ochres, siennas, and umbers dissolve slightly in linseed oil, forming dark

coloured liquids which cause lowering of tone and stain through.

VERMILION. This is one of the oldest pigments in the artist's palette. Originally the native sulphide of mercury or cinnabar was used, but even in the time of Pliny the preparation of vermilion by the subliming together of sulphur and mercury was known. This is the method used to-day in China, but has been replaced in Europe by wet methods of manufacture. Vermilion under ordinary conditions in the light of a room or gallery is permanent, as can be seen by examining some of the old pictures in which vermilion has been used, such as "The Rape of Helen," National Gallery (Plate 34). When exposed to sunlight the sulphide of mercury is converted from the red to the black variety, thus going brown. This is a molecular change and cannot be prevented by protection with varnishes. It is somewhat capricious, some samples standing exposure without change, but it is evident that vermilion cannot be safely used for outside painting. Sometimes the vermilions made in this country contain residue of alkaline sulphide, in which case they are not safe to mix with white lead. The Chinese vermilion is almost chemically pure, containing less than one part in a thousand of a harmless neutral ash. Pure vermilion can be safely mixed with pure white lead without any change. The opacity of vermilion is about the same as chrome yellow, and it is almost to be regarded as an opaque pigment ; its place in the table will be found in the chapter on Oil Painting.

Red lead is an oxide of lead obtained by roasting massicot gently. It is occasionally found in mediæval manuscripts, and when it has not turned black, has stood well. Modern tests have shown that it is not permanent either in oil or water colour.

THE PIGMENTS USED

CADMIUM SCARLET. A comparatively new pigment in the artist's palette is cadmium scarlet. The cadmium yellows are compounds of the metal cadmium with sulphur. Closely related to sulphur is another element known as selenium. The cadmium scarlets are compounds containing both sulphur and selenium. Tests of exposure to light show them to be remarkably permanent, and they form a valuable addition to the artist's palette.

ORANGES AND YELLOWS. Two oranges are available, cadmium orange and chrome orange. They are both of doubtful stability. The cadmium orange on exposure to light changes into cadmium mid, and the question of the permanency of chrome orange will be discussed when we come to chrome yellow. The cadmium yellows, including cadmium orange, are sulphides of the metal cadmium. By varying the methods of manufacture a series of tints can be obtained, from a very pale yellow up to cadmium orange. Of these the only one sufficiently permanent for oil painting is what is sometimes called cadmium yellow, and sometimes cadmium mid, and which can be obtained by the precipitation of a cadmium salt in acid solution with sulphuretted hydrogen gas. The paler varieties either fade completely when exposed to light or turn a deeper tint. There is only one way in which a pale cadmium can be made which is reasonably permanent. If cadmium sulphide is precipitated with sulphide of zinc, or hydrate of zinc, or of magnesia, and is then heated to a temperature of from 500° to 600° C. for a couple of hours, a beautiful pale yellow is obtained which resists exposure to light. This is the only pale cadmium which should be used by the artist.

It is also possible to make a permanent orange cadmium in the same way in which cadmium scarlet is made, but

with less selenium. As far as I am aware, no such orange cadmium is on the market. Ground in methylene-iodide saturated with sulphur, the cadmium yellows are translucent bodies.

CHROME YELLOWS. The chrome orange and chrome yellow are chromates of lead. They are very beautiful pigments and on the whole moderately permanent, but unfortunately are not above suspicion. If acted upon by sulphuretted hydrogen they are decomposed, and the colour cannot be restored by exposure to light, as in the case of white lead. Moreover, under certain conditions they tend to become greenish in hue. I have seen chrome yellow on an oil sketch by Constable as perfect as the day it was painted, while, on the other hand, the chrome yellows in experiments made by Mr. Holman Hunt are all greenish in colour. Further investigation is required to find out the conditions of stability for this pigment. Lead chromate ground in bromonaphthalene is seen to consist of transparent double refracting crystals. The orange chromes are basic chromates obtained by treating the normal chromate with caustic soda. It is a remarkable fact that in spite of modern chemical discoveries, the bright yellows remain the weak point in the artist's palette, just as they were in earlier times, when the only bright yellow available was orpiment, the yellow sulphide of arsenic, a most beautiful pigment ; but, if the experience of the older painters is to be trusted, dangerous to mix with any other pigment. So great were their difficulties in the matter of a bright yellow that I have found Holbein using gold leaf and yellow ochre to obtain a high point of light in yellow—an excellent device.

COBALT YELLOW or AUREOLINE. Cobalt yellow is a complex salt of potassium and cobalt which, judging by its composition, would not be likely to yield a stable

pigment, but the tests made by Captain Abney and Professor Russell showed it to be quite reliable in water colour. It is a potassium cobalt nitrite obtained by precipitating cobalt sulphate with potassium nitrite in the presence of acetic acid. When used in oil it must be remembered that it is a very transparent pigment, and that if too much oil is used it will go brown.

BARIUM CHROMATE (lemon yellow). There is more than one pigment sold under the name of lemon yellow. It may be a pale lead chrome, a strontium chromate, or barium chromate. If it is barium chromate, obtained by precipitating a barium salt with potassium chromate, it is an absolutely permanent and reliable pigment.

ZINC CHROMATE. This is a beautiful yellow, but it is not permanent in oil, and is slightly soluble in water.

ORPIMENT. This is a sulphide of arsenic, and can be obtained naturally or prepared artificially by heating sulphur and arsenic together in a covered crucible. The orpiment collects on the cool surface of the cover by precipitating the sulphide from a solution of arsenic.

It has been used from early times on illuminated manuscripts, and has also been used in oil painting. Old writers complain of its slow drying, and state that it must not be mixed with white lead or copper carbonate, which is quite likely correct as it is a sulphide. It is described as fugitive by Sir Arthur Church and other writers. Sir Arthur Church quotes an experiment of Sir Joshua Reynolds in support of this, in which orpiment in oil has faded, while orpiment in Venice turpentine has lasted. It has lasted perfectly in illuminated manuscript, and it seems unlikely that the mineral itself is not permanent. Further experiments on this would be of interest. It is a beautiful yellow, but very

THE PIGMENTS USED

poisonous, and is not very likely to be reintroduced into the artist's palette.

MASSICOT (the yellow oxide of lead). This yellow is obtained by roasting metallic lead, and can also be prepared by roasting white lead.

It has been used from very early times, and is mentioned among others by Leonardo da Vinci for use in flesh painting.

The flesh of the "La Belle Ferroniére," by Leonardo da Vinci, in the Louvre, when examined under the microscope, apparently contains this pigment.

NAPLES YELLOW. A favourite yellow with the early oil painters is Naples yellow, made by heating together the leads of oxide and antimony.

The original Naples yellow is supposed to have been a native pigment found on Vesuvius. Naples yellow, like massicot, has been removed from the artist's palette owing to the fear of darkening by the action of sulphuretted hydrogen, and is now replaced by mixtures of yellow of the same tint. The older painters seem also to have used a yellow made by heating together the oxides of lead and tin.

INDIAN YELLOW. Prepared from purree, which used to be used in water colour, is no longer obtainable, and there are no other permanent yellows available for the artist.

CHAPTER VII

THE PIGMENTS USED IN PAINTING (*Continued*)

GREENS, BLUES, LAKES, MADDER, AND A LIST OF THE PERMANENT PIGMENTS

GREENS

CHROME GREEN. There is apt to be some confusion owing to the names given to a group of greens, some of which are permanent and some of which are fugitive. Chrome green is a mixture of Prussian blue and chrome yellow, and is not reliable. Oxide of chromium green, on the other hand, is one of the most permanent pigments on the artist's palette, and viridian, or, as the French call it, verte emeraude, the hydrated oxide of chromium, is also a permanent pigment. Viridian is prepared by heating together sodium bichromate and boracic acid and washing the product. Owing to its transparency, it will tend, if painted on too thick, in oil, to turn very dark in time.

COBALT GREEN. The cobalt greens are absolutely permanent, having been made at a white heat like cobalt blue, and it may be generally assumed that pigments made at high temperatures are permanent. Several tints of cobalt green are available. They are compounds of the oxides of zinc and cobalt, and have the same opacity as chrome yellow, and therefore will not alter nearly so much by the changes in the linseed oil as viridian.

THE PIGMENTS USED

EMERALD GREEN. Emerald green, which is a compound contained of arsenic and copper and which is very poisonous, is very little used by the artist to-day, but it is a remarkable pigment with a quality of tint contained by no other green. It is permanent, but if mixed either with cadmium yellow or vermilion, acts chemically upon these two pigments with the production of a deep brown colour.

MALACHITE. Malachite green is a native carbonate of copper, and has been used through the whole history of painting and is a beautiful and permanent pigment, but with little staining power, and is little used to-day. Green bice, the artificial copper carbonate, which is of more doubtful permanence, is also very little used. It should not be mixed with cadmium yellow.

SAP GREEN. Sap green is a notoriously fugitive pigment, but has been replaced by many artists' colourmen by a similar green prepared from a coal tar dye, which is much more permanent than the old sap green. It is a preparation from buckthorn berries by boiling down the juice with alum.

VERDIGRIS, the basic copper acetate, is one of the oldest pigments, its preparation by the corrosion of copper plates by acetic acid vapour being described by Pliny. It is rightly excluded from the artist's palette. I have described elsewhere how a permanent green was prepared from it in the Middle Ages by dissolving it in pine balsam.

BLUES

PRUSSIAN BLUE. Prussian blue is obtained by the oxidation of a precipitate formed when sulphate of iron is mixed with ferro-cyanide of potassium. It is a very beautiful blue, and may be regarded as just on the margin between reasonably permanent and fugitive

pigments. It may be included in the oil palette, but should not be used for water-colour painting, and is useless in *Buon-Fresco*, as it is destroyed by the lime. I was recently confirmed in my belief in its reliability in oil by seeing a ceiling painted with Prussian blue more than one hundred years ago, in which the colour was quite bright and good. Being a very transparent pigment at the blue end of the spectrum, it is seriously affected by the yellowing of linseed oil, and should therefore only be used for thin glazings and scumblings or mixed with a large quantity of white.

COBALT BLUE. Cobalt blue, obtained by heating together in a furnace compounds of cobalt with alumina to a high temperature for a long time, is an absolutely permanent pigment, and can be used freely in water-colour and in fresco painting; but being transparent and at the blue end of the spectrum, the same precautions must be taken in its use in oil as in the case of Prussian blue.

ULTRAMARINE. The real ultramarine used by the old painters was extracted from lapis lazuli by mixing the finely ground mineral, after heating, with a mixture of resin and oil, leaving this for some weeks and then kneading the mass under water rendered slightly alkaline by wood ashes. In this way the blue is extracted, and separated from the other minerals present. This is a remarkably permanent blue of a very beautiful quality, and was much prized by the old painters. There seem to be certain conditions under which it turns grey, known as ultramarine sickness, but this is very rare, and probably is due to some accidental cause which has not yet been determined. In most cases the blue seems to last without any change. To-day we have artificial ultramarine made by heating together silica, soda, sulphur and coal, which while not so permanent as the

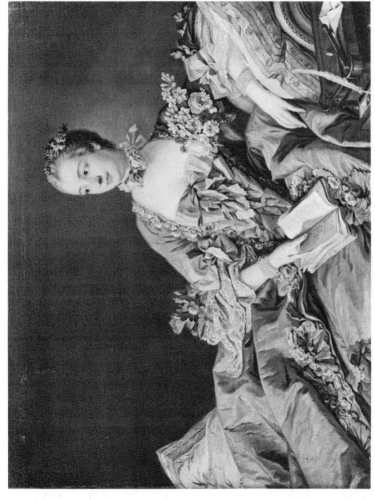

Plate 8. MADAME POMPADOUR. By François Boucher.

This is one of the most perfectly preserved pictures in the Edinburgh National Gallery. It is thinly painted on a fine canvas, the whites very thin and not solid and raised. It has a smooth enamel-like surface. It is also of interest as the dress is painted with blue bice, usually condemned as going green in oil, but here it is perfect in tone and brilliancy.

THE PIGMENTS USED

natural ultramarine, seems quite reasonably permanent for ordinary use, having now been used by artists since its discovery early in the nineteenth century. It is not quite so transparent as cobalt blue, but is quite sufficiently transparent to get very dark in tone if painted on thickly in oil, all the more as a large quantity of oil is required to grind it. The same precautions should therefore be taken for using it in oil as in the case of cobalt blue.

CERULEAN BLUE. This blue, made by heating compounds of tin magnesium and cobalt for a long time at a high temperature, is quite permanent, and has an opacity about the same as cobalt green and chrome yellow. It will therefore keep up its colour key in oil much better than any other blue.

AZURITE. Azurite, or Azzurro della Magna, the beautiful native carbonate of copper which was used very largely between the middle of the fifteenth to the middle of the seventeenth century, is no longer obtainable, and the artificial variety of this carbonate of copper, blue bice, is a weak pigment which is little used to-day. At the same time its permanency and brilliancy, if properly used, can be seen in the portrait of Madame Pompadour by Boucher, in the National Gallery, Edinburgh.

EGYPTIAN BLUE. This blue, manufactured and used in Egypt for over two thousand years, disappeared from the artist's palette somewhere between the second and the seventh century. If we had not cobalt blue, it would be worth while to revive its manufacture for use in *Buon-Fresco*. It is made by heating sand, copper carbonate, soda, and lime to a temperature between 850° and 900° C. for several days. If the temperature is raised too high the green is obtained, which was used so much in Egyptian painting.

THE PIGMENTS USED

SMALT. This beautiful blue, which was discovered towards the close of the sixteenth century, is a finely powdered cobalt glass. It was used very largely by seventeenth-century painters, and is to be found in the skies of Teniers. It is now very seldom used. It is quite a reliable pigment in oil.

INDIGO. Indigo, obtained from indigofera tinctoria, forms a very permanent dye, but as a pigment is quite unreliable, and should not be used.

VIOLETS. Cobalt violet and manganese violet—these two pigments, prepared from cobalt and manganese respectively by the formation of phosphates or arsenates, are quite reliable and permanent.

THE LAKES. We have now described all the pigments which are worthy to be included in the artist's palette, with the exception of the lakes. These pigments are obtained by dyeing the translucent precipitate of alumina obtained by adding soda to alum, with an animal or vegetable dye, and their preparation and method of manufacture is very old—apparently having been understood even in the time of Pliny. Their permanency depends entirely upon the dye selected, and consequently Dutch pink, in which the dye is Persian berries ; crimson lake and carmine, in which the dye is cochineal ; lac lake, in which the dye is obtained from the colouring matter in shellac and lakes from dye woods, are all fugitive and should not be used. Of all the dye stuffs, the madder root alone yields a dye sufficiently permanent for artists' purposes. It is difficult to know when madder lakes were first prepared, but they are at any rate as old as the fifteenth century, and where we find a brilliant lake which has resisted the changes of time in an old picture, we may take it to be madder lake. The madder lakes fade slowly when exposed to light, so that they cannot be regarded as of as high an order of permanency

THE PIGMENTS USED

as a pigment like cobalt blue, but are sufficiently permanent for all practical purposes, both in oil and water colour. Being very transparent, they are slightly affected by the yellowing of linseed oil ; but not seriously so, owing to their being at the red end of the spectrum. The dyeing principle of the madder root, alizarin, has not only been extracted from the root, but is now made artificially. The lakes prepared from alizarin are deeper and stronger than those obtained from the madder root, and seem to be equally permanent. To-day the word madder lake is very commonly used for lakes that may be made from the root or from synthetic alizarin or from blends of the two, but for practical purposes this need not trouble the artist. A more dangerous matter is that the word alizarin is now not only applied to crimson and red lakes, but also to green and blue lakes made from allied dye stuffs which, while all of a fair order of permanence; require careful testing before they can be assumed to be as reliable as the madder and alizarin crimson.

I have identified as madder a beautiful lake on a manuscript in the Advocates' Library, Edinburgh (Speculum, Vitae, Christi, 18.1.7), which from internal evidence is known to have been inscribed between 1465 and 1489. But the madder lakes are much older than this.

Professor Russell, having found a pigment consisting of sulphate of lime dyed with madder among Egyptian pigments, succeeded in imitating it by boiling the madder root with lime and sulphate of lime.

The question naturally arises why recipes for madder lakes are absent from mediæval manuscripts. The following is, I think, the explanation :

Madder was used for dyeing from early times, and we know for instance that from the thirteenth century

the dyeing with madder was an important industry in Marseilles. Now frequent references are made in the old recipes to the extraction of colour from dyed wool trimmings for making lakes. If, on the other hand, we attempt to make a bright lake from the madder root direct we get a dull lake, owing to the other dyes present. How this difficulty is avoided by makers of madder lakes I cannot say, as these are jealously guarded secrets and published recipes are of no value.

I have myself succeeded in making fine lakes by first charring the madder root with sulphuric acid, so as to destroy everything but the stable alizarin group, and then dissolving out the dye stuff with sulphate of alumina. Such methods were not available in early times, and therefore probably madder lakes were always prepared from the dyed wool trimmings.

There are other pigments to be found in artists' colourmen's lists, some of which are quite useful and reliable ; but their name and number is legion, and it is sufficient for us to deal with those most commonly used and which the tests made by chemists and the experience of artists' colourmen have shown to be reliable.

PERMANENT PIGMENTS

In the past, Captain Abney, Professor Russell, and Sir Arthur Church carried out experiments on the permanency of artists' pigments, experiments which are dealt with very fully in Sir Arthur Church's *Chemistry of Paints and Painting*. Since then Professor Eibner and others have carried out similar researches.

In addition to these the English artists' colourmen have for many years not only obtained the valuable experience of manufacture and sale, but have carried out experiments in their own laboratories. The result

of this cumulative experience and experiment is to be found in their catalogues. One firm limits the palette for sale to what they regard as sufficiently permanent pigments; others divide the pigments into groups, according to their order of permanency.

As a result of comparing these various sources of information I regard the following pigments as reliable for oil painting, namely :—

White lead
Permanent whites
Zinc white
Lamp or vegetable black
Ivory black
Charcoal black
THE EARTH COLOURS
Yellow ochre
Red ochre
Raw sienna
Burnt sienna
Mars yellows
Mars reds
Venetian red
Indian red
Terre verte
The umbers
Vermilion

Cadmium scarlet
Cadmium mid
Cadmium pale (furnace process)
Lemon yellow (barium chromate)
Aureoline
Viridian
Oxide of chromium
Cobalt green
Ultramarine
Cobalt blue
Cerulean blue
Prussian blue (Antwerp blue)
Cobalt violet
Manganese violet
Madder and alizarin lakes

For water colour and tempera, white lead and Prussian blue must be excluded, and ultramarine if the egg medium contains acetic acid. For fresco only the earth colours and viridian, oxide of chromium, cobalt green, cerulean blue, cobalt blue, and cobalt and manganese violets should be used.

In my opinion the most doubtful pigment in the whole list is cadmium yellow.

THE PIGMENTS USED

It is evident that all the firms regard a mid cadmium as permanent, and that is the only one I have included. They are also satisfied as to the deep cadmiums, but are more doubtful as to the pale cadmium.

As far as my own experience goes, pale cadmiums are fugitive or permanent according to the method of manufacture, while deep orange cadmiums have a tendency to become yellower. I have dealt with this more fully under cadmium yellow.

Ultramarines require special consideration. They are largely manufactured for paper-makers, for whom they require to be of great stability to resist the action of alum, and a great deal of research has therefore had to be made by ultramarine manufacturers as to the conditions necessary for stability. It will be noted that they are accepted as permanent by all the artists' colourmen, yet it is known that the real ultramarine in the oil pictures by old masters sometimes suffer from "ultramarine sickness," the pigment becoming grey.

This—it has been suggested by Van der Sleen—is due to the deposition of moisture containing sulphur dioxide in solution which in contact with the oil film becomes oxidized to sulphuric acid, and he has carried out many experiments to demonstrate this.

It is evident that if ultramarine is to remain in the artist's palette the conditions for obtaining the most stable variety must be laid down.

Prussian blue has always been regarded on the margin as a permanent pigment, but I know one example of a picture painted more than forty years ago with Prussian blue which is in perfect condition, and the Office of Works, in their repairs to the roof of the Great Hall at Hampton Court, proved that the wooden panels had originally been painted blue with azurite, had been repainted with Prussian blue in the eighteenth century,

and that this again had been covered with an imitation oak paint in the nineteenth century. The Prussian blue, which had been exposed for probably about a hundred years, was in perfect condition, which seems to justify its inclusion in an oil palette.

Chrome yellow from lead may be regarded as being on probation.

As stated in the beginning of this chapter, certain firms have added new pigments to their lists which they are satisfied are permanent, largely to replace fugitive pigments.

These pigments are worthy of investigation, but in the meantime I have confined myself to pigments which have long been on the artist's palette.

Professor Eibner has proved that ultramarine, vermilion, and cadmium yellow ground in oil can safely be mixed with white lead free from acetate. He condemns lead chromes, and has come to the conclusion that zinc oxide mixed with many pigments in water colour causes them to fade rapidly when exposed to light in presence of an excess of moisture.

CHAPTER VIII

THE BEHAVIOUR OF WHITE LIGHT WHEN BEING TRANSMITTED THROUGH AND BEING REFLECTED FROM TRANSPARENT SUBSTANCES

BEFORE discussing further the properties of pigments and oils it is necessary to deal with certain fundamental optical principles. We are accustomed to regard a sheet of window-glass as a transparent substance through which light passes without any obstruction. But a little consideration will enable us to realise that obstruction does take place.

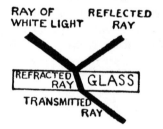

A RAY OF LIGHT PASSING
THROUGH A GLASS PLATE
Fig. 2.

The window-panes of a railway carriage when the train is travelling at night act as very perfect mirrors reflecting the interior of the carriage, and a distant window-pane catching the rays of the sun flashes with a brilliance that can be seen for miles.

102

BEHAVIOUR OF WHITE LIGHT

The rays of light on passing from air to glass meet with obstruction and, in consequence, some are reflected while only a part is transmitted. If the incident ray hits the glass at an angle, the transmitted ray is *bent* out of its path on passing into the glass so as to shorten its path.

The bending of this ray is called refraction, and the amount of bending is the measure of the obstruction suffered by the ray.

If we proceed to experiment on various transparent substances such as water, oil, glass, and diamond, we shall find that the obstruction they offer to the passage of a ray of light through them varies, so that the proportion between the light which is reflected and the light which is transmitted also varies.

In order to make this comparison we must be careful to arrange that the slope of the ray to the surface of the transparent substance, or angle of incidence, is the same in each case. The angle of incidence is defined as the angle between the incident ray and a perpendicular to the surface, and the angle of refraction is defined as the angle between the refracted ray and perpendicular to the surface, and it has been found that, whatever the angle of incidence be, when light is passing from a vacuum into a given substance, such as glass or water, there is a definite mathematical relationship between the two angles which is defined as follows and is called the index of refraction.

In mathematical language, if A is the angle of incidence, and B the angle of refraction, then the measure of the amount of refraction, which is called the refractive index, is obtained from the formula, the refractive index

$$= \frac{\sin A}{\sin B}$$

We can show experimentally that refraction takes place in the following way : Allow a ray of light to fall

on a surface of water contained in a trough with parallel glass sides. We can then trace the paths of the rays owing to floating particles of dust in the air and in the water.

We are all familiar with the concept that light consists of tiny waves, and we have all seen waves of water striking a breakwater and being reflected from the surface, the reflected waves running through the others out to sea. We may take as a rough analogy to a sub-

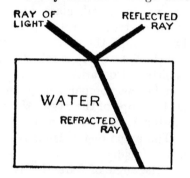

A RAY OF LIGHT PASSING
THROUGH TRANSPARENT LIQUID

Fig. 3.

stance like glass a pier made of piles with spaces between them. Some of the water waves will pass through, while others will be reflected and thrown back.

All that we need to understand for our present purpose is that a substance which has a higher " index of refraction " is a substance which is offering more obstruction to the passage of the ray of light, and therefore a larger proportion of the ray will be reflected.

We have now to ask ourselves what will happen when the ray of light is passing from one transparent substance

BEHAVIOUR OF WHITE LIGHT

of one index of refraction to another substance of another index of refraction.

If, then, a ray of light passes from a transparent substance like air with a low index of refraction to a transparent substance of a high index of refraction—that is, offering more obstruction to the passage of the light, part of the light will be reflected at the intervening surface. We can easily illustrate this with a glass trough used in the former experiment. The trough is now half filled

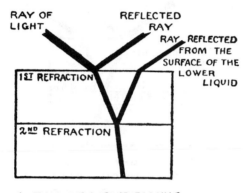

A RAY OF LIGHT PASSING THROUGH TWO LIQUIDS, ONE OF LOW AND ONE OF HIGH REFRACTIVE INDEX

FIG. 4.

with a liquid of a high index of refraction, and floating upon it is a liquid of a low index of refraction. We shall now see a reflection of a part of the ray where the two liquids meet.

As a rule solid bodies have a higher index of refraction than liquid, and consequently, if we again fill the trough with water alone, and suspend below the surface

a horizontal sheet of glass, we shall again obtain a reflected ray where the glass and water meet.

Let us now suppose that instead of a sheet of glass we introduce a transparent sheet of material with a low index of refraction, like gelatine ; we shall then get a comparatively feeble reflection where the water and gelatine meet.

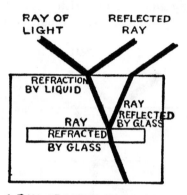

A RAY OF LIGHT PASSING THROUGH A LIQUID OF LOW REFRACTIVE INDEX AND THEN THRO' A GLASS PLATE

Fig. 5.

Or if instead of removing the glass we replace the water by a series of liquids of higher and higher refractive index, the reflection will be feebler and feebler until, if we finally use a liquid of the same refractive index as glass, there will be no reflected ray at the meeting of the liquid and glass at all.

These experiments may seem remote from the subject of oil paintings, but they have very direct practical application, as we shall presently see.

BEHAVIOUR OF WHITE LIGHT

To sum up our conclusions, when a ray of light is passing from a transparent substance of low refractive index to a transparent substance of high refractive index, light is reflected at the boundary, and the amount of light reflected will be the greater the greater the difference between their respective refractive indices.

We shall now return to the glass sheet in order to carry out an experiment of the greatest practical importance, but before carrying out this experiment let us hold the glass plate so as to look at the edge of the plate. The light is now travelling to the eye through a considerable thickness of glass and the glass appears green in colour. Therefore, besides reflecting and refracting the light, the glass is absorbing a certain kind of light and so appears green. We shall have more to say about this presently.

Our next experiment is to break the glass sheet to pieces and grind it into a fine powder. This powder is white and opaque. If we had not seen the glass as a continuous sheet, we would never have thought of it as a transparent substance, and yet each separate particle of the powdered glass, if examined under a lens, is seen to be transparent. The explanation is that the light reflected from a million facets is scattered, and it is scattered light which produces the effect of opacity. It is by scattered light that we are able to see objects, and it is with scattered light that the artist has to do.

We shall now pour the glass powder into a glass vessel and then fill up this vessel with water. Water has not so high a refractive index as glass, but its index is much higher than that of air. As the liquid rises, the glass powder no longer reflects so much light. It becomes partly translucent, and this although the liquid has not so high a refractive index as glass. If the liquid had the same refractive index, the glass would be almost invisible. We already know the explanation. Reflection

takes place when light is passing from a transparent substance of lower to one of higher refractive index. Though water is not of so high refractive index as glass, it is very much higher than air, and as we see the glass by scattered reflection, if the reflection no longer takes place, the glass disappears, just as in the story by Wells of the invisible man ; he became invisible by reducing the refractive index of all his tissues to the refractive index of air.

We can at once proceed to make some very important practical applications of these experiments. We are accustomed to regard some pigments as transparent or, at any rate, translucent, and others as opaque.

It is a question which we shall have to discuss later whether there is any such thing as an opaque pigment. We shall, at any rate, find that many pigments usually regarded as opaque are transparent in a highly refractive medium. In the meantime we shall confine our researches to the bearing which our observations have on white lead and zinc white, so as to avoid the complications of colour which we shall have to consider presently.

If white lead is ground in a liquid of highly refractive index like bromonaphthalene, it becomes a translucent pigment of a low-toned greyish white ; and if the ground pigment is flooded with bromonaphthalene and examined under the microscope by transmitted light, it is seen to consist of transparent crystals with a high refractive index, glittering like diamonds. White lead, therefore, is an extreme case of our powdered glass, and the amount of white light it will reflect will depend on the refractive index of the liquid in which it is immersed.

It reflects most light as a dry powder in air and reflects less light when ground in a medium like egg or size, and still less light when ground in oil, which has a higher refractive index than either egg or size.

BEHAVIOUR OF WHITE LIGHT

If zinc white is examined in the same way, it is also found to consist of transparent particles, and therefore behaves in the same way as white lead in media of varying refractive index.

We now come to a very important practical question. I am proposing to put a thin coat of oil over a white ground from which I wish to secure the maximum brilliancy by the reflection of scattered light. I have therefore painted the ground with white lead or zinc white mixed with a low refractive medium like size. What would be the effect of varnishing the surface with oil? The reply is, that if the surface is absorbent, that is, if the pigment is not effectively coated with size, the oil will soak in, with degradation of tone. But if the surface is non-absorbent, there will be so little degradation of tone as to be hardly visible.

Therefore to obtain the highest illumination through a layer of oil we must mix the white lead or zinc white with a medium of low refractive index and introduce sufficient of the medium to produce a non-absorbent surface.

We shall now proceed to make another practical application of our experiment.

Every artist knows that if an under-painting of definite shape is painted out it slowly becomes visible, appearing like a ghost through what is painted above. Such pentimenti can be detected in many pictures. It is evident that, while this coming through of the under-painting is only visible where the under-painting had a definite shape, the same increased translucency of the surface layer must be taking place all over the picture.

If we paint out a board with black and white squares and then paint on layer upon layer of zinc white or white lead in oil, until the black and white squares are no longer visible, and then expose the whole to light, in a

few months the black and white squares begin to show out again.

It is a commonplace of artists' experience to find that Venetian and Indian red " come through " a surface painting. These pigments, as we shall find, are among the most opaque we possess.

Let us see if we can find an explanation of these phenomena. We know that zinc white and white lead are transparent pigments, and that they will become more and more transparent if immersed in a medium of higher and higher refractive index. If, then, the linseed oil film increases in refractive index, as it gets older we should expect the results that are found in practice. Measurements of the refractive index of a linseed-oil film shows that it rises in refractive index while and after drying, and this change probably continues through many years. While the change in translucency may in part be due to chemical change, the most important cause is probably the change in refractive index of the dried oil film.

We should therefore expect to find, as we do find, that pigments like white lead and zinc oxide will become more transparent with age, and therefore, if we have darker paint below them, the picture will go down in tone ; but if we have lighter paint below them, then, if the oil remain colourless, the picture would tend to go up in tone. We shall now proceed in the next chapter to investigate the question of colour.

CHAPTER IX

COLOUR AND THE PRISM

In the last chapter we described some experiments with a sheet of glass. For the experiments we are now about to make we shall replace the sheet of glass by a prism of glass and allow a ray of white light to fall upon it as shown in the diagram.

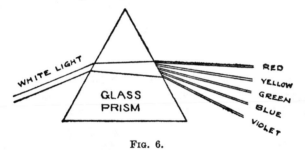

FIG. 6.

This ray will be refracted both on entering and leaving the prism ; and, having arranged matters so as to have sloping sides, the ray will be bent in the same direction both on entering and leaving the prism, and we shall find that, in addition to refraction, something else is taking place.

Besides being refracted, the ray has been opened out fanlike into a band of colour beginning with red, passing from red to orange, orange to yellow, yellow to green, green to blue, and blue to violet. Dispersion as well as refraction has taken place. This band of colour is called the spectrum.

COLOUR AND THE PRISM

Two explanations might be given of this result—one that the glass had somehow changed the nature of white light ; the other that white light itself is a complex of different coloured lights which we have succeeded in separating from each other.

In order to decide which of these two things has happened we shall make two experiments. We can

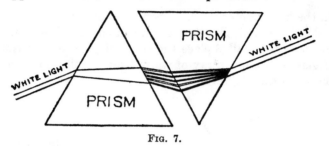

Fig. 7.

catch our coloured band in a second prism placed the opposite way, in which case our coloured band is closed up again and appears as a ray of white light.

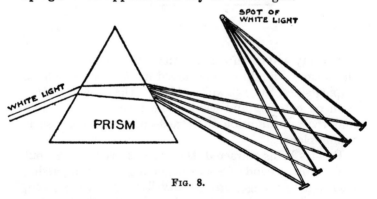

Fig. 8.

Or we can catch our coloured band on a row of little mirrors so placed as to close it up again, when a ray of

112

CHAPTER IX

COLOUR AND THE PRISM

In the last chapter we described some experiments with a sheet of glass. For the experiments we are now about to make we shall replace the sheet of glass by a prism of glass and allow a ray of white light to fall upon it as shown in the diagram.

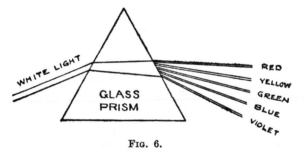

FIG. 6.

This ray will be refracted both on entering and leaving the prism; and, having arranged matters so as to have sloping sides, the ray will be bent in the same direction both on entering and leaving the prism, and we shall find that, in addition to refraction, something else is taking place.

Besides being refracted, the ray has been opened out fanlike into a band of colour beginning with red, passing from red to orange, orange to yellow, yellow to green, green to blue, and blue to violet. Dispersion as well as refraction has taken place. This band of colour is called the spectrum.

111

COLOUR AND THE PRISM

Two explanations might be given of this result—one that the glass had somehow changed the nature of white light ; the other that white light itself is a complex of different coloured lights which we have succeeded in separating from each other.

In order to decide which of these two things has happened we shall make two experiments. We can

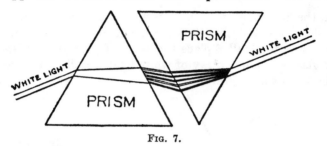

Fig. 7.

catch our coloured band in a second prism placed the opposite way, in which case our coloured band is closed up again and appears as a ray of white light.

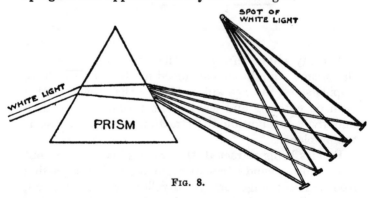

Fig. 8.

Or we can catch our coloured band on a row of little mirrors so placed as to close it up again, when a ray of

112

white light is again obtained. We are therefore justified in concluding that white light is in reality composed of these different coloured lights.

We have already spoken of light as composed of tiny waves which are obstructed in their passage through glass. Experiment has demonstrated that a ray of white light is a complex of waves of different wavelengths and that each wave is refracted at a different angle according to its wave-length, the long red wave being refracted least and the short violet wave being refracted most, so that on passing through the prism they are bent apart and separated from each other. These waves of different wave-lengths produce different colour sensations, which we name red, orange, yellow, green, blue, and violet.

We are now on the way to a simple explanation of why different substances have different colours. Suppose instead of using a piece of colourless glass, as we did in the former experiment, we use a piece of red glass, we shall find that, in addition to reflection and transmission, the red glass absorbs, destroys, or obliterates light of certain wave-lengths—namely, the blue, green, and yellow, and only allows the red waves to be transmitted.

All colour is contained in white light. Some substances reflect all the light, and we call them white. Some absorb the light, and we call them black; and some absorb certain coloured waves and transmit the others, and we call them red, yellow, green, blue, and so on.

Let us next try to understand what happens when two or more pigments are intimately mixed together. In the first place, we shall select pigments which are transparent or, at any rate, translucent in oil, such as alizarin red, cobalt yellow, viridian, and cobalt blue. If we mix these together in the proper proportions we shall obtain a black.

COLOUR AND THE PRISM

The explanation is simple : the white light is being filtered and refiltered, sinking deep into the transparent mass of oil and pigment, transmitted and reflected and retransmitted, and as it passes through each pigment it is robbed of some of its coloured rays—the cobalt blue robs it of all but blue and violet, the alizarin of all but red, the cobalt yellow of all but yellow, the viridian of all but green, till nothing is left.

In our next experiment we shall select two pigments— a pale chrome, or pale cadmium yellow, and Prussian blue. On mixing these two pigments we obtain a green.

In order to explain this result we must find out what part of the spectrum each of these pigments reflects.

This can be done by throwing the spectrum band of colour on the pigment thickly painted out and observing what part of the spectrum it reflects. As a result of this experiment we find that what we call a pure pale yellow pigment also reflects a great deal of white light, and more especially the whole of the spectrum from red to, and including, green, and that a blue, like Prussian blue, also reflects a good deal of the green.

When mixed together there will be a certain amount of light reflected from the surface particles of both pigments, which we shall find later on gives us a cold grey ; but the greater part of the light, penetrating into the mass of mixed pigment and being reflected and transmitted from particle to particle, loses all the blue-violet by absorption by the yellow, and all the red-yellow by absorption by the blue, and what is left is the part of the spectrum common to both pigments—namely, green.

If we take an orange-tinted yellow like mid-cadmium, and a purple-blue like cobalt blue, we get on mixing a dirty brownish green, because we no longer have pigments which are reflecting much of the green band of the spectrum. In fact, the colour obtained from a

COLOUR AND THE PRISM

mixture of pigments is always very largely a residue effect, each pigment absorbing its complementary colour in the spectrum. We shall have to go much more fully into this matter of colour and colour sensation later on. At this stage I propose to deal only with certain aspects of it.

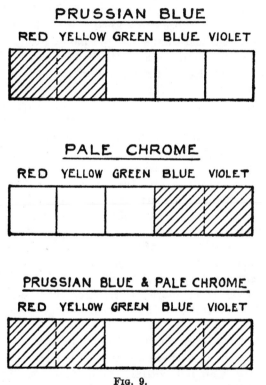

PRUSSIAN BLUE

RED YELLOW GREEN BLUE VIOLET

PALE CHROME

RED YELLOW GREEN BLUE VIOLET

PRUSSIAN BLUE & PALE CHROME

RED YELLOW GREEN BLUE VIOLET

FIG. 9.

This diagram shows quite clearly how it is that a mixture of blue and yellow produces green. The shaded portions indicate the colours of the spectrum which are destroyed by each pigment. Thus we see that the green light alone escapes.

COLOUR AND THE PRISM

We now come to a fundamental experiment of the greatest importance if we are to understand all that follows.

In the last chapter I described an experiment with powdered glass. We found that colourless, transparent glass, when powdered, gave us an opaque white powder, but on immersing it in a medium of a higher refractive index than air it became translucent. This we found was due to the fact that when light passes from a medium of one refractive index to another of a higher refractive index a great deal of light is reflected at the boundary between the two media, and as they approach nearer and nearer in refractive index, less and less is reflected until when they have the same refractive index no light is reflected at all, but it is all transmitted.

We are now dealing not only with reflection and refraction, but also with absorption of certain coloured rays and reflection and transmission of the complementary colours. Let us try to understand what happens when a ray of white light strikes a piece of ruby glass at an angle. In the first place, the amount of absorption depends on the depth of penetration.

A very, very thin sheet of ruby glass would hardly appear red at all, for as the light passes through layer after layer more of the blue-green end of the spectrum is absorbed, and the colour gets deeper and deeper.

It follows from this that the light that is reflected from the surface where air and glass meet will consist very largely, if not entirely, of white light. The light will not have penetrated sufficiently for much absorption to take place. There may have been some absorption, so that the reflected light may be tinged with red, but roughly, for our present purpose, we can regard it as consisting largely, if not entirely, of white light. In the

116

case of scattered light from a broken surface the re-flected light will contain a larger portion of the pre-dominating colour mixed with white. For in the case of the rough surface necessary to scatter the light, some of it is transmitted before it is reflected.

This being understood, let us proceed to repeat our former experiment with colourless glass and grind our deep ruby glass into a powder. The result is that we obtain a pale pink opaque powder, which, the finer it is ground, approaches nearer and nearer to white. We have multiplied a millionfold the surface reflections, and these, as we have seen, consist largely of white light, and so we obtain a pale pink opaque powder. Now mix this powder with a liquid of moderately high re-fractive index—linseed oil will do for the purpose—and at once we obtain a deep red translucent pigment rather like madder or crimson lake.

In order to understand this, we must go a little further back to our experiment with the glass plate immersed in a trough of water, but instead of one glass plate we shall now place three plates of ruby glass one below the other—A, B, and C. In the first place, let us suppose the plates immersed in a liquid of very low refractive index, so that there is a great deal of white light (2) re-flected from the surface of the first plate. The red ray (3) transmitted through the first plate will be partially reflected by B, giving a reflected red ray (4) which will mingle with the white light (2). The red ray which passes through B will again be partially reflected by C, and so on.

If most of the light has been reflected by A as white light, the red rays from B and C will be diluted with a great deal of white light.

If we now replace the liquid of low refractive index by a liquid of high refractive index, very little white

light will be reflected by A and most of the light will be transmitted through A, with reflections of red light by B and C, and so on, these red rays being very little diluted with white and therefore giving it a deep-coloured reflection.

We have repeated our old experiment with a variation by introducing absorption of certain portions of the spectrum, as well as reflection and refraction. In this description the internal reflections at the glass liquid surfaces are omitted, as they are common to both experiments.

COLOUR AND THE PRISM

We have next to ask ourselves, Are the pigments which we use transparent or opaque ? We have already found white lead and zinc oxide to be transparent, but how about the others ? Many we know to be transparent or, at any rate, translucent—namely, the lakes, cobalt yellow, viridian, Prussian and cobalt blue. In order to test whether any more of them are transparent, the obvious plan is to immerse them in liquids of higher and higher refractive index, so as to get rid of surface reflections.

White lead and zinc oxide become dirty grey, translucent pigments in bromonaphthalene, and are seen when immersed in this liquid and examined by transmitted light under the microscope to be composed of transparent crystals.

Let us, then, mix some of our best known bright pigments in bromonaphthalene and observe the change of tints produced by cutting out some of the surface reflections. For this purpose the pigment is best piled up in a little heap and then wetted with bromonaphthalene so as to get the full value of the internal reflections and transmissions.

Vermilion and the madders do not change very much in tint. Bright French yellow ochres become a brownish yellow ; raw sienna a deep brown ; pale chrome and cadmium yellows brownish orange ; the green pigments much darker and deeper ; and the blues almost black.

We learn some very interesting facts from these experiments. The mingling of white light with the red pigments makes them brighter, but does not alter their tint very much, and the same is true of greens and blues.

In the case of yellows the eye is capable of obtaining the sensation of yellow from a small portion of the

spectrum—namely, the D double line of sodium; but the yellow sensation is also evidently produced by a mixture of orange and white light which the pale yellow pigments reflect.

The next most obvious experiment is to examine the pigments ground in bromonaphthalene under the microscope. Vermilion, raw sienna, chrome yellow, cobalt green, ultramarine, and cerulean blue all prove to be transparent; French light yellow ochre, cadmium yellow, and Venetian and Indian reds being opaque.

It is evident from their change of tints and deepening of tone that they also are probably transparent in a liquid of sufficiently high refractive index.

If we now grind these remaining pigments in methylene iodide, saturated with sulphur, which has a refractive index of about 1·8, yellow ochre and cadmium yellow are seen to be transparent, and we are only left with Venetian and Indian red.

Doubtless a liquid of sufficiently high refractive index would resolve these also, as we know the crystalline hæmatite in sufficiently thin layers is transparent, and the blacks and browns will also prove to be transparent, highly absorbent substances.

The opacity of a pigment is due to the amount of absorption, of which black is a typical example, also to the refractive index, to the size of the particles and to the amount of internal reflection within the pigment.

The result of this rough analysis of the principal bright pigments will enable us to arrange them in a table of a relative opacity, or with more exactness relative refractive index, the practical importance of which will appear later.

We can now explain many phenomena with which the painter is familiar.

COLOUR AND THE PRISM

When pigments are mixed with water, or water to-gether with size, gum, or egg, they are comparatively deep in tint, but dry, very much paler. This is because the spaces occupied by the water of high refractive index are replaced by air of low refractive index, and therefore much more white light is reflected from the surface layer.

Pictures painted in size or egg are much more brilliant than pictures in oil, because of the low refractive index of these media.

A very important practical question now requires to be answered. We found in Chapter VIII that a layer of colourless oil did not affect the brilliancy of a pigment painted out in size or egg if the ground was non-absorbent.

Is there any way in which we can restore the brilliancy of a pigment ground in a liquid of high refractive index ? There is a way. If painted out very thin on a white solid, non-absorbent surface, the light passing through, reflected back, and passing through the thin layers of translucent or transparent pigment restores its full brilliancy. Cobalt blue, for instance, heaped up and wetted with bromonaphthalene appears almost black ; spread thinly on a white porcelain plate, it at once becomes again a brilliant blue.

Finally, it is obvious that if, as we have found, linseed oil increases in refractive index with age, all pigments will deepen in tone, the most transparent being most affected, and the most opaque least affected.

In another chapter we shall discuss the cause of the yellowing of the oil and how much can be done to prevent it, and how far different oils vary in the extent to which they turn yellow. Here we are interested only in the fact that oils do yellow and the optical results that will follow. After the experiments already made, and the facts ascertained, we can decide what would be the

effect on different pigments. The simplest way of con-
sidering this is to imagine a little of a transparent
brownish yellow pigment mixed in throughout the
palette.

In order to understand what will happen, let us take
as an example a pigment like cobalt blue. Cobalt blue
when examined under the microscope is seen to consist
of transparent blue particles. The light will therefore
penetrate to some depth before it is returned to the
surface by internal reflection. If the blue particles are
floating in a colourless medium, this will not matter;

A RAY OF LIGHT PASSING THROUGH
A COLOURLESS OIL FILM AND
THENCE THROUGH BLUE PIGMENT

FIG. 11.

but if we suppose them to be floating in a brownish
yellow medium, which consequently absorbs the blue
end of the spectrum, we may get complete absorption.
The cobalt blue absorbs the red-yellow end, and the
brownish yellow absorbs the greenish blue end, and so
between them we get complete absorption, and the
cobalt blue appears to be black. An opaque blue like
cerulean blue does not suffer so much from the yellow-
ing of the oil because there is more surface reflection.
Pigments at the red end of the spectrum will not suffer
so much because they are absorbing very much the same
part of the spectrum as the brownish yellow oil. Trans-
parent pigments at the green and blue end of the

spectrum, if painted in mass, are bound to be degraded by the yellowing of the oil. If thinly glazed or scumbled on a brighter foundation, or mixed with white, which has the same effect, the particles of white reflecting the light back through the transparent particles of pigment, they will then keep nearly their full value in the picture.

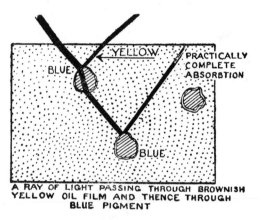

A RAY OF LIGHT PASSING THROUGH BROWNISH YELLOW OIL FILM AND THENCE THROUGH BLUE PIGMENT

Fig. 12.

From the experiments made with different pigments in liquids of different refractive index we are now in a position to draw up a table which will give us a rough measure of the effect of the increasing refractive index and the yellowing of the oil on pigments. White and black and dark brown pigments like umber are omitted, though as an actual fact the blackness of black varies according to the nature of the black and the refractive index of the medium, all blacks reflecting some white light. The whites we have already studied. The nearer a pigment is to the blue end of the spectrum, and the more transparent it is, the more it will be affected. I have selected for my table the pigments most commonly

used which are from the chemist's point of view fairly
permanent.

PIGMENTS LEAST AFFECTED BY CHANGES IN LINSEED OIL.			
RED	YELLOW	GREEN	BLUE
Venetian & Indian Red			
Cadmium Scarlet	Cadmium Yellows Light French Ochre		
Vermillion	Chrome Yellows	Oxide of Chromium & Cobalt Green	Cerulean Blue
Burnt Sienna	Raw Sienna		Ultramarine
Madder & Alizarine Lakes	Cobalt Yellow	Veridian.	Prussian Blue & Cobalt Blue
		PIGMENTS MOST AFFECTED BY CHANGES IN LINSEED OIL.	

FIG. 13.

As nearly as possible the position of the pigments has
been placed so as to indicate the effect of the alteration
in the oil in the pigment if painted thickly. For instance,
cobalt yellow being a yellow is not so much affected,
but being very transparent, suffers more than an opaque
pigment. Cobalt green being nearer the blue end of the

spectrum is affected, but being also very opaque does not show much change. Pigments like cadmium scarlet, Venetian and Indian red will remain practically unchanged, and cadmium yellow will be changed less than chromes. Raw sienna, owing to its transparency, will darken, but owing to its colour is not very seriously affected. There is no highly opaque blue, the nearest approach being cerulean blue. The madders and alizarin, cobalt yellow, viridian, Prussian blue, cobalt blue, and ultramarine should only be used for glazing and scumbling on a light solid background or for mixing with white.

All this has nothing to do with the permanence of the pigment from a chemical point of view. Cobalt blue, for instance, is of the highest order of permanence, and is therefore of the utmost value in fresco, water colour, and tempera. We are dealing here with optical effects of the oil in altering the tint and brilliancy of the pigments.

Finally, it should be written up above the door of every atelier : " Remember white lead and zinc white ground in oil are transparent pigments."

Let us now return to our experiment for the making of black by a mixture of alizarin, cobalt yellow, viridian, and cobalt blue in oil. If instead of taking these pigments as ground in oil we had taken them ground in size, or, still more, if we had mixed the dry powder, we would have obtained a grey, fairly deep for size, and much paler in the case of the dry pigment.

Or if instead of these pigments we had selected pigments which are opaque in oil in comparison, such as vermilion, cadmium yellow, cobalt green, and cerulean blue, we would have got a grey. It is not difficult after what we have learnt about the reflection and transmission of light by pigments to understand these effects.

COLOUR AND THE PRISM

If the particles of the pigment are lying side by side, and if they are sufficiently opaque to reflect most of the light falling on them, then, though this light is deeply tinted with their specific colour so that we may assume for our present purpose to be red, yellow, and blue light, we already know that the combination of coloured light produces white light; consequently the rays of light from such a mixture reflected from the surface will produce the sensation of white light on the eye, and consequently a mixture of pigments covering the range of the spectrum will appear light grey to black, accord-

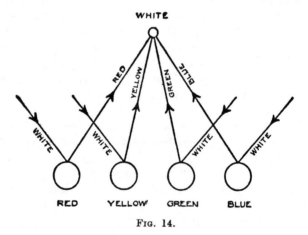

Fig. 14.

ing to their transparency and the refractive index of the medium in which they are ground.

We can now understand why we get quite different effects if we paint little dabs of pure pigment side by side instead of intimately mixing them. We get the full value of the light reflected by each pigment, the coloured rays being blended in the eye, and consequently a much more brilliant result is obtained than by intimately

COLOUR AND THE PRISM

mixing, by which large portions of the complete spectrum are absorbed.

One curious and interesting result is that this method of painting does not produce a sensation of green. Blue and yellow painted side by side produce a cool grey. In the case of other pigments, the tints obtained by the two methods, while different in brilliancy, belong to the same order of colour—a brilliant purple replacing a deep dull purple, and so on. Only in the case of blue and yellow a green can only be obtained either by using a green paint or mixing a suitable blue and yellow together.

The connection between this interesting fact and the Young Theory of Colour Sensation will be found fully discussed in books on Colour. Here we are strictly confining ourselves to experimental facts.

From what we have already learnt, the meaning of a complementary colour is sufficiently obvious. If any portion of the spectrum is selected, the rest of the spectrum, which is required with the first portion selected to produce the sensation of white light, is the complementary colour. There are thus an infinite number of complementary colours. Two complementary colours laid side by side mutually reinforce each other. Sir Arthur Church gives the following list of useful complementary colours in his book on *Colour* :—

> Red—Blue-Green.
> Orange—Turquoise.
> Yellow—Lapis Lazuli.
> Yellow-Green—Violet.
> Green—Purple.
> Green-Blue—Carmine.

CHAPTER X

LINSEED OIL, WALNUT OIL, AND POPPY OIL

Linseed Oil

Linseed oil is prepared by grinding, heating, and pressing the seeds of the common cultivated flax, *Linum usitatissimum*. As it comes from the press it requires to be refined. This can be done in various ways. The oldest and the most satisfactory manner for artists' purposes is to expose it to light and air in covered glass vessels. A variation of this method is to float it on salt water, introducing as well a certain amount of sand. Large glass flasks are filled one-third of salt water, one-third of oil, and are then loosely corked and placed outside. Every day for the first two or three weeks the contents are vigorously shaken up. The oil is then left for a few weeks to clarify and bleach. By this process mucilaginous and albumenoid substances are removed from the oil, and the final product, pale and clear, dries quite quickly enough for artists' purposes.

Owing to partial oxidation, this oil has a somewhat high acid value.

The same result is obtained on a large scale by the addition of a small quantity of sulphuric acid, which chars and removes impurities, and subsequent washing. Other methods of refining and bleaching are also known.

Linseed oil consists principally of the glycerides of three fatty acids—linolenic acid, linoleic acid and oleic

acid linked together. On exposure to air oxygen is absorbed and the oil oxidised, being converted into a transparent leathery and insoluble substance which is called linoxyn.

During this process the oil film is not only absorbing oxygen and therefore increasing in weight, but is also losing certain volatile products of the oxidation, thus losing weight. If a thin film of the oil is painted out on glass and weighed from time to time, it will be found to increase in weight in passing from liquid to sticky, and then from sticky to surface dry. It now begins to lose in weight, the rate of loss slowly diminishing.

The complete oxidation of a film of oil is a very slow process, a film four hundred years old giving reactions which show that it is not yet complete. It is doubtless for this reason that the picture-cleaner finds he can dissolve off fresh painting from older painting underneath, the older oil resisting the action of the solvent. The dangerous time for cracking is just after the film has become surface dry, as it now has a skin on the surface and is at the same time losing weight and shrinking.

The principal agent in promoting the oxidation of a film is the linolenic acid. While the chemical changes produced by the oxygen are going on, which result in the drying of the film, they are followed by changes produced by moisture which result in the yellowing of the film. This yellowing is unfortunately the property of linolenic acid itself, and is not due to any impurity in the oil. Yellowing is promoted by certain substances, such as lead driers, explaining, as I have formerly suggested, the excessive darkening of some of the paint films painted out by Mr. Holman Hunt.

As yellowing is produced by moisture, protection of the oil paint from the introduction of moisture, both from the back and the front, is important. The linseed

oil film itself is easily permeable by moisture. The films left by the spirit varnishes, like mastic, are not. I have already advised protecting the back of the canvas with tinfoil or with beeswax and resin, which is impermeable.

The yellowing of the oil takes place most rapidly in the dark. On exposure to light in a window the oil is bleached. On replacing in the dark, it again yellows. In the diffused light of a room a certain amount of yellowing takes place. What ultimately happens, whether the yellowing reaches a maximum in course of time and then begins to bleach—in fact, the entire relationship between yellowing, light, and time—is well worthy of investigation. It has been assumed from certain traditions and the Rubens Letters that it was the custom of the early painters in oil to put their pictures out in the sun while drying. This was probably often done ; but we now know that exposure to sunlight while drying is very injurious to a linseed-oil film.

If linseed oil is heated and exposed at the same time to oxidation by blowing air through it, an oil is obtained which dries more quickly than raw oil. This drying is still further promoted by dissolving in the oil certain substances which are called driers and hasten the drying process, such as sugar of lead, litharge, and compounds of cobalt and manganese. These drying oils are seldom required by artists. Sometimes a little is added to hasten the drying. A drying oil with a lead drier should in this case be avoided, manganese or cobalt driers being safer.

The preparation of thickened oils by boiling was known in mediæval times. Eraclius describes the boiling of the oil with calcined bones, which would help to remove water from the oil ; and Cennino Cennini describes the boiling of an oil till reduced to one-half

its volume for preparing a mordant for sticking on gold leaf. For painting purposes he advises bleaching the oil in the sun. This boiling of the oil will produce two changes—partial oxidation and at the same time what the chemist calls polymerization, or the grouping of the oil molecules into larger molecules. If linseed oil is boiled with the exclusion of air, polymerization alone takes place, and a thick sticky oil is obtained, known as Stand oil, which has long been prepared in Holland.

It is slow in drying unless driers are introduced ; rather dark, sticky, and flowing, so that it has all the faults which a painting oil can have, but it has one advantage—it yellows much less than linseed oil prepared in any other way, and Professor Eibner suggests it may have been used by the early painters in oil. It also probably produces the most permanent film of any oil. It is a constituent of the enamel used by the house-painter.

Many years ago, as stated in Chapter V, I tested the assertion of the house-painter that black and white squares when painted out with coats of white lead until they became invisible would show again in time, and I have recently confirmed this experiment. Professor Forbes tells me that he has been for some years making various tests on similar lines with a view to showing the extent to which lower coats of paint gradually become more visible. There are three possible causes—slow interpenetration of the pigment by the oil, formation of soaps with increased translucency, or a change in the refractive index of the oil itself. If it is due to slow penetration of the oil, or formation of soaps, this should surely take place when the pigments are ground in oil in tubes. I have never seen any indication of this. Increase in the refractive index could only result in increased transparency if the pigments

were themselves transparent. As I have shown in the chapter on Oil Painting, the greater number of the pigments used by the artist, including white lead, are transparent, or, at any rate, translucent, and it becomes necessary to investigate whether the linseed oil film increases in refractive index with time. In order to test this a film of linseed oil, cold-pressed and sun-refined, obtained from a well-known artists' colourman, was spread on the glass of a Herbert Smith refractometer, and the refractive index measured with sodium light.

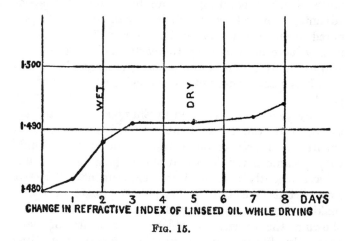

CHANGE IN REFRACTIVE INDEX OF LINSEED OIL WHILE DRYING

Fig. 15.

It is evident from this experiment that the refractive index of a linseed oil film is slowly rising. As we know the chemical change continues in the films for many years, the probability is that the refractive index continues to rise as well. Experiments continued for many months show the refractive index to be still rising. After nine months it has reached 1·500. Nut and poppy oil will doubtless behave in the same way.

LINSEED OIL, WALNUT OIL, POPPY OIL

WALNUT OIL

The kernel of the walnut contains a drying oil, the use of which has been known since the time of Ætius of the fifth century, who advises varnishing wax pictures with it. Linseed oil is the only oil mentioned by Theophilus, but there can be little doubt that the use of walnut oil for painting is very old. Either oil, linseed or walnut, seems to have been regarded as satisfactory. Vasari mentions both, and only remarks that walnut oil does not yellow so much as linseed oil. It can be obtained from the walnut kernel by grinding and pressing, or it can be extracted by boiling with water, the oil rising to the top ; or by dissolving it in a suitable solvent. It has long been used as an edible oil; but is not used to-day for the grinding of artists' pigments as a general rule, and is difficult to obtain commercially. It is now obtainable from America, being prepared pure under conditions laid down by the American Walnut Growers' Association. It dries very slowly, but if exposed to light or air over water it can be obtained very pale in colour and drying quite as quickly as the linseed oil prepared for painters' use.

According to Professor Eibner's experiments, while this oil does not darken nearly so much as linseed oil, it has two defects—its curve of drying is practically the same as the curve of drying for poppy oil shown on page 135. That is to say, it loses weight very rapidly after it is surface dry, and is therefore very likely to crack. It does not form so insoluble and permanent a film as linseed oil. This is due to the fact that while very similar in composition it contains a good deal less linolenic acid.

LINSEED OIL, WALNUT OIL, POPPY OIL

Poppy Oil

Poppy oil, which is expressed from the seed of the opium poppy, known from classical times, was first brought into use early in the seventeenth century, and we have reason to believe was very largely used by the painters of the Dutch school, both to paint with and to grind with their pigments. It is used to-day by the artists' colourman for the grinding of flake white, because it is so pale in colour. Like walnut oil, it does not darken much in time, but also, like walnut oil, it is defective in the amount of linolenic acid it contains, and is much more likely to crack than linseed oil and does not form nearly so insoluble a film. Its composition is similar to linseed oil, but like nut oil contains less linolenic acid.

Other drying oils are known, but the only other one of importance to artists is Tung oil, prepared from the seed *Aleurites cordata*. This is a drying oil, which has always been used in China and is now exported in large quantities to Europe. It owes its drying qualities to quite a different set of fatty acids to those found in linseed oil. It is a reliable drying oil, but unfortunately yellows just like linseed oil. It has the property of drying flat, and makes an excellent emulsion with size.

In conclusion, the question as to which of these oils it is safest for the painter to use is a very difficult one. Linseed oil has the defect of yellowing more than the other two, but it is less likely to crack in drying and produces a more durable film.

The following diagram, which gives the general form of the drying curve for linseed and poppy and nut oil, brings out clearly the results of Professor Eibner's researches. In each case a very thin film of oil on glass was weighed at intervals. In the case of linseed oil

it will be noted that after reaching the maximum weight at " surface dry " it falls off in weight very slowly, while poppy and nut oil fall off in weight rapidly, which means a rapid shrinkage at this stage, a shrinkage which will cause cracking in the film itself or in a superposed film.

In addition to these defects Professor Eibner has shown that owing to the low content of linolenic acid

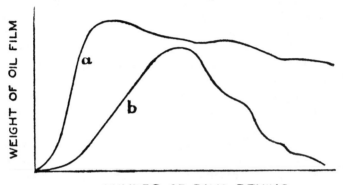

NUMBER OF DAYS DRYING

a = LINSEED OIL
b = POPPY OIL

Fig. 16.

the dried films of poppy and walnut oils are much more easily attacked by solvents. On the other hand, it must be remembered that all these vegetable oils, even olive oil, will dry in time, and it is, at any rate possible, that with time the poppy and walnut films will continue to improve.

Against Professor Eibner's conclusions we have the fact that walnut oil was used from the earliest times, and that there is no suggestion by early writers of

painting that they found walnut oil unreliable, and that there is also considerable evidence that the Dutch painters of the seventeenth century used poppy oil to grind with white lead and with the more delicately coloured pigments.

It has also been shown by Dr. Morrell that under certain conditions linseed oil paint will crack freely.

The most important conclusion to be drawn from Professor Eibner's and Dr. Morrell's researches is that, while it is safe to paint into wet oil (the method used by the Pre-Raphaelites), it is very dangerous to paint over a film just surface dry. When this stage has been reached the picture should not be continued for two or three weeks.

Cracking is, of course, as much a question of careful manipulation as it is of the nature of the oil. Thin painting, with time to dry between each layer, is safe with any oil. Modern impasto puts an undue strain on a drying oil, and the marvel is that all the modern pictures *do not* crack—not that some *do*. As long as painters understand that there is increased danger of cracking in the use of poppy oil and nut oil, there is something to be said for grinding pigments in them, in spite of Professor Eibner's conclusions. Evidently further inquiry is necessary, more especially an examination of the Dutch pictures, with a view to deciding how durable the films of these oils become in time.

I have already stated the conclusions come to by Professor Eibner as to the yellowing of drying oils. It therefore remains to describe some experiments which throw further light on this question.

The rate of yellowing is hastened by darkness and by the presence of moisture, and therefore in order to obtain results in a comparatively short time I enclosed the samples, painted out on glass slides, in the dark and

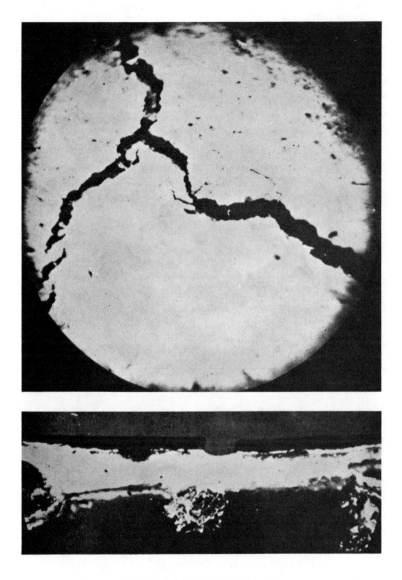

Plate 9. CRACKS IN AN OIL PICTURE.

These are micro-photographs, in plan and in section, of a crack in an oil painting. The shrinking of the layer of paint above the priming, causing a crack with straight sides, is clearly shown. The pull on the priming by the shrinking layer of paint is also shown, the priming having been drawn out. Incidentally, it is very difficult for the forger of Old Masters to produce artificially cracks which will stand examination under the microscope and comparison with genuine cracks produced by the shrinkage of the paint film.

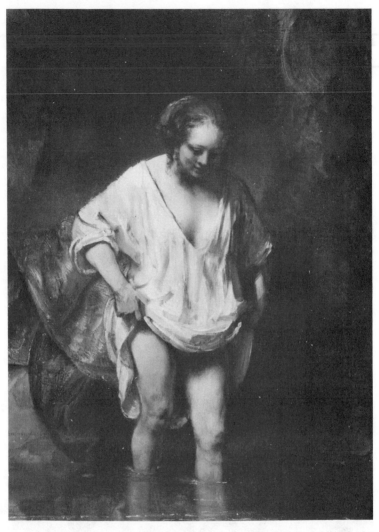

Plate 10. A WOMAN BATHING. By REMBRANDT.

On the whole, Rembrandt's pictures are in good condition. Some of them are very low in tone, but this seems to be due to subsequent varnishing with a varnish which has yellowed badly, the paint below being little degraded from its original condition. The most durable variety of linseed oil, and the kind that yellows least, is Stand oil which has, for centuries, been prepared in Holland, and Professor Eibner suggests that it may have been used by the early Flemish and Dutch painters.

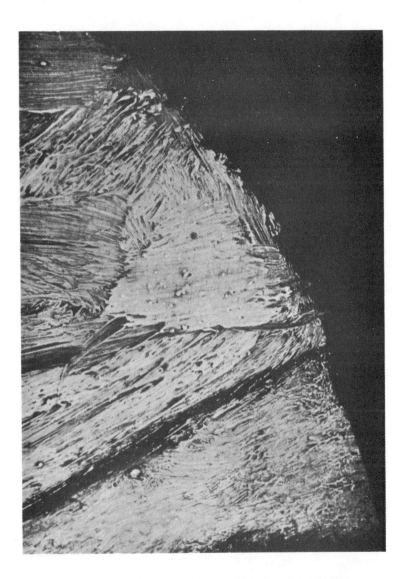

Plate 11. MAGNIFIED PHOTOGRAPH OF THE BRUSH-WORK IN THE
"WOMAN BATHING" BY REMBRANDT.

The significance of the peculiar texture of the paint as suggesting the nature of the oil used is fully
dealt with in the text. Whatever the nature of the medium, this photograph of Rembrandt's brush-
work should prove of great interest to the art student. The thick and sticky nature of Stand oil, and
the peculiar texture of Rembrandt's brush-work, as revealed in this magnified photograph, seem to
make it possible that he may have used this oil.

LINSEED OIL, WALNUT OIL, POPPY OIL

in an atmosphere saturated with water. A flake white and a zinc white used for artists' purposes were ground with various samples of oil and varnish, weighed quantities of the pigment being ground with weighed quantities of the medium. The oils used were—a linseed oil, cold-pressed and sun-refined over water, a pure sample of poppy oil, pure walnut oil, which was also bleached and refined in the sun, a Dutch quick-drying Stand oil containing driers, a mastic varnish, copal varnish made by dissolving hard Sierra Leone copal in the specially prepared linseed oil and a dammar varnish made by dissolving 20 per cent of dammar in the Dutch Stand oil, and a carefully rectified specimen of American oil of turpentine.

The samples were painted out on glass slides and allowed to dry in ordinary daylight, and then placed in the moist dark atmosphere under a bell jar. After one month they were examined and compared with fresh grindings of the same pigments and oils. Out of the twenty-four samples prepared, zinc white in poppy oil, white lead in walnut oil, white lead in an emulsion of Stand oil and yolk of egg, white lead ground in the Stand oil, dammar varnish thinned with a little turpentine, and white lead ground in a mixture half of linseed oil and half of mastic, had shown least change.

The mixture of oil in mastic varnish proved unsatisfactory, the surface being easily powdered and brittle, so it must be excluded from these successful results. The superiority of walnut and poppy oil as compared with linseed oil was clearly shown, a sample of white lead ground stiff in the sun-refined linseed oil having become distinctly yellow. White lead ground in a double quantity of linseed oil had yellowed very much more than a white lead ground stiff, showing the importance of keeping down the quantity of oil.

LINSEED OIL, WALNUT OIL, POPPY OIL

A sample of white lead ground in oil thinned with turpentine had not yellowed any more than another sample ground in the same quantity of oil without turpentine.

These results are very much what we might have expected, but the behaviour of the Stand oil varnish is of special interest and also the Stand oil egg yolk emulsion. This emulsion does not crack on drying even if laid on thick, and is short and crisp under the brush.

The experiment with zinc white and poppy oil was very satisfactory; but, as I have already stated, Professor Eibner has thrown great doubt on the value of poppy oil as a permanent medium, and it seemed advisable to compare flake white with zinc white in linseed oil. If both pigments are ground as stiffly as possible, zinc white requires about double the amount of oil that flake white requires, and 2 grammes of white lead with ·3 grammes of linseed oil is of a convenient stiffness, but 2 grammes of zinc white require ·6 grammes of linseed oil.

If the flake white and the zinc white are ground with equal quantities of oil, the yellowing is equal, but if both are ground to an equal working stiffness the zinc white yellows more than the flake white, as it contains more oil.

If, therefore, an artist wishes to use colours ground in linseed oil, he will find that stiff flake white will retain its whiteness better than stiff zinc white. Flake white, with equal amounts of copal oil varnish and linseed oil respectively, yellow to about the same extent. The bad reputation of copal varnish as a medium seems, therefore, to be due to its being added in excess of the amount of oil already present.

An examination after six months proved poppy oil

to change least, Stand oil without dryers and walnut oil to come next, and that dilution with turpentine had caused some yellowing, showing petroleum properly rectified to be the safer diluent. The copal oil varnish had yellowed a good deal more, but the Stand oil with dammar dissolved in it at a gentle heat had changed very little. The mediæval varnishes made with soft resins probably therefore yellowed much less than hard resin oil varnishes of to-day. Dammar in Stand oil as an artists' varnish is worth the attention of artists' colourmen.

As it is known that the yellowing of the oil is due to the action of moisture, the question of protection of the oil from moisture becomes of importance.

In a former chapter I have explained why, on account of the permeability of oil to moisture, it is advisable to protect the back of the canvas as well as the front of the picture. The importance of this is clearly brought out by the following experiment :

Some flake white ground in linseed oil was rubbed out, A on a sheet of glass, B and C on ordinary artist's primed canvas. When the films of paint were dry, B was varnished with mastic, and C was both varnished with mastic in front and the canvas soaked with mastic at the back. Of these, B, the canvas plus mastic had yellowed most, the rubbing on glass came next, and the whitest was canvas C with mastic on both sides. Evidently the mastic had not proved so good a protective surface as the glass, and the primed canvas had proved of no value at all as a protective agent, while the white lead oil film sealed on both sides had remained practically unchanged. A great deal of the darkening of our pictures is doubtless due to the neglect of protecting the back of the canvas by an impervious coating, so as to prevent the passage of moisture.

CHAPTER XI

THE OPTICAL PROPERTIES OF OIL AS ILLUS-TRATED PRINCIPALLY BY THE EXAMINA-TION OF PICTURES OF THE FIFTEENTH, SIXTEENTH, AND SEVENTEENTH CEN-TURIES

In the last chapter, as a result of some simple optical experiments, we came to certain conclusions which have a very direct bearing on our methods of painting, and now require further consideration. Those results are not only a valuable guide in modern practice, but they throw an illuminating light on much of the early technique in oil painting, and by studying this technique in the light of our experiments we shall gain much useful information.

Let us then briefly restate the practical conclusions to which we have come.

The object of the experiment was to determine, among other things, how to paint a picture in an oil medium which should remain high in key.

It is obvious, if the pictures which have not been painted very long are examined, that there is a tendency for them to go down in tone. This varies very much with different painters. We have an infinite variety of technique among painters in oil, and the technique of some leads to a much more serious lowering of tone than the technique of others.

On the other hand, whether we look at the fifteenth-century painters in oil, or at many of those of a later

140

date, we do not find that the pictures have seriously altered through the centuries. It is evidently, therefore, of the first importance that we should thoroughly understand this matter. Is it due to faulty chemistry —to impure or wrongly prepared oils and pigments, or is it due to a faulty method of using the materials ?

A very striking instance of this lowering of tone was brought before me by Sir Arthur Cope. He had two sketches which he had made some fifteen years ago of a light bit of woodland, full of sunshine and wild flowers. The one sketch was in size and the other in oil. When first done they were as nearly as the medium would allow, of the same colour key. The picture in size was glowing and brilliant : the picture in oil was, when placed beside it, dark and dull. I examined the oil picture carefully under the microsope, and found that the surface had to some extent become ingrained with soot. This could not be removed without removing paint, and accounted for some of our trouble. The oil also had yellowed.

After washing with saponin and water, I placed the picture for some months in a north window. This improved it considerably ; the oil bleaching to some extent, but it still remained far behind the size picture in brilliancy.

That experience and many other similar ones have been haunting me for years, and I have felt that there remained something unexplained in the use of oil—some unexplored corner in the properties of oils and pigments, which would throw light on these matters. The optical inquiries, the results of which are given in a former chapter, have, as we shall see, very definite practical application. Let us then discuss what the conclusions are to which we have come.

We have learnt to regard our pigments as transparent

pieces of coloured glass, and to realize that their opacity and brilliancy will depend on the optical properties of the medium they are mixed with. If mixed with size or egg, we get very nearly their full brilliancy and opacity, and owing to the fact that these mediums do not alter appreciably in refractive index after they are dry, this brilliancy remains practically unaltered by time.

A permanent and unalterable white is the gesso on which an old panel picture was painted, the mixture of size and plaster of Paris if non-absorbent forming an opaque white background. The exposed gesso surface of old pictures has got soiled and dirty, but protected gesso remains of a pure white. If then we choose to paint in size or egg our troubles are over, as then we can select—which we can easily do—pigments which are in themselves permanent.

We have here the technique of the early tempera painters, and of the tempera painters of to-day—painting on the white gesso in a medium which gives each pigment nearly its full value and will not change.

If we now proceed to grind our pigments in oil, we at once notice a change. They are all deeper in tone and more translucent. The new medium has a much higher refractive index than size or egg, and consequently our paints are appreciably nearer to their true tints unmixed with white light, revealing something of their transparency.

If this were all, if the oil medium were as reliable and unchangeable as the egg or size medium, then we could work freely without fear with the new medium. But unfortunately it has two vices. In the first place it changes in refractive index with age. This begins from the moment the oil paint, painted out in a thin layer, has begun to dry. The dry paint is already not so

opaque, not so brilliant, as the paint squeezed out of the tube. This change goes on slowly but remorselessly through the years, though, of course, at a diminishing rate. We know that the slow chemical changes which take place in the linseed oil film are not complete after four hundred years, that the film is still improving in toughness and insolubility. As the changes in the refractive index are doubtless due to these slow chemical changes, the change in the refractive index is probably also going on.

The pigments then are growing deeper in tone and more translucent, and hence it is that we have pentimenti, the under-paintings ultimately showing through.

The other change, which is also closely connected with the chemical change which results in the " drying " of the oil, is the yellowing of the oil. Unfortunately for the painter, the better the oil the worse the yellowing. The researches of Professor Eibner show conclusively that it is the valuable constituent which turns the oil into a tough elastic film, which also by another change causes the yellowing. Linseed oil yellows more than· poppy or walnut oil, but it also produces a far more durable and insoluble film—and they all yellow.

It does not require a profound optical knowledge to see that this yellowing will affect blue and green paints more than red and orange paints, and that it will affect most the more transparent paints where the light is plunging deep into the oil pigment layer.

These matters we have already discussed. The yellowing of the oil will affect the blues more than the reds, and will darken and blacken the transparent cobalt blue much more than the comparatively opaque cerulean blue.

The table on page 124 summarizes the results.

The changes in the oil make us regard our whites—

whether flake white or zinc white—with suspicion. We have found both of them to consist of transparent crystalline particles.

Not only will they yellow with the yellowing of the oil, but they will also grow more translucent, allowing dark under-painting to show through.

As I have stated in Chapter IX, this is easily found experimentally. Paint on a canvas or a panel, black and white squares with size, cover the whole with size to make it non-absorbent. Then paint layer upon layer of zinc white or flake white over the black and white squares till they are completely covered and invisible. To hasten the action of time, place the finished panel in a window. In a few months the pattern of the black and white squares will be seen coming through.

In the chapter dealing with colour we made certain other experiments which are of fundamental importance if we are to understand the early oil technique.

We found that if a pigment had been painted out in egg or size and had sufficient medium to be non-absorbent, the painting of oil on it, if the oil was colourless, did not appreciably affect its brilliancy ; and we also found that while a transparent paint like cobalt blue mixed with a highly refractive liquid, when in a thick layer would look almost black, that when spread thinly on a light under-surface it resumed at once its full brilliancy.

Let us now consider the early oil techniques in the light of these experiments.

In merely mentioning the words " oil technique " I am aware that I am entering on dangerous controversial ground. Frankly I am going to make certain bold assumptions, and so avoid a controversy as to whether the Van Eycks had or had not a secret medium and what the nature of that medium was, and the extent to

Plate 12. A SECTION THROUGH THE GESSO OF THE "HOLY FAMILY"
ATTRIBUTED TO CORREGGIO (Plate 18).

This is a micro-photograph of a section cut through the gesso of the unfinished picture examined by
Mr. Thomson. By means of a special stain Mr. Thomson succeeded in staining the thin oil layer which
had soaked into the thin layer of absorbent ground.

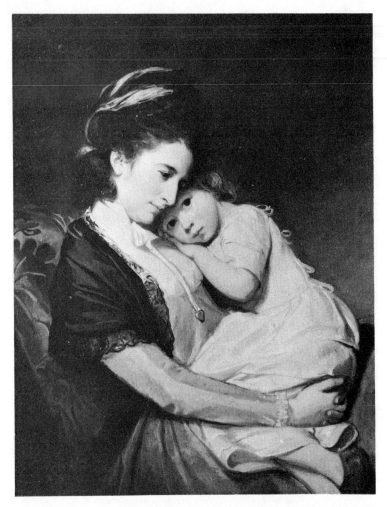

Plate 13. LADY JOHNSTONE AND HER SON. By ROMNEY.

Romney was trained by an itinerant portrait painter, who had, no doubt, sound traditions and he does not seem to have deviated from them. A limited palette, simple direct painting without foozling, and his pigments ground with just the right quantity of oil, seem to have been his secrets.

His pictures are in good preservation, though somewhat cracked, especially in the whites, and have kept up to a high colour key, showing little degradation of tone.

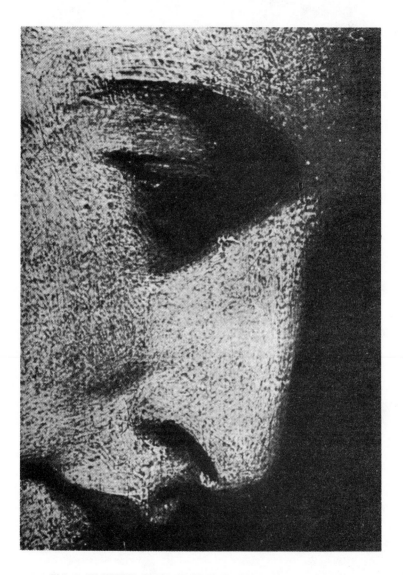

Plate 14. MAGNIFIED PHOTO OF PART OF THE "LADY JOHNSTONE
AND HER SON" BY ROMNEY.

Showing the modelling of the face. Very rarely Romney used a little asphaltum, and this, of
course, has always gone wrong. Occasionally he painted very thinly on a twilled canvas, with hardly
any priming. The magnified photograph of a part of this picture illustrates his brush-work.

Plate 15. SAINT BARBARA. Unfinished Picture by Jan Van Eyck at
Antwerp.

This unfinished picture is of supreme interest. Only the blue of the sky has been
laid in oil.

The picture has been completely modelled in black and white, the white being the
surface of the gesso. On this black and white the thin glazings of the translucent oil
paint will be laid. The full significance of this combined tempera oil technique is
explained in the text.

which their pictures were not only begun, but finished in tempera or in a water emulsion.

We shall take as our guide certain unfinished pictures and we shall assume, and the unfinished pictures seem to justify that assumption, that the foundations of the pictures are laid in tempera, whether egg or size or water emulsion, and are finished in an oil preparation, whether oil or oil varnish or blend of oil and egg, which being essentially an oil medium, with the properties of an oil medium, would yellow with time and changing in refractive index make the paints more translucent.

Let us begin, in the light of what we have learned, to examine the unfinished picture by Jan Van Eyck at Antwerp.

This picture is on a white gesso panel and has been completed as a drawing—completed, that is, in monochrome before the oil painting was begun. Part of the colour, the blue of the sky, has been already laid in. Now let us proceed to lay this oil colour on this drawing, and consider what will happen in course of time. Let us take, for example, the robe of the figure, and in order to select a pigment which will be most affected by the changes in the oil, let us suppose that we have glazed it with a transparent, or, at any rate, translucent blue. In time the oil will yellow, thus degenerating our blue ; but also the oil changing in refractive index will make our blue still more translucent, so that more white light will be shining through from the white gesso reflecting the light from below. The original scheme of light and shade of black and white, in permanent monochrome below, will correct the flattening effect of the yellowing of the oil.

Moreover, we have seen that a pigment deepens in tone merely from the rise in the refractive index of the oil—a transparent blue in thick layer turning black,

but that the remedy for this is to paint thinly on a light ground. We are therefore actually utilizing one fault of the oil to correct the other—we are ensuring that increase of brilliancy will result from the rise in refractive index.

Let us next consider painting where white lead has been used—let us say in the flesh paintings, which we may regard as white lead tinted with red. The yellowing of the oil will yellow, darken, and degrade the white lead, but the increasing translucency of the white lead will increase the luminosity from the white gesso below.

I shall now proceed to examine another unfinished picture, attributed to Cima da Conegliano, in the National Gallery, Edinburgh. In this picture we have the opportunity of studying the method of oil painting at a later period. This painter is said to have been strongly influenced by Giovanni Bellini. The picture is in a half-finished condition, the laying on of oil paint just begun. The whole has been painted first in a tempera monochrome, over which the oil paint is being laid, so that we have here the same technique, with little change, which we found in the unfinished Van Eyck.

The next unfinished picture which we shall examine shows us another aspect of this early technique.

In the National Gallery, London, we have two unfinished pictures attributed to Michael Angelo. The first we shall consider, "The Entombment" (Plate 21), was formerly described as a tempera picture; but is now rightly described as an oil picture, or rather an example of the combined oil and tempera technique. We have here, again, the white gesso as our foundation white, and the preparation for the oil, in tempera monochrome; but we have in addition an example of an under-painting in tempera with a bright colour.

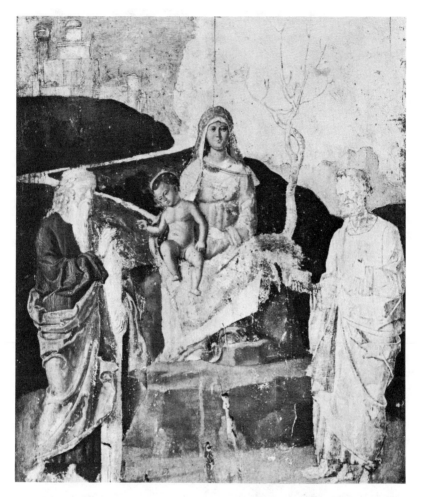

Plate 16. UNFINISHED PICTURE. By CIMA DA CONEGLIANO.

This picture is of great interest as revealing the oil tempera technique at the close of the 15th and beginning of the 16th century. The whole picture has been laid on in a tempera monochrome on a white gesso and the over painting with oil has just been begun.

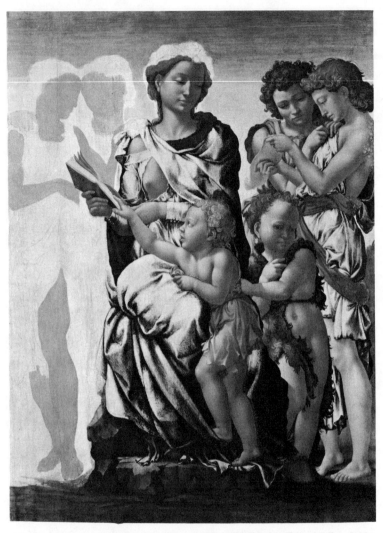

Plate 17. MADONNA AND CHILD. By MICHAEL ANGELO.

This unfinished picture in tempera oil technique by Michael Angelo is of special interest. On a white gesso panel the picture has, in the first place, been laid in in tempera. The Virgin's robe, which doubtless he intended to glaze with real ultramarine or Azzurro della Magna, has been completely modelled in black and the white of the gesso, while the flesh tints have been deliberately lowered by a thin wash on the gesso of terre verte.

OPTICAL PROPERTIES OF OIL

The figure on the left of the spectator, supporting the dead body of the Christ, wears a garment laid on in a brilliant red on the white gesso, either vermilion or red lead. The colour is very brilliant and fresh, and is ready to receive the subsequent glazings of translucent oil paint.

For example, let us suppose a lake, in oil, laid over this red. The yellowing of the oil will degrade the lake, but the thin painting of the lake on the bright red will ensure no lowering of tone owing to the rise in refractive index of the oil. On the other hand, the rise in refractive index, by increasing the translucency of the oil paint, will ensure a more brilliant light from underneath.

The next picture we shall consider is the other unfinished Michael Angelo (Plate 17).

Here, again, in the drawing of the Virgin's robe we see a completed black and white monochrome, the white being the gesso, ready for the glazings of transparent blue, probably Azzurro della Magna.

But this picture is of interest for another reason. Cennino Cennini, whose MS. we shall discuss fully later on, advises tempera painters to lay a thin coat of terre verte over the flesh, as a ground painting for the subsequent flesh tints. It has been assumed by some that this direction of his indicates a universal practice on the part of tempera painters. In most cases their flesh painting is too high in key for this to be probable, and it certainly is not the practice in any oil pictures I have examined.

But whatever may be the truth of this matter, Michael Angelo has adopted the practice in this picture, the uncompleted figures having the flesh covered with a dull thin wash of green, and if we turn to the finished figures, the low tone of the flesh as compared with the draperies is conspicuous.

OPTICAL PROPERTIES OF OIL

What is of interest to us is the proof of the value Michael Angelo laid on the pure white gesso underlying his paint, since he deliberately stains it when he wants to lower the tone of his painting. That the green under-painting is supposed to give quality to the flesh tones is neither here nor there for our present purpose, which is the value in thin oil painting of the white gesso underneath.

During the whole of this chapter we have made an assumption that the gesso itself was non-absorbent.

On this matter Cennino Cennini's instructions are quite definite.

Having described how to paint in oil, he says : " In the same manner we may work on iron, or stone, or any panel, always sizing first."

It is evident that if the gesso is absorbent and stained with oil it loses all its optical value. When panel pictures have had the panel planed away the gesso is always found to be pure and white. Some have objected that if the gesso is non-absorbent the oil layer will not remain firmly attached. In my own experiments I have found that an oil film does remain firmly attached to a film either of size or albumen ; but evidently this fear was sometimes present, as is shown by the examination made by Mr. Thompson, of Harvard University, of an old panel picture.

This panel had an interesting history.

It was a picture of the Holy Family, attributed to Correggio. The panel was old and worm-eaten, the painting obviously late restorers' work. Mr. Brown, the picture restorer into whose possession the panel had come, determined to treat it with solvents in order to discover if there was any genuine early painting below. The result was that all the modern paint was removed, and the panel was found to have on it the outline of the

OPTICAL PROPERTIES OF OIL

The figure on the left of the spectator, supporting the dead body of the Christ, wears a garment laid on in a brilliant red on the white gesso, either vermilion or red lead. The colour is very brilliant and fresh, and is ready to receive the subsequent glazings of translucent oil paint.

For example, let us suppose a lake, in oil, laid over this red. The yellowing of the oil will degrade the lake, but the thin painting of the lake on the bright red will ensure no lowering of tone owing to the rise in refractive index of the oil. On the other hand, the rise in refractive index, by increasing the translucency of the oil paint, will ensure a more brilliant light from underneath.

The next picture we shall consider is the other unfinished Michael Angelo (Plate 17).

Here, again, in the drawing of the Virgin's robe we see a completed black and white monochrome, the white being the gesso, ready for the glazings of transparent blue, probably Azzurro della Magna.

But this picture is of interest for another reason. Cennino Cennini, whose MS. we shall discuss fully later on, advises tempera painters to lay a thin coat of terre verte over the flesh, as a ground painting for the subsequent flesh tints. It has been assumed by some that this direction of his indicates a universal practice on the part of tempera painters. In most cases their flesh painting is too high in key for this to be probable, and it certainly is not the practice in any oil pictures I have examined.

But whatever may be the truth of this matter, Michael Angelo has adopted the practice in this picture, the uncompleted figures having the flesh covered with a dull thin wash of green, and if we turn to the finished figures, the low tone of the flesh as compared with the draperies is conspicuous.

What is of interest to us is the proof of the value Michael Angelo laid on the pure white gesso underlying his paint, since he deliberately stains it when he wants to lower the tone of his painting. That the green under-painting is supposed to give quality to the flesh tones is neither here nor there for our present purpose, which is the value in thin oil painting of the white gesso underneath.

During the whole of this chapter we have made an assumption that the gesso itself was non-absorbent.

On this matter Cennino Cennini's instructions are quite definite.

Having described how to paint in oil, he says : " In the same manner we may work on iron, or stone, or any panel, always sizing first."

It is evident that if the gesso is absorbent and stained with oil it loses all its optical value. When panel pictures have had the panel planed away the gesso is always found to be pure and white. Some have objected that if the gesso is non-absorbent the oil layer will not remain firmly attached. In my own experiments I have found that an oil film does remain firmly attached to a film either of size or albumen ; but evidently this fear was sometimes present, as is shown by the examination made by Mr. Thompson, of Harvard University, of an old panel picture.

This panel had an interesting history.

It was a picture of the Holy Family, attributed to Correggio. The panel was old and worm-eaten, the painting obviously late restorers' work. Mr. Brown, the picture restorer into whose possession the panel had come, determined to treat it with solvents in order to discover if there was any genuine early painting below. The result was that all the modern paint was removed, and the panel was found to have on it the outline of the

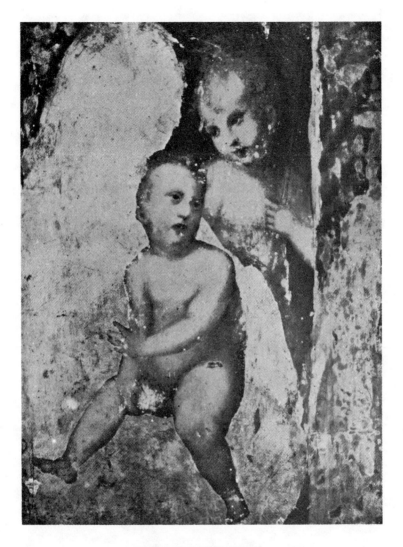

Plate 18. THE HOLY FAMILY.

This unfinished picture on a very old panel has an interesting history. Originally completely covered with paint it was attributed to Correggio, but was evidently pure picture faker's work. Mr. Brown, the picture restorer, removed all the comparatively modern paint, revealing the unfinished picture as shown in the photograph, probably late 16th century work.

Mr. Thomson of the Fogg Art Museum, made a careful examination of this panel, and found that it was coated with a non-absorbent white gesso covered with a very thin skin of absorbent gesso into which the oil had soaked. He also found the oil painting of the high lights of the flesh very thinly painted compared with the shadows.

Plate 19. PORTRAIT OF A LADY.

An examination of the pigments of this picture showed it to be of the late 16th century or early 17th century. A sample was taken through the dark background and through the high light of the flesh. The whole picture is on a white gesso panel, and it was found that while the paint of the dark background was some three thousandth of an inch in thickness, the flesh painting was not more than three ten-thousandth of an inch, being the thinnest possible painting of white lead in oil on the white gesso below, thus ensuring for all time the high lights of the flesh.

figures of the Virgin and the Christ and St. John painted on the white gesso in oil. Mr. Thompson subjected this panel to a very thorough investigation. The gesso was composed of whitening and size and was non-absorbent to oil. But on the surface of this gesso a very thin layer of plaster of Paris had been laid, only a small fraction of a millimetre thick. This layer was absorbent, and by cutting sections through the gesso and staining it he found that the oil had penetrated this very thin layer but had gone no further, thus on the one hand binding the oil to the gesso, on the other hand preserving the full luminosity of the white gesso below the oil painting.

This panel also enabled us to test another matter in connection with the oil technique.

Some years ago I had in my possession a portrait of a lady of about 1600, judging by the style, painted on an oak panel. I took borings through the dark painting and through the flesh painting and measured the thickness in each case of the paint layer. In the dark parts of the picture the thickness of the oil paint or the gesso was some 3 or 4 thousandths of an inch, about the usual thickness of a paint layer as laid on by a house-painter. But the flesh painting on the white gesso was only 2 or 3 ten-thousandths of an inch in thickness, being the thinnest possible glazing of tinted white lead over the gesso below.

Tests made by Mr. Thompson on the panel already described confirmed these results.

The painting of the Infants was very thin and translucent, the suggestions of outline in charcoal showing plainly through ; but the paint in the shading was much thicker than the paint in the high lights of the flesh.

From its style I should place the panel as late in the sixteenth century. Both these pictures show a departure from the early technique. The picture is no longer first laid in in monochrome or in colour with a tempera

medium. The oil is laid directly on the white gesso, but the value of the white gesso is still retained, as is shown by the very thin painting of the high lights of the flesh over the white ground.

I shall take one more example.

When the Rokeby Venus was slashed by a Suffragette, Sir Charles Holroyd gave me the opportunity of making a thorough examination of the picture and the detached pigments. The result of that examination and the proof of the authenticity of the picture has been published elsewhere. Here we are only interested in one result of the examination.

The priming is of white lead, and would therefore degrade in tone to some extent compared with gesso, but still would retain much of its whiteness.

On this priming a layer of deep red paint had been laid except under the flesh of the Venus. Here there is nothing but white upon white, and we are all familiar with the way in which the nude figure stands out luminous against the dark background. Whether this was a habitual practice by Velazquez I do not know. I am inclined to doubt it, as, compared with his other pictures in the National Gallery, this nude figure is very vivid. It may have been an experiment.

If we turn from the examination of actual pictures to writers on painting, from Vasari onwards, we shall find no clear indication of a definite method based upon the optical properties of the medium, the priming, and the pigments. Van Mander tells us that Van Eyck covered his white gesso with a thin translucent, warm tone. It may be so. The painter having secured his white background may play with it as he likes with translucent tintings.

I have produced sufficient evidence to show that in the fifteenth century and for some time later there must

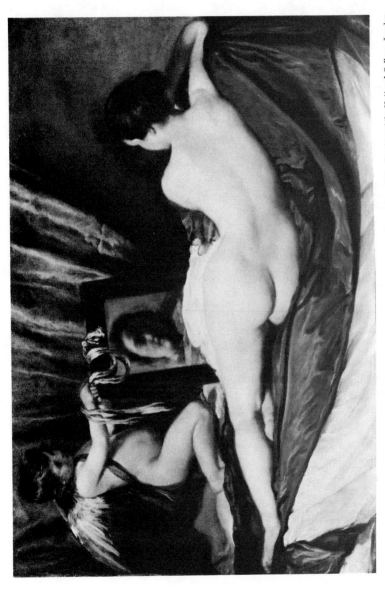

Plate 20. THE ROKEBY VENUS. By VELAZQUEZ.

Many years ago I had the opportunity of examining this picture after it had been injured by a Suffragette. The scientific examination proved the authenticity of the picture conclusively. Into this I do not propose to enter here, but merely to mention one point, and that is the nature of the priming. The canvas is primed with white lead in oil, and this has been covered except under the nude figure of the Venus, with a deep red priming. Beneath the Venus herself, there is nothing but white, thus causing the nude figure to stand out clearly for all time against the background.

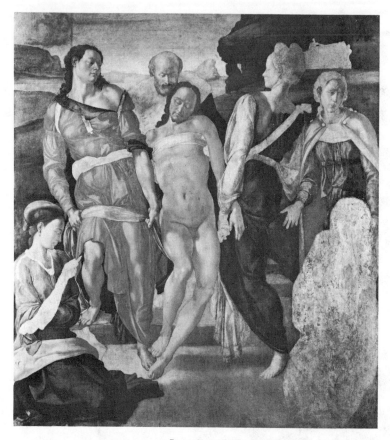

Plate 21. THE ENTOMBMENT. By MICHAEL ANGELO.

This unfinished picture in the tempera and oil technique is of great interest. In the earlier examples given of this technique the treatment with tempera has been confined to monochrome in black and white.

Here we see a further development, the garment of the figure on the right of the picture being modelled in a brilliant scarlet and white in a tempera medium, the white being the gesso. Doubtless, the intention was to glaze with translucent lakes in oil over the bright red and white modelling. The advantage of this method of painting on scientific grounds is described in the text.

have been in existence studio traditions for a correct use of a combined oil and tempera technique which were based on a complete understanding of the optical properties of oil, though not, of course, an understanding in our sense. They knew nothing of the scientific principles involved, but by trial and error and experience there was in the time of Van Eyck and his followers a thorough knowledge of the use of this medium, in which its many defects are utilised to correct each other.

When we come to later times the trail becomes confused. The writers on painting have no longer a grip on the fundamental optical principles, and to Rubens is ascribed the theory of solid lights and transparent shadows which has influenced so much the technique of the modern painter.

Let us examine this also from the point of view of the optical properties of oil and pigments.

In some of the Dutch painters, like Pieter de Hooch, we find especially in their panel pictures a triumphant permanency and brilliancy which equals that of the early Flemish painters. It is evident that their method closely resembles the old technique : the white ground is covered with a thin painting in oil. Under this thin painting there may have been translucent tints of the white priming.

In his *Practice of Oil Painting*, Mr. Solomon J. Solomon says :—

" With Terburg, Metsu, de Keyser, Hals, and occasionally with Velazquez and many others, the grounds were prepared with varying tones of warm or cool grey evenly laid, graduating to a lighter ochre colour in the lower part, which is to represent the floor, and on this ground incidents, and accidents of light and shade, are thinly indicated, such as the blacks and dark draperies

151

generally. Where this preparation is not much darker than the half-tones of the scheme, the light of the picture does not suffer ; but where it is considerably darker, we find that the tonality of a work is affected throughout, and most strikingly in the less solidly touched parts."

The concluding words are significant. Sometimes they overdid the lowering of the white by a thin wash of pigment, and he notes the result of the blunder.

The result of the examination with the skilled, trained eye of an artist of these pictures is of much significance as supporting the conclusion, to which we have come, based upon purely optical grounds.

But to return to the question of solid lights. Let us look at some examples.

We can find one in a picture by Pieter de Hooch in the National Gallery, L. No. 832. The picture, which is on panel, has evidently been painted thinly on a white panel and is full of the luminosity to be expected ; but for his very highest light, where the light is falling, for instance, on the sleeve of the man sitting by the table, he has put a solid thick painting of white lead.

We find, then, two techniques combined in the picture, but in order to do this he has had to take obvious precautions.

The white lead is ground very stiff with the minimum of oil ; in fact, I suspect it of being merely mixed with the oil with the palette-knife, as it seems to contain unground particles.

The whiteness of the white where used solidly by these Dutch painters is very remarkable and raises questions as to the oils they used.

According to the authority of Willem Beurs, the Dutch painters used poppy oil for grinding their whites and their more delicately coloured pigments ; but modern

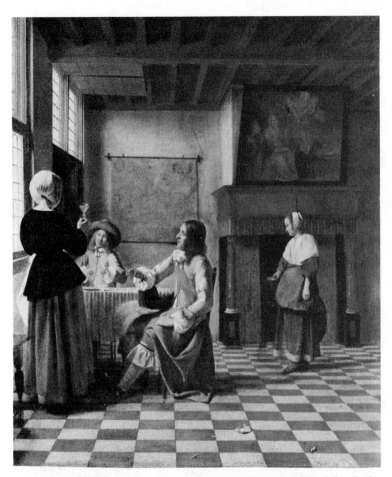

Plate 22. INTERIOR OF A DUTCH HOUSE. By PIETER DE HOOCH.

This picture is an interesting example of Dutch technique. It is also of interest as being an example of pentimento, the tiles showing through the woman's dress, owing to the very thin painting in oil having gradually grown more translucent with age. Beginning with a white ground, thin translucent oil paint has been laid on the luminous non-absorbent white ground. Where a very high light is required, as on the sleeve of the man sitting at the table, solid white lead has been used, but stiffly and coarsely ground in the minimum of oil. The whiteness of the whites in the Dutch pictures is remarkable.

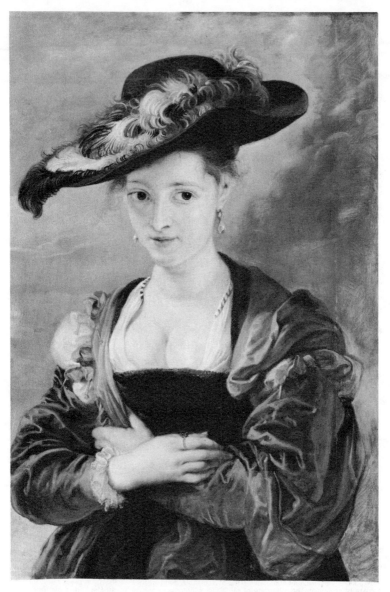

Plate 23. SUSANNE FOURMENT. By RUBENS.

To Rubens is attributed the advice to paint the high lights solid and the shadows translucent, a reversal of the methods of the earlier painters in oil.

In this picture, however, on a white gesso panel, he has followed very closely the best traditions of the Dutch School, based on the Flemish School of Van Eyck and his followers, and has painted thinly on the white gesso ground. The picture is in excellent preservation and compares favourably with many of his larger canvases from this point of view.

research has thrown doubt on the reliability of poppy oil, and has directed attention to the unchangeable character of Dutch Stand oil. It is somewhat dark, sticky, and flowing, an abominable medium, but could be used either mixed with yolk of egg or thinned with turpentine, and yellows very slightly with age.

These are questions worthy of further enquiry, but at present we are dealing with general principles.

If a high light is to be produced by white lead and not by light from the gesso surface, the white lead must be ground very stiffly with a minimum of oil and either painted over white or painted very thickly. This precaution was understood by the early painters. Examples of the use of white for a high light solidly painted is to be found in fifteenth-century tempera pictures. In the picture on panel by Rubens in the National Gallery the portrait of Susanne Fourment (No. 852), which is in fine condition, we see that he could appreciate the value of thin painting on a white gesso. In his large oil paintings we often find yellowing and degradation of tone, the boldness of the design and of the colour scheme hiding these defects. It is not without significance that, according to contemporary records, Rubens only used oil of turpentine as a diluent, thus keeping the oil content as low as possible.

Thousands of pictures show in the masses of brownish yellow white lead they contain the danger of the theory of solid lights when applied by men who had no understanding of the optical properties of oil.

The interesting question arises here of how thick and stiff white lead must be to be safely painted over a dark ground.

In my experiments I have found that black and white squares would begin to show through a stiff layer of white lead in oil of 2 thousandths of an inch in thickness.

OPTICAL PROPERTIES OF OIL

In the Van Dyck in the London National Gallery (Plate 24), the lace of the collar has been painted in white over black, but very stiff paint has been used, and it has been put on in thick blobs. In Plate 26, "Portrait of a Gentleman," by Gerard Terborch, one of the most perfectly preserved pictures in the Gallery, solid white has been used on the high lights, and is very bright and pure, and seems in places to be painted over the dark coat below.

Another interesting example of the painting of white over black is to be seen at the side of the window in Rembrandt's "Philosopher" (Plate 25), the white having been laid on over black and then removed, apparently with the end of the brush handle, showing the black below. On the whole, his paint is thick enough to stand it, but it is not so luminous as the white of the window, laid thickly over a light-coloured ground. In this and many other pictures Rembrandt's brushwork suggests the use of Stand oil.

Another interesting question about the Dutch painters is whether they painted their canvas pictures on a gesso ground or on an oil ground. They seem to have painted indifferently on panel and on canvas, and on the whole their panel pictures are the best preserved; but their canvas pictures are remarkably good and of a high luminosity. The ground they painted on, therefore, is of the greatest practical importance.

I have, I think, said sufficient to show that Van Eyck and his followers had a complete understanding of the optical properties of their pigments and media and made full use of that knowledge; and that later on, as new methods of painting were evolved, the more careful painters still followed the old tradition and utilized new methods with caution and common sense. They were fully aware of the following facts :—

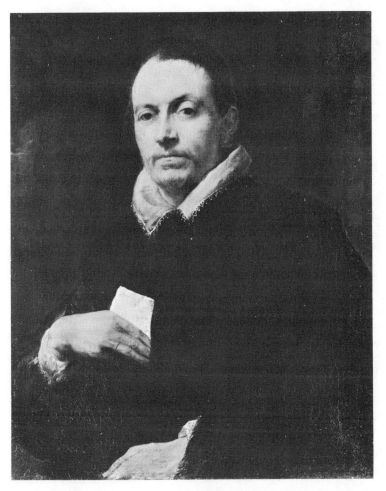

Plate 24. MARCHESE GIOVANNI BATTISTA CATTANEO. By VAN DYCK.

One of the subjects discussed in the text is the gradual increase in translucency of white lead ground in oil.

This picture is of interest because Van Dyck, painting at a time when the technique of oil painting was thoroughly understood, has deliberately, in painting the lace of the collar, laid white over black. The white, very stiffly ground, has been laid on in little thick blobs, thick enough and dense enough to keep up their full tone of white through the centuries.

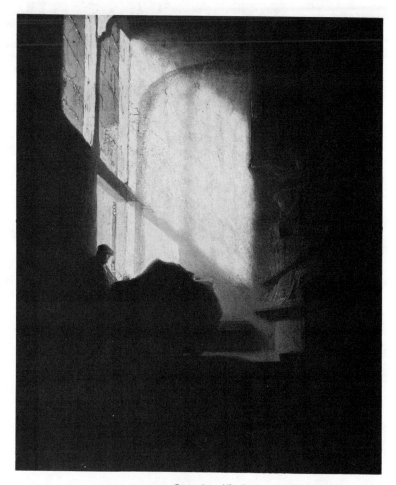

Plate 25. THE PHILOSOPHER. By Rembrandt.

This picture has been selected to show how far it is safe to paint white over black. The lower toned white along the edge of the illuminated wall is painted over black, and here and there the stiff white wet paint seems to have been removed with the wooden end of the brush.

The main illuminated surface is white laid very stiffly on a greyish toned background.

OPTICAL PROPERTIES OF OIL

1. That oil yellows with time.
2. That pigments in oil get more translucent with time.
3. That pigments in tempera are much brighter than pigments in oil and retain their brightness.
4. That glazing in oil over pigments in tempera does not impair their brightness if the tempera surface is non-absorbent.
5. That transparent pigments suffer more degradation in oil than opaque pigments, and should therefore be used for glazing and scumbling on solid underpaintings.
6. That this is more especially true of blues and greens. See the black and white modelling of the Blue Robe, already referred to, and the practice of Venetian painters of putting on blue with size.
7. That a pigment which suffers degradation in tone from the rise in the refractive index of the oil has its brilliancy fully preserved if painted thinly on a bright under surface.
8. That the most brilliant permanent white is the white gesso of the panel, which should therefore be utilized wherever possible.
9. That solid whites in oil will go down in tone unless the minimum of medium was used, the paint being put on very dry and, if there is dark painting below, very thick.

CHAPTER XII

HOW TO PAINT OIL PICTURES

In Chapter V we have dealt fully with canvas and panel and the priming of both with oil paint or gesso. We have learned there that the best foundation for a picture is a panel of old seasoned mahogany, or 5-ply well-seasoned birch, painted with oil paint and with canvas glued on, which is then coated with gesso. Instructions are also given for priming a canvas with oil.

An oil primed canvas, whether prepared by the artist or purchased, should be kept at least six months before painting on it. During this time the oil will have had time to dry, and the canvas will probably have darkened and will represent more nearly the tone which it will ultimately take. A white canvas is preferable to a grey canvas. It is better for the artist to tone down the surface for himself with a thin transparent wash, and still better to block out the future high lights and shadows in a neutral tint.

If a very thin layer of oil is painted out on a sheet of glass and weighed from time to time, we can follow the process of the drying of an oil. The oil absorbs oxygen and moisture from the air, thus increasing in weight, but at the same time, owing to the complex changes going on during the oxidation of the film, it is losing certain volatile products formed during oxidation. During the first stage of the drying it is rapidly increasing in weight, and during the latter stages losing weight and shrinking. It goes through four stages. It

is first wet, then sticky, then surface dry, and finally dried through. Drying through takes a long time. In fact, slow chemical changes are still going on after four hundred years, and an oil cannot be regarded as dried through under a few weeks. During the change from wet to sticky the oil is not contracting, the most rapid contraction taking place just after it is surface dry, and then after that the rate of contraction getting slower and slower.

The time, therefore, of danger, when a fresh layer of oil is apt to be cracked, is when the oil film below has just reached the stage of surface dry. It is quite safe to paint into wet oil ; but once the oil is surface dry it should be given some weeks before paint is laid above it. Linseed oil loses much less weight than poppy or nut oil, and therefore is not nearly so likely to crack. It may possibly be better, therefore, to give up the practice of grinding colours in poppy oil, though it has the advantage of not yellowing so much as linseed oil. The first layer of paint should contain a higher percentage of pigment to oil than the next layer.

Thin painting is much less likely to crack than thick, but the main thing is to allow a sufficient time for drying between each layer of paint, and, if possible, the dried surface should be rubbed down between each painting with fine sand-paper or pumice.

Volatile mediums containing resins dissolved in them should be avoided. They are apt to cause cracking. In fact all methods of hastening the painting of the next layer over the layer below are dangerous.

In the chapter on optics we have fully described the effects of yellowing and the change in refractive index. We have now to apply what we learned in those chapters in practice.

The pigments supplied ground in oil by the artists'

colourmen contain quite sufficient oil, and in the case of viridian, cobalt blue, madder and alizarin lakes, and French ultramarine the oil is apt to be in excess, and will float up and ultimately darken the pigments. Only stiff white lead should be used. The thin varieties contain an excess of oil.

If possible oil, varnish, and oily mediums should be avoided. This merely means increasing the oil content and therefore increasing the ultimate lowering of tone of the picture. No volatile medium should be used containing soft resins; they are apt to cause cracking. The diluents should either be well-rectified turpentine or better well-rectified petroleum; neither should leave the slightest stain on blotting-paper soaked in them and left to evaporate in the air.

The artist should paint out samples of the colours which he uses pure from the tube, and diluted with different quantities of turpentine. It is easy to see if any of them have an excess of oil. In the case of these some of the oil should be removed before using with blotting-paper, care being taken not to remove too much. Some of the colour, after mixing with turpentine, may dry dead. This does not mean that they have not a sufficiency of oil to bind. To test this, after they are dry, rub with a rag placed over the finger and moistened. If no colour comes off they are bound. To remove the matt or dead appearance, rub on a little oil with the finger and wipe off with a rag. This will probably be found quite sufficient, and if not, the surface can be gently polished with a soft rag when dry. If the colour can be rubbed off, the treatment with oil will be found satisfactory.

One pigment if used pure requires special care, and that is cadmium yellow. In course of time the cadmium yellows act on the oil so that they can be washed off.

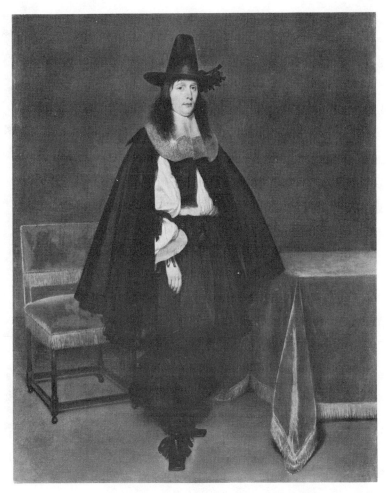

Plate 26. PORTRAIT OF A GENTLEMAN. By GERARD TERBORCH (1617–1681).

This picture is in perfect condition, and the whites are pure white and have not yellowed with time. As it is known that white lead in oil gets more translucent in time, this picture raises interesting questions as to how far the white overlies the black, and how far it is on a white priming on the panel.

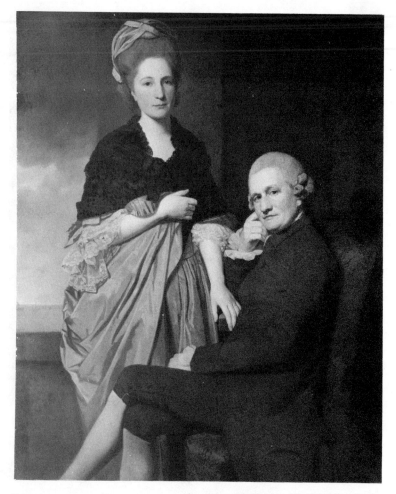

Plate 27. MR. AND MRS. LINDOW. By ROMNEY.

Romney's method of painting has been fully dealt with in the description of the "Lady Johnstone and Her Son." The magnified photograph of a portion of this picture showing its brush-work is of great interest.

Plate 28. MAGNIFIED PHOTOGRAPH OF A PORTION OF THE PORTRAIT OF
"MR. AND MRS. LINDOW" BY ROMNEY

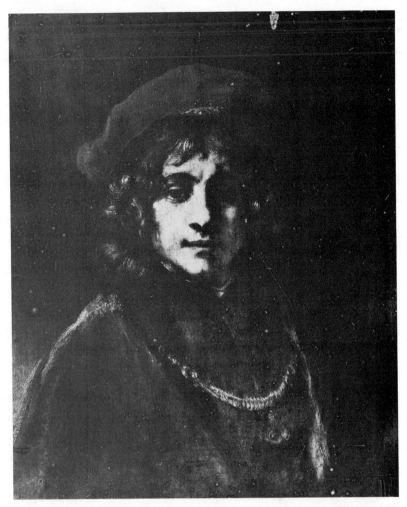

Plate 29. PORTRAIT OF THE ARTIST'S SON, TITUS. By REMBRANDT.
(Wallace Collection.)

The magnified photograph of the brush-work of this picture is reproduced with the view to showing the peculiar texture of the paint, which it is suggested may have been a pigment ground in Stand oil.

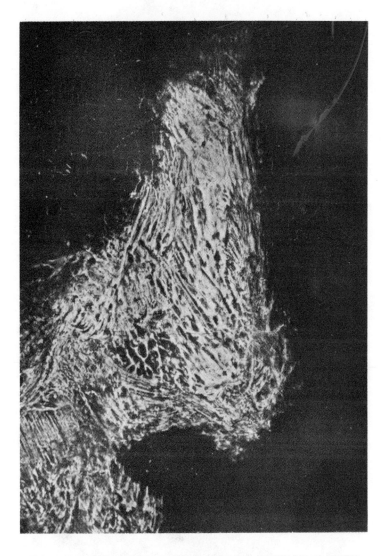

Plate 30. MAGNIFIED PHOTO OF THE NOSE IN THE "PORTRAIT OF TITUS"
BY REMBRANDT. (Wallace Collection.)

Quite apart from the interest of this photograph as revealing Rembrandt's brush-work, the peculiar texture bears out what has already been said about the "Woman Bathing" as to the peculiar quality of his medium.

Bol and others, while under Rembrandt's influence, produced a similar surface, but when magnified photographs are compared they are extraordinarily weak and meaningless beside the work of the master.

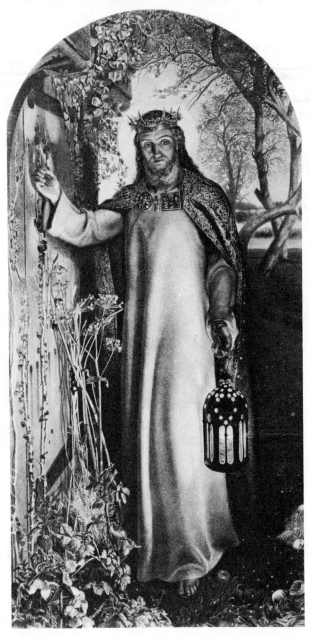

Plate 31. THE LIGHT OF THE WORLD. By HOLMAN HUNT.
(Oxford University.)

This, the most famous of Holman Hunt's pictures, is an interesting example of the special technique employed by the Pre-Raphaelite Brotherhood which has proved to be sound, by the excellent condition of their pictures. On a hard, well-matured white priming, white lead stiffly mixed with copal varnish was laid, and thin translucent painting in oil laid on the still sticky priming. The absence of cracking, and the well-sustained high colour-key, is to be expected from this method of painting in the light of the most recent scientific researches into the properties of oil and pigments.

HOW TO PAINT OIL PICTURES

A little copal varnish, either rubbed on or mixed with the paint, is a wise precaution in the case of these yellows. Generally there is no objection to the use of copal varnish instead of oil if used in this cautious way. If a picture has dried dead in parts, oiling out should be done in the way already described, all excess of oil being wiped off, and if still not shiny enough, try polishing with a silk handkerchief before resorting to more oil. If a colour is oily, a thick layer is worse than a thin one, as more oil rises to the surface of a thick layer, and will therefore when it yellows cause more lowering of tone.

It is safer to dilute with turpentine and rub on a little oil in the way described above than to dilute a colour with oil, as too much oil is apt to be added. If a painter finds the addition of some oil necessary to get his results, a little oil, or oil and copal varnish thinned with turpentine is safer than oil alone, as he is less likely to add the oil in excess. Rubbing a dried oil surface with sandpaper or pumice before painting on it removes excess of oil which has floated up, gives a tooth for the binding of the next layer, and makes the surface very slightly absorbent.

It is not a bad plan, in the case of an oily pigment, to remove a little of the oil with blotting-paper, care being taken that too much oil is not removed so that the pigment will no longer be bound.

Some artists like to add a little copal varnish to their pigments, thus following a traditional practice. If the copal varnish is added to the pigment as supplied ground by the artists' colourmen, there will be an excess of medium and the picture will go down in tone. Copal varnish must be used to replace oil, and therefore a little of the oil should be removed by blotting-paper before the copal varnish is added. Copal varnish yellows more than linseed oil.

HOW TO PAINT OIL PICTURES

Owing to the present practice of supplying pigments ground in oil put up in tubes and to the demand on the part of the artists for a pigment in perfect condition, no matter how long it has been in the tube, buttery and crisp and short under the brush, artists' colourmen are compelled to add some substance of a transparent nature to certain pigments which will float the pigment in the oil. This tends to cause an excess of oil to be present beyond that necessary to carry the pigment, which probably tends to lowering of tone. If artists would return to the practice of grinding the pigments in oil as they want them, probably much of the lowering of tone complained of would disappear.

The pigments should be ground with a muller on a glass slab, preferably with linseed oil cold-pressed and sun-refined, sufficiently stiff to stand up. Two or three drops of copal varnish can be added to each grinding. They can be kept in little jars with a piece of oil paper or bladder over them. The white lead must be ground as stiffly as possible and can be kept under water.

When we come to the application of the results of our optical investigations of the properties of oil and pigments to oil painting we are in a difficulty. Every artist has his own technique which he uses to express his own personality, and naturally regards with impatience any restrictions on his methods. The painters of the fifteenth and sixteenth centuries were apparently willing to accept certain definite methods for the building up of the picture and to express themselves through those methods. This is no longer possible or desirable, and therefore all that we can do is to lay down certain general principles.

In the first place, a picture should start from as white a priming as possible. If painted on panel this can be

gesso, the most permanent and reliable of white ; if painted on canvas only an oil priming is safe, and therefore a certain degradation of tone is inevitable, but must be reduced to a minimum.

Beginning with the foundation of pure white, if we imagine a section cut through the finished oil painting the gradation should always be from dark to light, starting from the outer surface to the priming below, and there is only one exception to this, namely, that flake white can be used for a high light if painted very solidly and stiffly, even though there is darker paint below ; but it is wiser even here, if possible, to avoid such darker painting.

If an artist deliberately decides to put darker paint under lighter paint—as in the case already discussed, where Michael Angelo has put a dull green under his flesh—he must do so deliberately with knowledge that in time the effect of this darker painting is going to be emphasized.

Starting with the restricted palette based on purely chemical grounds, it should consist of the following pigments :—

White lead, *zinc white, *permanent white, *yellow and *red ochres, *Venetian red, *Indian red, *cadmium scarlet, vermilion, cadmium mid, cadmium yellow pale, made by a furnace process, *barium chromate, aureolin, *cobalt green, *oxide of chromium, *viridian, *cobalt blue, ultramarine, Prussian blue, *permanent violet, *cobalt violet, madder and alizarine lakes.

The Prussian blue is the most doubtful pigment in this list, and it is still an undecided question whether a carefully prepared and washed lead chrome should not be added.

Those marked with an asterisk are the most permanent of all.

HOW TO PAINT OIL PICTURES

Of these pigments, a further selection is to be made of Venetian and Indian red, vermilion, opaque bright yellow ochre, cadmium mid and cadmium pale (made by a furnace process), cobalt green, and oxide of chromium green and cerulean blue for the bright solid pigments which will be least affected by alterations from the oil.

These pigments should be used for solid underpainting, and should also be used where pure spots of colour are required on the picture.

The madders, raw and burnt sienna, aureolin, viridian, cobalt blue, ultramarine, and Prussian blue should be used for thin glazings and scumblings and for tinting white. Lemon chrome occupies an intermediate position.

If the artists' technique lends itself to thin painting on a pure white ground, after the manner of fifteenth-century painters and some of the Dutch painters and the Pre-Raphaelites, these translucent pigments will be the most suitable he can use if he wishes to get the full value of the white reflected from the white ground below.

Never forget that increased translucency is inevitable and will lower the tone unless we have always been careful to build up from light to dark. Dark underpainting is sure sooner or later to show through and lower the tone of thinner painting above. Stiff white, thinned if necessary with turpentine, should be used for high lights, and, if there is dark paint below, should be laid on thickly.

The less oil in the white, the better it will keep up its tone.

To select the pigments which best keep up their tone, get whites and bright colours from different artists' colourmen, paint them out side by side on a canvas. When dry, place a pail two-thirds full of water in a black, dark cupboard, place the canvas on the top of

162

the pail, lock up the cupboard, and examine for change of tint every month, filling up the pail when necessary.

Finally, the picture should be varnished with mastic not sooner than six months after its completion, and during that time should be protected from dust and dirt. Mastic varnish is better than an oil varnish, because it not only protects the painting below from the attacks of oxygen and moisture and deleterious gases, but it has the advantage that it can be easily removed when it yellows and cracks without any injury to the paint film below. It should be laid on very slightly warm, the picture being gently warmed and dry, and rubbed over with a warm silk handkerchief before laying on the varnish. If care is not taken to do this, mastic is apt to bloom.

The back of the canvas should be covered with tinfoil or with beeswax and resin as described in Chapter V.

In conclusion, there can be no doubt that the most brilliant permanent white is gesso ; and that the combined tempera and oil technique gives pictures which keep up their tone better than any picture painted entirely in oil.

CHAPTER XIII

BALSAMS, RESINS, TURPENTINE, PETROLEUM AND OIL AND SPIRIT VARNISHES, BEESWAX, PARAFFIN WAX, GUM-ARABIC, SIZE, CASEIN

The balsams and oleo resins exude from certain trees and are emulsions of resins, in oil esters in the case of the balsams, and in essential oils in the case of the oleo resins, but the word balsam is very often applied to both.

Copaiba Balsam. Copaiba balsam is an example of a true balsam containing 40 per cent of oil esters and some 60 per cent of resin, and is the exudation of different varieties of copaiferæ occurring in South America, East Indies, and Africa. I have mentioned its use in the cleaning of pictures from old varnish. It was used by Pettenkofer as a varnish, whose methods of cleaning pictures I have referred to, and is still used as a varnish by certain picture restorers in place of mastic. Its use for this purpose is worthy of further investigation.

Strasburg and Venice Turpentine. Three oleo resins are of interest to the artist—namely, Strasburg turpentine, which the Italians called olio d'Abezzo, which is obtained from the silver fir, and has some 80 per cent of resin acids and resins dissolved in some 20 per cent of terpenes, and which was used by the old painters as a varnish by thinning with a little oil of turpentine and also as an ingredient in their oil varnishes, being sometimes used to dissolve the more insoluble resins like amber. Thinned with turpentine, it dries slowly and remains sticky for a long time, but

ultimately makes an excellent varnish for the surface of a picture, and it is also at any time easily removed.

Another is Venice turpentine, from the larch, containing about 80 per cent of resins and resinous acids and 20 per cent of terpenes. It was also used in the making of varnishes, as can be seen in the old recipes. Neither of these substances is used in varnish-making to-day.

The third is Canada balsam, from the *Pinus balsamea*, which is the easiest of these balsams to obtain pure and reliable at the present day, and which, for those who wish to experiment with these materials, will be found an excellent substitute for Strasburg or Venice turpentine.

All these balsams have a high protective value, when they have dried, as varnishes, resisting the entrance of air, moisture, and deleterious gases ; and I have already described in Chapter III how a transparent and permanent green can be prepared from verdigris by dissolving it in them.

The question as to how far they entered into the medium used by the early oil painters has not yet been settled. A varnish made by combining them with oil is very soft and sticky, but hardens in course of time, and it may well be that, though they would be condemned by the modern varnish-maker as giving soft and perishable varnishes, they continue steadily to improve with age.

SPIRITS OF TURPENTINE. From these oleo resins, by the process of distillation, oil or spirits of turpentine is obtained. The American turpentine, which is chiefly used, is prepared from the oleo resins of two trees, *Pinus australis* and *Pinus tœda*. The turpentines are mixtures of bodies known as terpenes, the proportion of absorbent terpenes present depending upon the tree from which the turpentine has been prepared. All these terpenes,

BALSAMS, RESINS, VARNISHES, ETC.

on exposure to air, oxidize, forming sticky resins which are very objectionable if introduced into the film of oil.

We should therefore select for artists' purposes a turpentine which does not oxidize too readily. Sir Arthur Church regards the French oil of turpentine, *Pinus maritima*, as the least oxidizable, and next to that the American oil of turpentine. Owing to this tendency to oxidize, the artist should always have fresh turpentine and should keep it closely corked up so as to prevent oxidation. A simple test of its condition is to pour a little on blotting-paper and allow it to evaporate. It should evaporate clean, leaving no oily stain. Sir Arthur Church advises putting a lump of quicklime in each bottle.

Some artists are prejudiced against spirits of turpentine as a diluent, but it has been used so long and so universally that, if fresh and properly rectified, there is no reason to suppose that it can have any injurious effects. It is added merely to thin the paint, evaporating clean, and leaving the oil and pigments behind ; but it also acts as a drier, stimulating the drying of the linseed oil. If a large quantity is introduced, the painted surface dries flat or dead. It has a slight tendency to make the oil film turn yellow.

OIL OF SPIKE LAVENDER. Some artists prefer to use oil of spike lavender, obtained by the distillation from the flowers of a species of lavender known as *Lavandula spica*. The same precautions have to be taken with oil of lavender as with turpentine, as it also oxidizes and thickens when exposed to the air.

RESINS AND VARNISHES. If the oleo resins are heated so as to distil off the terpenes they contain, we have the resins left behind. In the case of the ordinary turpentines, the resin left behind is known as rosin, or colophony. This resin, if dissolved either in turpentine or in linseed

oil, forms a very soft varnish, and, while formerly used for this purpose, is not used in modern varnish-making where the oil is linseed oil, but, on the other hand, it is used for making varnishes with tung oil, for which it is excellently suited. There are a large number of resins coming from various sources and used in varnish-making, some of which are as follows :—

MASTIC. This resin is obtained from the *Pistacia lentiscus,* which is found in the Levant and the Greek Archipelago. Its specific gravity is between 1·056 and 1·060 and melts between 221° and 248° F. It is soluble in turpentine and alcohol and in oil. The picture varnish used by artists is made by dissolving mastic in turpentine.

Sir Arthur Church gives the following recipe :—

Dissolve 14 parts of ground mastic mixed with 6 parts of fine sand and 44 parts of spirits of turpentine by heating in a water-bath. Pour off into a bottle, cork, and leave to stand until it becomes perfectly clear. In order to make the varnish less brittle, a little Venice turpentine, Canada balsam, or Elemi resin, or a very little linseed oil may be added. The advantage of mastic as a picture varnish is the ease with which it can be removed without injury to the painted surface below by friction or solvents.

SANDARACH. This resin is obtained from *Callitris quadrivalvis,* a dwarf tree which grows in the north-west of Africa. It melts at 135° C., and is completely soluble in ether and hot pure alcohol and partially soluble in oil of turpentine. The mediæval sandarach may have been this resin, but was more probably the resin of the juniper. It is used for making spirit varnishes.

DAMMAR. This resin is obtained principally from the Dutch East Indies and British Malaya. It is the product of the *Dammara orientalis.* It melts between 260° and

BALSAMS, RESINS, VARNISHES, ETC.

300° F. It is soluble in turpentine, petroleum spirit, and in oil, and is used for making spirit varnishes.

Lac. Lac comes principally from India. It is obtained from several trees, and is due to the action on the juices of the plant by the female insect *Coccus lacca.* This insect secretes the lac round its eggs, and finally becomes itself embedded. The lac as obtained from the trees contains a dye, owing to the presence of the bodies of the insects. This dye is extracted by water and was formerly used in Europe, both for dyeing and for making lakes. The lac after the extraction of the dye is melted and filtered through canvas bags. Shellac is partially soluble in alcohol, the solution being what is known as shellac varnish.

Copal. The name copal should be restricted to certain fossil resins which come principally from Africa, but also from Australia and other places. Unfortunately, two resins may be obtained from the same source, a fossil resin found some 3 or 4 ft. under the ground, and a resin from the same tree collected from the tree itself, which is much softer. For example, at one time Sierra Leone copal was one of the hardest of the fossil resins ; to-day Sierra Leone copal is collected from the living tree. The hard fossil resins to-day are Congo copal from Central Africa, and Zanzibar copal (or animi) from East Africa, angola from West Africa, manilla from Manilla and the East Indies, and kauri from New Zealand. The soft resins are also obtained from the same sources. Manilla copal, for instance, may be a hard fossil resin or a soft resin from the living tree. Only the finest fossil copals should be used for making copal varnish for artists' use.

Amber. Amber is the hardest and most infusible of the resins. If fused and blended with oil, a very dark slow-drying dichroic varnish is obtained. Certain

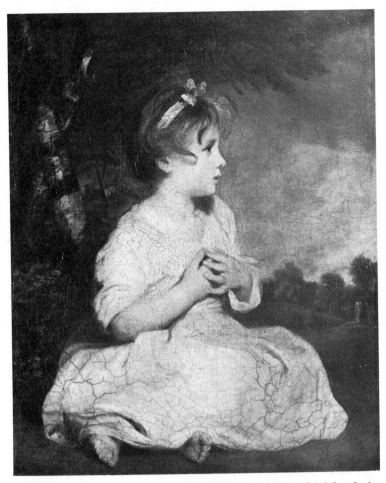

Plate 32. THE AGE OF INNOCENCE. By SIR JOSHUA REYNOLDS.

The condition of this picture is much worse than appears in the photograph, and is well worth comparing with the contemporary pictures by Romney. Romney, trained by an itinerant portrait painter, painted simply and directly with a limited palette, the pigments ground to just the right consistency with oil.

Sir Joshua Reynolds was constantly experimenting with balsams, wax and such like materials mixed and dissolved in the oil. His pictures vary in their condition. This one has been selected as one of the most striking examples of the danger of departing from sound tradition.

solvents, such as chloroform and epichlorohydine, dissolve it partially, and it can be dissolved under pressure and high temperature in sealed tubes in turpentine and other solvents. The principal sources of supply are the Prussian shores of the Baltic Sea, where it is found in veins and quarries. It has a specific gravity of 1·07 and a hardness of 2·5, and fuses at about 300° C. It is practically insoluble in ordinary resin solvents.

It consists principally of a resin called succinite, and on destructive distillation yields succinic acid. It is highly improbable that pure amber varnish was used by the early painters. It is more probable that the name amber varnish was applied to the varnish because of its colour resembling amber.

VARNISH. The process of making an oil varnish is the same to-day as it was in the eleventh century. The resin or resins are fused, the linseed oil is heated, the two are blended and heated together until a thorough union has taken place, and a drop of the varnish, when put on a glass plate to cool, remains clear and transparent. In the case of the modern varnish, driers are incorporated, and the whole is thinned down with spirits of turpentine. In the case of the mediæval varnishes, it is evident from the recipe that they had no turpentine, and the varnish must have been very thick and sticky and had to be rubbed on hot, or required, if used as a painting medium, to be emulsified with yolk of egg. It is not till we come to the recipe for varnish-making of the sixteenth century that we find both alcohol and turpentine freely mentioned. As far as we can judge, the old varnishes contained a much higher percentage of resin to oil than the modern varnishes. Much softer resins, such as pine balsam, rosin, and sandarach, being used, so that they would not be as durable as a good modern copal varnish, but, owing to the high resin

content, would form a better protective surface for fugitive pigments, and would not yellow so much.

The softer resins can be dissolved, some in alcohol and some in turpentine, forming spirit varnishes. I have already given a recipe for mastic varnish.

The distinction between the two types of varnish— the oil varnish and spirit varnish—is obvious. When the turpentine has evaporated from mastic varnish we have a thin film of the pure resin left which is practically impervious to moisture, but is brittle and fragile.

In the case of the oil-varnish, the film which is left is a blend of oil and resin, and the drying of the oil varnish depends upon the drying—that is, the oxidation of the oil it contains. The result is a hard but flexible film of great durability and very insoluble, but it is not so waterproof as the film of pure resin, both moisture and gases being able to permeate the linseed-oil film.

For the preserving of fugitive pigments the pure resin itself is best, and the method which was used by the old-fashioned coach-painter was to protect his pigment by mixing it with turpentine and resin, and then protect the friable resin by a coat of oil varnish on the top. By this method he obtained a very durable combination ; while, owing to the fact that the coach was constantly exposed to light, the yellowing of the oil varnish was not a serious objection.

Another method of making oil varnishes is to begin by dissolving the resin in a powerful solvent like chloroform, by boiling the powdered resin in chloroform for some time, the flask being fitted with an inverted condenser. Along with the chloroform a certain amount of turpentine is also added. At the end of the operation the chloroform is distilled off, leaving the turpentine. The dissolved resin is again boiled with the turpentine alone and then mixed with a linseed drying oil which

Plate 33. MICRO-PHOTOGRAPH OF MASTIC VARNISH, SHOWING CRACKS.

This photograph reveals the fact that mastic varnish is far from a perfect protecting agent for the oil paint below. It seems to crack owing to movements in the oil film and the slow desiccation of the varnish. The cracks are quite different in character from those occurring in oil paint. What is required is a varnish which will protect the oil paint below from injurious gas or moisture as perfectly as mastic, and at the same time will not yellow or crack.

BALSAMS, RESINS, VARNISHES, ETC.

has been heated, and the whole heated and stirred for some time. Amber can be partially dissolved by this method.

For full and detailed information about resins and varnishes the reader is referred to *Varnishes and their Components*, by Dr. Morrell.

PETROLEUM. By rectification the natural petroleum oils which are mixtures of hydrocarbons are separated into oils of different boiling-points. The portion boiling under 170° C. is called petroleum spirit and can again be rectified into oils of various boiling-points, the lowest being about 50° C. As a diluent for artists' use, according to Sir Arthur Church, no fraction having a boiling-point higher than 170° C. should be used. The petroleum should evaporate clean. Blotting-paper soaked in it and left in the air at ordinary temperatures should ultimately leave no greasy stain or smell.

BEESWAX AND PARAFFIN WAX

BEESWAX. Reference has been made more than once to the use of beeswax for various purposes, both old and new. It is a fairly permanent substance, but not so permanent as seems to have been assumed by those who tried to reintroduce wax painting, as by long-continued exposure it disintegrates and partially perishes by oxidation. The excellent state of preservation of the pictures from Hawara has led to false conclusions. Not only were certain repairs necessary on them by remelting the wax, but it also must be remembered that they had been preserved in Egyptian sand.

If beeswax is dissolved in turpentine, spread over a surface thinly, and polished, it forms a protective coating against dust and dirt, and it has a very high value as a protection against the action of air, moisture, and

injurious acids. From tests which I have made, I put its protective value as about equal to the protective value of mastic varnish. On the other hand, a layer of melted wax and resin, say about the twentieth of an inch in thickness, resists the attack of air, moisture, and acid fumes about ten times as long as mastic varnish, and may be regarded as practically indestructible when laid between layers of canvas. And it is for this reason that I have advocated it for the backing of canvas pictures in oil and tempera.

PARAFFIN WAX. Paraffin wax, of which the one with the highest melting-point is known as ceresin, is a modern product obtained from native petroleum and ozokerite and consists of a mixture of the substances known to chemists as hydrocarbons. These are known to be very stable and permanent substances, and not to be attacked by most chemical reagents. For this reason they are rightly regarded by chemists as much more permanent than beeswax, and Sir Arthur Church introduced them into the Gambier Parry medium in place of beeswax for this reason. Theoretically they would be better than beeswax for the mixture that I proposed for the backing of pictures, and they have proved excellent for the preservation of frescoes, being melted into the surface of the plaster.

My reason for preferring beeswax as a backing for pictures is that the mixture with resin is sticky and firmly binds the two layers of canvas together. Paraffin wax does not form so sticky a layer.

GUM-ARABIC. Gum-arabic, which is obtained from the *Acacia arabica*, is used to prepare the medium for water-colour painting. It is an example of what is known as a vegetable gum, these gums differing from resins in being soluble in water. It was used as a medium by the Egyptians and forms a very durable film for the

attaching of the pigments to paper, but has no protective value, and for that reason we have to select a more limited palette of pigments for the water-colour painter. There is another reason for limiting the palette, and that is that in water-colour painting the pigments are washed out in very thin layers exposing large surface without any depth to the action of air and light, so that a pigment which might prove quite suitable for painting in oil will not resist the severe test of being used in a water colour. It is for this reason that tests as to the permanency of a pigment are usually made in water-colour washes, so as to try them under the severest conditions.

In the grinding of water colours, in order to keep them moist and to counteract the brittleness of the gum, it has long been the custom to add a little honey, the use of honey for such purposes being mentioned by Cennino Cennini and in other early recipes. Honey consists of a mixture of two sugars, known as dextrose and lævulose, with a little sucrose. The useful properties depend on the properties of lævulose. This is non-crystalline and gives the required flexibility. The lævuloses can be separated from honey by taking crystallized and semi-solid honey, mixing it with four times its volume of proof-spirits, filtering, and evaporating the solution.

The objection to the presence of honey is that all sugars are slightly hygroscopic and attract moisture, and the presence of moisture is of course dangerous for the pigments, but, judging by the long tradition behind it, the presence of honey does no harm.

The modern practice of the artists' colourman is to add glycerine in order to keep the water colour moist.

Formerly artists were content to have their water colour prepared in cake form. Then they required them moist in pans ; now they demand them put up in tubes,

each of these changes meaning an increase in the amount of the hygroscopic constituents, thus increasing the possibility of the fading of the picture.

SIZE. In Chapter XIV I describe the methods given by Cennino Cennini for the preparation of size. Both the materials and modern methods of manufacture are very much the same to-day as in his time, the final product being a mixture in different proportions of two substances—gelatin and chondrin.

I have already advised (Chapter V) that in order to obtain a pure and reliable article, the gelatin which is perpared for making solutions for the breeding of bacteria is the best. In order to prevent the size from putrifying a lump of camphor or a few drops of eugenol from oil of cloves is sufficient.

A painting done with size, after it is dry, should be sprayed or painted over with a weak solution of formalin. This will make the size insoluble in water, although still capable of absorbing water and swelling slightly. Such a surface of size treated with formalin is very permanent, and there seems to be no reason why size should not be used instead of egg in painting the foundations for an oil picture. As I have stated elsewhere, the oil film dries well on the size without cracking or wrinkling, and the two are firmly attached to each other.

The following is a modern recipe for the preparation of parchment size from the *Transactions* of the Tempera Society, 1901–1907, by L. Agnes Talbot, taken from an account of how to gild on gesso to which the student who wishes information on this subject is referred.

TO MAKE PARCHMENT SIZE. The parchment shavings are cut into pieces and put to soak in water throughout the night. In the morning measure them in a vessel not pressed down. Boil them in water (a double saucepan is best) until the smaller pieces begin to dissolve

and break. Then strain through muslin. One measure (measured after soaking, before boiling) should make one and a half measures of size. If when you pour it off there is more than this, boil till it is reduced to the right amount, if less add water. This, I am aware, is not an exact or satisfactory method of measuring, and I should be very glad to know of a better. If one weighed the parchment dry in delicate scales one could come nearer to accuracy ; but even then the continual warming of the size, when in use, increases the strength, and one has to add water, so that it becomes a rule-of-thumb business after all. This strength of the size is rather important, because on it depends the hardness of the gesso ; a too soft gesso does not take burnish and is tiresome to manipulate, while on a too hard one the gold loses quality and has a glittery appearance.

CASEIN. Casein is prepared from milk, and is one of the constituents of cheese, which consists of casein and the butter fats that milk contains. It is a nitrogenous body corresponding closely to size and albumen, and has been introduced in the isolated state as an article of commerce in comparatively recent times. It is insoluble in water, but can be dissolved by the addition of a little ammonia, potash, or lime, and then ultimately hardens and becomes insoluble again. It is very largely used to-day for the manufacture of water paints—casein, a little lime, and the pigments being ground up together, and it has been used by artists both as a painting medium and for the preparation of grounds. The safest solvent is ammonia, as this evaporates, leaving the casein behind ; alkalies, such as potash, remaining in the film, which may ultimately prove injurious.

If used for the preparation of grounds or of a painting medium, it dries very hard and brittle, and, therefore, the introduction of glycerin has been advised. The

introduction of glycerine is objectionable, because it is hygroscopic.

It must be remembered that our experience of casein is short ; but, on the other hand, as far as our experience goes it has proved reliable for the preparation of grounds. On the whole, therefore, I prefer to advise preparing grounds either with size or oil, thus sticking to known tradition. It is more doubtful as a painting medium. Very complex recipes have been made up containing caustic potash, castor oil, and other ingredients. The presence of the caustic potash will, to some extent, saponify the oils introduced, and it is impossible for anyone to predict what the future behaviour of such complex mediums will be.

It has been argued that because there are mediæval recipes for cementing together the different portions of a panel with cheese and lime, casein must be a reliable substance ; but the cheese contains the butter fats, which will be saponified by the lime as well as the casein, and such a combination may have proved very durable as a cement, but it is never recommended either for the making of gesso ground or as a painting medium, and the presence of the butter fats may have a protective value. There are very impure caseins on the market, and only the best quality should be used. It is nearly white, has no smell, is not acid to litmus paper, and gives a nearly colourless transparent solution with water and ammonia.

There are other gums and materials such as starch which can be used as mediums for painting, but they are not commonly used.

CHAPTER XIV

HOW TO PAINT IN TEMPERA

THE medium used universally in Italy during the four-
teenth and, at any rate, up to the middle and to about
the close of the fifteenth century, was yolk of egg.

It is difficult to say how old the egg medium is. We
know that the Greek painters of classical times used two
media, and that one was wax ; but we have no reliable
record of what the other medium was. Pliny, while
describing the pigments used and the technique of the
wax medium, states that two media were used, but
omits to mention what the second medium was. It
may have been gum-arabic, used largely by the
Egyptians, glue, or egg, or a drying oil. Pliny mentions
the use of egg, but only for specific purposes. The
Lucca manuscript of the eighth century mentions size
and wax as media, but makes no mention of egg. As
we have already stated, in the manuscripts of the
eleventh and twelfth centuries, we have descriptions of
oil painting, but no mention of painting with yolk of
egg. The statement of the early and universal use of
egg yolk as a medium seems to have been copied from
Vasari, and it is, at any rate, open to question whether
it was universally used in earlier centuries than the
thirteenth, though it is highly probable that so excellent
a natural medium was devised in early times.

We have sufficient evidence from the excellent con-
dition of many pictures of the fourteenth and fifteenth

century, painted in this medium, to satisfy us as to its lasting qualities, and its value as allowing pigments to retain their full brilliancy of tone ; and we are fortunate in possessing in the treatise by Cennino Cennini, supposed to be written about 1432, a most complete and detailed account of this process, so that the artist painting in yolk of egg to-day has a full guide to all the technical processes involved.

Before proceeding to give a short résumé of this method of painting, as described by Cennino Cennini, I think it advisable to say something of the special properties of yolk of egg as a painting medium. The white of the egg consists of an emulsion of egg albumen and water, which was used for attaching gold leaf and in miniature painting. The yolk is an emulsion containing, among other things, water, albumens, an oil, and a substance known as lecithin.

The oil consists of the glycerides of oleic, palmitic, and stearic acids. It is therefore an example of what we should call a non-drying oil, like olive oil ; but as an actual fact these fatty oils will dry in course of time, and we cannot make a sharp distinction between a drying oil like linseed oil and a non-drying oil like olive oil.

The egg albumen if raised to 70°–75° C. becomes insoluble in water, and if exposed in thin layers at ordinary temperatures, ultimately becomes insoluble. We have here an example, therefore, of what we call an emulsion containing an oil, containing water, and containing an emulsifying agent, namely, the albumen, in which in course of time the albumen will become insoluble, and the oil will " dry," so that we obtain a protective layer, which is very insoluble in any agent and very durable.

In addition to these substances the yolk of egg

contains a very remarkable substance known as lecithin, which is a fatty body which swells up when moistened with water, and therefore is an ideal agent for emulsifying oil and water together. This substance, lecithin, is found widely distributed through both the animal and vegetable kingdom, and seems to be nature's emulsifying agent. Probably if isolated and prepared for artists' use, it would prove very valuable. We can therefore regard yolk of egg as the most perfect of oil-water emulsions.

To return to Cennino Cennini, he begins with the preparation of the panel, and follows the whole process of painting a picture right through. We have already dealt fully with the preparation of the ground in Chapter III.

We therefore now come to a discussion of the actual mediums to be used in painting on this panel. Cennino Cennini describes three—size prepared from parchment, which he recommends for laying on real ultramarine ; linseed oil refined and bleached in the sun, which he recommends for painting on gold with viridian and lake, and also for painting the pile of velvet ; and, thirdly, yolk of egg. He advises the use of the white well beaten and mixed with water for the laying on of gold, and either the use of the yolk and the white beaten up with the young shoots of the fig tree, or, as a better medium, the yolk alone.

The reference to the fig tree and, in another recipe, to the addition of fig juice, where the egg is to be used to prepare the surface of a wall for tempera painting, has given rise to much speculation. It has been suggested that as the fig tree belongs to the same family as the rubber tree, the juice probably contains some caouchouc. Now that the rubber latex is obtainable in this country, experiments with mixtures of the latex

and egg would be of interest. Eibner thinks that the fig tree juice was simply added as an antiseptic in place of wine or vinegar, which are both mentioned in old recipes, and it is also possible that in the case of a mixture of the yolk and the white, it made the medium flow better under the brush.

It is sufficient for our purpose that Cennino Cennini recommends the pure yolk of the egg as the better medium ; and he also recommends town eggs, as he says the yolk is lighter in colour than country eggs. The yolk mixed with water is ground on a muller with pigment. He tells us to add about equal quantities of yolk to pigment ; but the amount varies with every pigment, and must be learnt by experience. His pigments are first ground with water and kept under water ready for use. He does not tell us how much water to add with the egg, but the pigment must have been very wet.

It is evident from his account that painters in Italy of his time did not necessarily confine themselves to egg, though it was their principal medium.

Finally, Cennino Cennini advises us to varnish the picture by rubbing over hot varnish with the hand, but this is not to be done till the picture is at least a year old. In spite of Cennino Cennini's directions, I do not believe that this was always done. It is obvious that in many cases the varnish is no longer there, and it has been suggested that it may have crumbled away. I have examined carefully tempera pictures which are in excellent preservation, and have never been touched by the restorer or covered by a modern varnish, and can see no indication of their having ever been varnished unless possibly with white of egg, which Cennino Cennini recommends as a temporary varnish.

If a picture is painted correctly in yolk of egg, it can

afterwards be polished with a soft rag, taking an egg-shell gloss, and this is exactly the appearance that many of these old pictures have. Modern tempera pictures more than twenty years old have the same glossy surface. The most perfect pictures in Italy come from the nunneries, where they have been taken care of in a clean and perfect atmosphere, and seem to be just as they left the studio, without any indication of change.

Successful painting in tempera requires considerable practice and experience ; the pigment has to be laid on very thin ; each thin layer must have time to dry ; and the amount of yolk of egg present must be neither too much nor too little.

Cennino Cennini says nothing about preventing the yolk from putrifying. Other old recipes mention the addition of wine or vinegar. The explanation is simple. The egg yolk is slightly alkaline, and putrifactive bacteria favour an alkaline medium. Either vinegar or the acids of the wine will therefore, by making the egg yolk acid, prevent this ; and the alcohol of the wine will also act as a preservative.

Sir Arthur Church recommends a saturated solution of eugenol, prepared from oil of cloves in 5 per cent acetic acid. This is added drop by drop with constant agitation to the yolk until turmeric paper, which is turned brownish red by the alkaline egg, just turns yellow again. A piece of camphor should also be added.

An acid solution will attack ultramarine blue. This blue should therefore not be used if the yolk has been acidified. Possibly the reason why Cennino Cennini recommends size for real ultramarine, which is also destroyed by acid, is due to the fact that he did add vinegar, but has omitted to say so.

I shall now give Mr. Duncan's account of how to paint

in tempera; I have already given his method of preparing his panel. The pigments are all ground in water, and placed in little covered jars. The water is allowed to settle and the excess of water poured off. The yolk is separated from the white.

Here I insert Mr. Tudor Hart's method of preparing the yolk of egg. Having separated it from the white he removes excess of white of egg by rolling the yolk gently from the palm of one hand to the palm of the other, and wiping the free palm between each change. Pinching the enclosing skin of the yolk between the thumb and finger, and lifting it gently from the palm of the hand, holding it suspended over the grinding slab, with a thin pointed blade he punctures the yolk from underneath by a quick stab and lets the yolk run out. The rest of the yolk can be expelled by placing the deflated skin on the slab and pressing it with the finger from the point at which it is held to that of the incision.

To continue with Mr. Duncan's account, add to each egg two egg-spoonfuls of water; strain the whole through muslin; and to every two eggs add one egg-spoonful of a 3 per cent solution of acetic acid. This will keep the egg fresh for a week, even in warm weather. Equal volumes of egg and pasty pigment are ground together on the muller. Some pigments, like terre verte and yellow ochre, require more egg. If a little of the pigment and its egg medium is painted out on glass and left to dry, next day it should be possible to remove it with a spatula as a leathery film. If it is powdery, enough egg has not been added. If the panel has been properly prepared, and the pigments thoroughly ground, each layer of pigment, when dry, can be polished with a piece of soft linen rag, giving translucent colour with an egg-shell gloss. If the pigment remains dry and

dead and opaque, the gesso has not been properly prepared. The finished picture is polished with a rag and does not require varnish, but after thorough drying can be varnished with mastic. Overlapping can be done so as to avoid the necessity of hatching or stippling Thin pigment and the brush squeezed out between each operation, as directed by Cennino Cennini, are essential. Preliminary shadows should be done with verdaccio. If it is desired to paint freely and easily with ready blending of tints, an emulsion of egg with oil or copal or mastic varnish must be used. This medium works excellently, but yellows slightly with age, and is apt to be easily separated from the gesso below. This is probably due to the use of oil copal. Gesso grounds on canvas crack and are not satisfactory. Casein grounds on canvas also crack, and are very hard and brittle. A tempera painting kept in the dark for fifteen years is as bright as the day it was painted.

We now come to the method adopted by Cennino Cennini to build up a picture which is of supreme importance, as throwing light on the early technique adopted in oil painting. He describes a pigment of a neutral tint, which he calls verdaccio, and which is a mixture of white, black, yellow ochre, and red ochre, giving a useful neutral tint, which he uses both for fresco and for tempera—the white in the one case being his special preparation of whiting, and in the other case white lead. With this pigment, as Lady Herringham points out, both in fresco and in tempera, he lays in his whole scheme in monochrome. On this thin glazings of bright pigment mixed with white are laid.

In the chapter on Oil Painting the early oil technique is explained, and its significance when we take full consideration of the optical properties of the oil medium. Such a technique was not so essential for either fresco

or tempera, but seems to have been common at this time to all schools of painting.

Cennino Cennini advises, in the case of tempera painting, washing a thin uniform tint of terre verte as an under-painting on the flesh parts of the picture, thus lowering the tone of the flesh by diminishing the reflections from the white gesso through the thin painting above. It seems to have been assumed that this was the universal practice of tempera painters. Judging by the high luminosity of their flesh, I doubt if this is true. It is certainly not true of any early oil pictures I have examined by taking a section right through the flesh. I have referred in the chapter on Oil Painting to the unfinished Michael Angelo in the National Gallery where this has been done, and to the consequent low tone of the flesh painting.

I have not discussed in this chapter the laying of gold leaf on a gesso panel. The readers can refer to Lady Herringham's translation of Cennino Cennini and the article on Gilding Gesso by L. Agnes Talbot in the *Transactions* of the Tempera Society, 1901–1907. Nor is it within my province to deal with the problem of painting in tempera and yet getting the fusion of tone without hatching, so successfully obtained by Jacopo Bellini.

I suspect the use of oil paint, to supplement the work in egg, to have been done much more frequently by the Italian tempera painters than has been supposed.

Plate 34. THE RAPE OF HELEN. By a follower of Fra Angelico.

This picture has been selected as an example of a tempera painting because it is in remarkably fine preservation and very high in colour-key. It is also of interest because vermilion has been freely used, and is not at all degraded in tone, shewing the permanency of this pigment in diffused daylight.

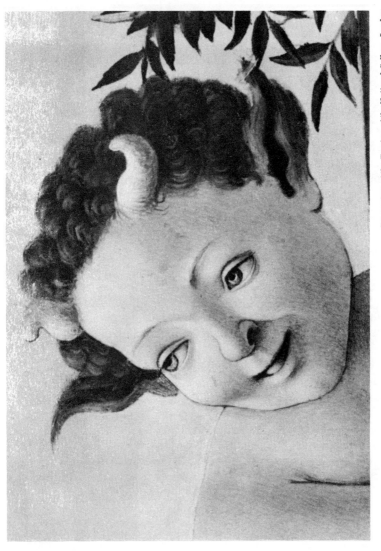

Plate 35. Detail from "MARS AND VENUS." By BOTTICELLI.

This magnified photograph of a head from "Mars and Venus" reveals a very different technical handling of the egg medium, in which the picture is painted, from the head of Christ by Fra Lippo Lippi (Plate 3), but it is equally instructive.

CHAPTER XV

EMULSIONS

THE revival of painting in yolk of egg has led to an increased interest on the part of painters in emulsion mediums. I have already explained that yolk of egg is the most perfect of emulsions. An emulsion medium consists of an oil or varnish, water, and an emulsifying agent. Among the emulsifying agents are size, albumen, gum-arabic, gum-tragacanth, casein, and soaps.

The artists' colourmen have put on the market tempera colours in which, in many cases, artificial emulsions are used. Some artists like to prepare their own emulsions, and oil-size emulsions are largely used by the house-painter, under the names of water-paint and washable distemper.

The advantage of an emulsion is that it enables the artist to paint freely with water as a diluent, and at the same time to have his pigments bound with a more or less waterproof medium. The pigment dries flat or dead, and owing to the low refractive index of the medium, the brilliancy of the pigment is assured. The emulsion seems to have the property, while drying, of preventing the oil floating to the surface.

In order to make a reliable emulsion, the proportions between oil, pigment emulsifying medium, and water have to be carefully adjusted. The medium must bind well, forming a waterproof coating, and the pigment should not crack when laid on thickly. The paint layer must remain firmly attached to the priming.

EMULSIONS

It is in the matter of this last requirement that we have not, in my opinion, sufficient information. Vasari tells us that experiments with emulsions were abandoned before his time because the paint tended to become detached from the ground ; and I have noticed the same thing in the case of copal varnish, egg emulsion ; and the house-painter sometimes has the same experience with water-paint. I am not satisfied, therefore, that we have sufficient evidence of the reliability of emulsions outside the natural yolk of egg emulsion, and probably also a natural milk emulsion.

As I have already pointed out, the yolk of egg emulsion is unique, as it contains lecithin, a fatty substance which emulsifies with water. For that reason, the best substance available for making emulsions is the yolk of egg itself. Blended with a little oil or varnish, it becomes possible to paint freely with it, thus producing a medium which is much more facile to the needs of the painter than egg alone. But, as I have stated above, it is possible that it may peel off, especially if laid on in thick layers.

It is evident that any mixture of, let us say, oil, water, and size will not form a satisfactory emulsion. They must be proportioned to each other in such a way as to obtain an easily worked medium which can be mixed with water. The first principle to be laid down is that the oil content must be sufficient alone to bind the pigment. The amount of oil required to bind the pigment is much less than the amount required to grind the pigment. If equal weights of pigment are ground with different quantities of oil, thinned with turpentine to make grinding possible, we can easily determine the minimum amount just necessary to bind.

As an example of the adjusting of these four proportions we may take an emulsion prepared for water-paint.

EMULSIONS

The pigment used was lithophone. By experiments with boiled oil and lithophone in the way prescribed it was found that ten parts by weight of lithophone was just bound by one part of oil. This gave the minimum of oil it would be safe to use, and starting on this as the minimum quantity, a satisfactory emulsion was ultimately obtained with fifty parts of lithophone, seven parts of oil, two parts of size, and twenty of water. This emulsion, while making a satisfactory water-paint, would crack if laid on thickly, owing to the high water content. If the water is kept down, so as to diminish the danger of cracking, the amount of pigment requires also to be reduced.

When making an emulsion with yolk of egg and oil the addition of a little oil of turpentine, or oil of spike, assists the amalgamation.

In the chapter on Oil Painting I have discussed the possibility of the use of Dutch Stand oil by the early painters. An emulsion of one part of yolk of egg by volume to one part of Dutch Stand oil, and a little turpentine, gives an excellent medium which, when ground with white lead, gives a crisp and easily worked paint which dries without flowing. Such a medium cannot be diluted with water.

In order to make an emulsion with Stand oil which can be diluted with water, two parts by volume of egg mixed with three parts by volume of water to one part by volume of Stand oil are required. Neither of these emulsions crack on drying when painted on thick.

A properly balanced egg oil emulsion can be mixed with oil, water, or turpentine. Balsams amalgamate excellently with yolk of egg.

Two volumes of egg yolk, one volume of linseed oil, and three volumes of water form an excellent emulsion that can be mixed with water.

EMULSIONS

Among the materials which can be used as emulsifying agents, as we have already stated, are the following : Size, gum-arabic, gum-tragacanth, casein, albumen, yolk of egg, and soaps. Of these, soaps are to be absolutely condemned, and casein is of very doubtful value. In order to dissolve it, an alkali—soda, potash, ammonia, or lime—must be added ; and this alkali will form soaps with the oil, thus introducing a dangerous element. Moreover, we have no experience of casein over long periods of time, and it is the least stable of the nitrogenous group to which it belongs.

There are many tempera mediums on the market, of which some, if not all, are artificial emulsions. There are so many ways of making up emulsions, and so many of them are unsound, that artists' colourmen should be required to state the composition of the medium on the label.

If an artist proposes to use one of these tempera mediums, it should stand the following tests : In the first place, a little of it moistened with water should be tested with litmus paper. If it is strongly alkaline, it probably contains a soap, though it is just possible that the alkalinity may be due to white of egg. It should be rejected unless the artists' colourman will guarantee the absence of soap-emulsion.

If it passes this test, a little should be rubbed out with water on a sheet of glass, and a lump squeezed out of the tube on to the glass as well, and the whole put aside for a month. At the end of that time it should have formed a tough film on the glass, and the lump should have dried without cracking. The glass sheet should now be plunged into hot water and left to stew in hot, not boiling, water for some hours. At the end of that time neither the film nor the lump should have disintegrated or become separated from the glass.

EMULSIONS

In discussing the Van Eyck green in my book on *Pigments and Mediums of the Old Masters*, I pointed out that the only green I knew of, available in the early fifteenth century, to produce the effects to be seen in these pictures, was made by dissolving verdigris in a pine balsam, and the resulting product would be too sticky to paint with, unless diluted with oil of turpentine, and that, as far as we could tell, this medium was not used by painters at that time, and that the only way to make a workable medium would be to emulsify the balsam with egg and a little oil.

It seems to have been assumed that I intended an emulsion that would mix with water. There is no need to make such an emulsion. If a little yolk of egg is mixed with a sticky oil like Stand oil or with varnish, a medium is obtained which will not mix with water, but will paint out nicely, leaving firm, crisp strokes which do not flow. That in certain cases the early fifteenth-century oil painters used such methods seems to me highly probable, but that does not mean that they prepared media which were miscible with water. For instance, one part of egg yolk to one part of Stand oil by volume produces a medium which gives a firm, crisp consistency to white lead and dries without flowing. It is essentially an oil medium, only containing about 7 per cent of albumen. If verdigris is dissolved in Venice turpentine, and one part of Venice turpentine by volume be mixed with one part of linseed oil, and one part of yolk of egg, a satisfactory medium is obtained which, while opaque when first painted out, becomes transparent on drying, giving a most beautiful green.

It has been stated more than once, even by painters, that the Van Eycks used a varnish medium. Varnish mediums are sticky and flowing, and it is impossible that the early Flemish pictures could have been done in

such a medium. In fact, the strokes of the brush are, in many cases, possibly too precise even for oil alone. In pictures of a later date little raised lumps of paint are often seen in the painting of jewellery and such-like, which are so sharp and definite as to suggest some amalgamation of the oil. The grinding of the pigment in oil or varnish with the yolk of egg gives the required crispness.

This suggestion of mine is quite different from the water-emulsion theory of the painting of these pictures at present in vogue, though a water emulsion may have been used in place of egg or size for the under-painting.

Finally, the safest emulsion for artists to use is yolk of egg, and if more freedom of handling is required, it should be obtained by the addition of a minimum of oil.

The reader will find many interesting experiments on emulsions in Professor Berger's *Beiträge zur Enwickel-ungs-Geschichte der Maltechnik.* There is also an interesting paper by Mr. Tudor Hart in the *Transactions* of the Tempera Society, 1901–1907.

CHAPTER XVI

FRESCO PAINTING

OF all the methods of painting, *Buon-Fresco* exercised the most powerful fascination over the Italian artists of the Renaissance. It was regarded as the supreme test of skill, requiring the most perfect craftsmanship, while utilizing the simplest materials.

In *Buon-Fresco* the pigments mixed with water are painted on the wet plaster of sand and lime, and are finally cemented into position by the conversion of the lime, by combination with the carbonic acid gas in the air, into calcium carbonate.

The most interesting and valuable experiments made to revive the process are to be found in the Houses of Parliament. Mrs. Merrifield made an exhaustive enquiry into such information as was available of the ancient methods, and contemporary artists were employed to carry out a big scheme of decoration.

From the point of view of permanency the results were unfortunate, repeated restoration and fixing by means of solutions of paraffin, wax, and varnish having been necessary. The rapid decay of these frescoes has confirmed the conclusion of chemists that we should avoid *Buon-Fresco* for decorative purposes in our modern cities, with air laden with soot and with the acids produced by the burning of the sulphur in coal. Against the views of the chemist modern followers of the process claim—at any rate, in the country districts—

that modern frescoes have shown considerable permanence.

While I am in agreement with my fellow-chemists in condemning its use in our modern cities in this country, there is no reason why it should not be used elsewhere. The cities of Italy are practically as free from coal smoke as they were in the days of Raphael ; and America, with its dry climate and absence of smoke in many of its cities, is peculiarly suitable for fresco painting. It must also be remembered that a revolution in the use of coal is rapidly approaching, owing to the universal application of electric current for light and power, while the necessary economy of coal will compel us to abandon our present wasteful methods, and we may hope in the near future to have smokeless cities.

There may therefore be a great future before fresco painting. An examination of the frescoes in Italy makes it difficult to come to a conclusion as to the durability of the method under proper conditions. In many cases they are in excellent condition, in others they have been restored, and in others they have very largely disappeared. I suspect that it depends on whether the walls themselves are dry or damp. The damp course of the modern architect was unknown in those days, and the soaking up of water with the dissolving and re-crystallization of the lime compounds present may be the cause of decay. There may also have been periods of exposure owing to neglect of the buildings. On the whole, the evidence is in favour of the view that under proper conditions, in a climate like Italy, and in towns free from coal smoke and sulphur acids in the air, they are a remarkably permanent form of decoration.

It has, however, been assumed, because of the bad state of decay of " The Last Supper," by Leonardo da

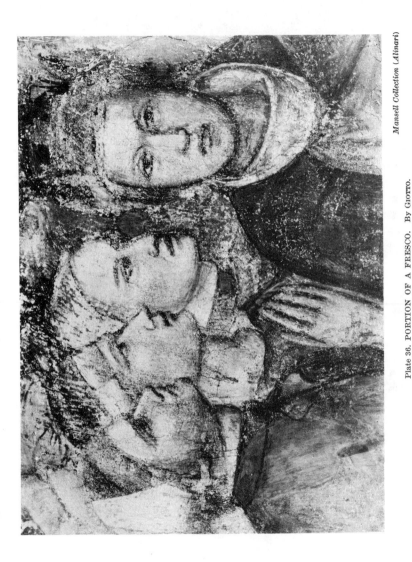

Plate 36. PORTION OF A FRESCO. By GIOTTO.
(National Museum, Florence.)

This, and the subsequent examples represent different periods of fresco painting in Italy. They are reproduced for the guidance of the student who wishes to practice *Buon-Fresco*, that is the painting with a pigment mixed with water on the wet plaster. It was by this method that the great frescoes in Italy which have stood the test of time were done.

Plate 37. BUON-FRESCO. By Benozzo Gozzoli.

A portion of the fresco painting by Benozzo Gozzoli in the Chapel of the Riccardi Palace, Florence.

Plate 38. BUON-FRESCO. By Benozzo Gozzoli.

Detail of fresco painting by Benozzo Gozzoli in the Chapel of the Riccardi Palace
Florence.

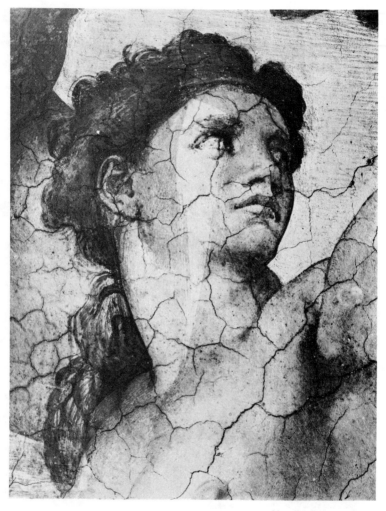

Plate 39. EVE. By MICHAEL ANGELO.

Detail of fresco painting by Michael Angelo taken from the Sistine Chapel in the Vatican.

FRESCO PAINTING

Vinci, that oil forms a fugitive form of wall painting. If tradition is correct, there are examples of oil painting in the Vatican frescoes which are in perfect preservation.

A matter of the first importance is the careful preparation of the plaster surface on which the painting of the fresco is to be done. The Romans took elaborate precautions in the preparations of their plaster surfaces, which were some 5 in. thick, and which have been very fully described by Vitruvius, an architect who lived in the time of Augustus. The first preparation was a coarse concrete of broken brick and lime followed by lime and sand, and finally finished with two or three coats of lime and marble dust. Care was taken that the slaked lime was thoroughly matured, and the mortar was in the first place stamped in the tub, and then worked and beaten on the wall. A stiff paste of lime belongs to that variety of semi-solid bodies which, while it sets up stiff, can be broken down into a sludge, which again sets up stiff—plasterers call this process " knocking up "—so that by proper breaking down it can be got into a usable condition without the addition of too much water. Each coat was laid on before the last was thoroughly dry, and the final coat, which, if a uniformly covered surface was required, was mixed with pigment, was worked with a trowel until a highly polished surface was obtained. On this surface the painting was done.

There has been much dispute as to whether this final painting was done with the pigment mixed with water or water and a little lime, or whether some medium like wax was used. The evidence, on the whole, is in favour of *Buon-Fresco*, the pigments being merely mixed with water, or possibly with a little slaked lime.

One of the objections to the view that they were

painted in *Buon-Fresco* is the absence of joins in the Pompeiian frescoes ; but it must be remembered that the great thickness of the plaster and the polishing of the surface would enable it to be kept moist for days. I have found that it is possible by proper working with the edge of the trowel day after day as the plaster gradually dries, with a mixture of lime and marble dust, to get up a surface like polished marble. No attempt seems to have been made in modern times to revive this classical method of fresco painting. I have also found that pigments laid in water on a surface of lime and marble dust, and then lightly pressed home with a trowel, became firmly attached and could not be removed by water ; and that if the Roman practice was adopted of a thick plaster damp throughout and " closed " by trowelling, then the fresco could be laid on some forty-eight hours after the plaster had been prepared.

In certain cases there is no doubt that beeswax was driven in by heat and polished as a final protective varnish, but there is no evidence of its universal use. It ought to be remembered that the Greeks and Romans admired polished surfaces.

While there is still much that is obscure in their methods, the care with which they prepared the plaster is well worthy of imitation. Marble dust and lime make an excellent finishing coat, and the gradual building up from the coarse broken brick to the sand, and from the sand to the still finer marble dust, is thoroughly scientific.

There is little of practical value to be learnt from the accounts we possess of the methods used in the Middle Ages, and the next information of value is to be obtained from the treatise of Cennino Cennini. Cennino Cennini describes three methods—painting on walls, *in secco* with

egg or with oil, and painting by the wet method or *Buon-Fresco*. We shall in the meantime confine ourselves to a description of *Buon-Fresco*.

It is evident that by his time a complete technique had developed, differing from the methods described by Theophilus and in the Hermeneia. The wall having been plastered, a drawing of the proposed fresco was made on the dry plaster of the wall, and then each day a freshly prepared plaster of lime and sand was spread over the portion which would occupy a day's painting, and on this wet surface the pigments were laid tempered with water. At the end of the day any portion of the plastered surface not utilized was cut away. The description of fresco painting given by Vasari does not differ in essentials, the preparation of a cartoon and pouncing on plaster having been substituted for the older method of drawing on the wall direct. Cennino Cennini describes very fully the preparation of the various tints and their utilization, the laying out of the wall surface, and so on. These matters it is not my province to discuss here.

The success of *Buon-Fresco* depends principally upon two things—the careful preparation of the slaked lime and the thorough working and mixing of the mortar. Quicklime is prepared by the heating with fuel in a kiln of carbonate of lime, of which many varieties occur in nature, such as chalk, limestone, and marble. The carbonic acid gas is driven off, leaving quicklime or calcium oxide behind. This compound is capable of combining with water to form slaked lime or calcium hydrate. It is obvious that, if these processes are considered, it is essential that the quicklime should be thoroughly slaked. Any particles not thoroughly slaked will slowly absorb water and, as they slake, expand and crack the plaster. Even quicklime prepared from marble contains some

portions that are over-burnt and others which contain impurities, which will therefore slake very slowly.

Quicklime should therefore be obtained from as pure a source as possible. Marble is certainly the best ; but Buxton lime is very pure. It should be slaked with water, and with occasional stirring and turning over, and kept for at least three months before use. Some people prefer to keep it for years, but if kept so long, care must be taken to exclude as much as possible the air which contains carbonic acid gas, and which therefore by carbonating the lime will destroy its properties.

There is considerable difference of opinion as to the right proportion between sand and lime. Pacheco and Palomino recommend half and half. Cennino Cennini recommends one-third lime to two-thirds sand. When thoroughly worked and amalgamated with sand, the trowel should come away clean from the mixture. Lime already slaked is now obtainable as a commercial product, and this should be a good starting-point, being mixed with water and allowed to mature instead of starting with quicklime. Clean sand should be used to mix with the lime, free from impurities and approaching as nearly as possible the chemically pure silica or quartz.

Ground quartz is now obtainable as a commercial product, and the introduction of a certain amount of this as a filler is beneficial. It is known that a much stronger and more durable concrete can be made by mixing cement with a graded aggregate, starting from coarse particles and ending with very fine ones. The sand should also be graded for the plaster on which the fresco is to be painted by sifting, in the first instance, into a series of different degrees of fineness. The following example of the grading of aggregates for the making of asphalt pavements should prove useful. The sand for

the asphalt pavements in New York is graded as follows :—

Passing 100 mesh to the inch sieve	= 13 per cent				
,,	80	,,	,,	,,	= 13 ,,
,,	50	,,	,,	,,	= 23·5 ,,
,,	40	,,	,,	,,	= 11·0 ,,
,,	30	,,	,,	,,	= 8·0 ,,
,,	20	,,	,,	,,	= 5·0 ,,
,,	10	,,	,,	,,	= 3·0 ,,

If the reader refers back to the description of the Roman method of preparing a plaster wall, he will see that the Romans graded from the back to the front of the plaster, using broken bricks for the first layer, and finishing with marble dust. Pieces of flint should be wedged into the wall to attach the first layer of plaster, and asbestos fibre should be introduced throughout.

Great care should be taken with the damp course, and where the fresco is to be on an outside wall a brick wall should be built inside the outside wall with an air space ventilated from the inside of the building. These precautions should be taken whatever method of fresco painting be adopted.

PIGMENTS SUITABLE FOR FRESCO

Cennino Cennini gives a very limited list of pigments. A white, bianco sangiovanni, of which I shall say more presently ; black, the yellow, red and brown ochres, and terre verte, which is also a natural earth owing its colour to compounds of iron ; and ultramarine from lapis lazuli. The ultramarine, he says, must be laid on in secco with an egg medium. The Italian painters up to 1600 had only two blues, real ultramarine and Azzurro della Magna —that is, azurite, the blue carbonate of copper obtained

from mines in Hungary. They did not regard it as safe to use real ultramarine on the wet lime ; and azurite will not stand the action of wet lime.

Towards the close of the sixteenth century smalt was introduced. The Melozzo da Forli fresco in the Picture Gallery of the Vatican is painted with smalt, but I suspect a restorer's hand replacing an older blue.

I suspect therefore that even in the time of Raphael the blues were laid on in secco. That azurite was used in large quantities is proved by the ceiling of the Franciscan Church at Assisi. The blue has turned in many cases to a magnificent green, evidence of azurite.

Terre verte, raw sienna, and yellow ochre, according to Professor Church, are apt to cause disintegration of the surface. I noticed terre verte doing so in the frescoes in the library at Siena. There is some doubt as to the right yellow ochre to use. Pliny suggests that a special ochre, which he calls " marmorosum," should be used. For this reason, Ward suggests replacing ochre with cadmium yellow, but, apart from the fact that it is quite the wrong colour key to go with these other earth colours, cadmium yellows are too much open to suspicion to be used for this purpose, and enquiry should be made into the properties of the earth pigments to be used.

It is quite evident from the frescoes in Italy that artists had no difficulty in finding suitable earth pigments, including yellow ochre. Possibly the same sources of supply could be used.

The modern artist is much better equipped. He has viridian, and green oxide of chromium and cobalt blue, cerulean blue, and smalt for blues. For the rest he should confine himself to the red, yellow, and brown earths. Potter's pink and potter's vernalis are safe.

So far I have said nothing about the white to be used in fresco painting. The modern and, I believe, the

sixteenth-century practice, was to use lime so that a binder and a white are being used together. Cennino Cennini recommends a white which he calls bianco sangiovanni, and which he prepared by moulding the lime into little bricks and leaving them exposed to the air for some months. This would result in the partial carbonating of the lime, the result being an intimate mixture of lime and chalk, which will be whiter than pure lime.

CHAPTER XVII

MODERN METHODS OF FRESCO PAINTING

As an example of modern practice I reprint here the greater part of the paper on " Fresco Painting," by Mrs. Sargant Florence in the *Transactions* of the Tempera Society. Students should consult a further paper by Mrs. Florence in the *Transactions* of the Tempera Society for 1907, 1924. She has finally adopted a mixture of one part fat lime, one-half part pit or river sand, and one-half part marble dust.

She uses the earth colours : vegetable black, bianco sangiovanni (refined lime putty), potters' pink, viridian, chromium oxides, and potters' " vernalis," also an oxide of chromium preparation, cobalt blue, artificial ultramarines, and perigord yellow (a yellow ochre). Of these the only one I regard as doubtful is ultramarine.

" To define the nature of fresco painting I cannot do better than quote Vasari, who puts the matter into a nutshell. He says : ' The picture must be painted on the lime while it is wet. The work must not be left until all that is intended to be done that day is finished. Because if the painting be long in hand a certain thin crust forms on the lime, as well from the heat as from the cold, the wind and the frost, which tarnishes and spots all the picture. And therefore the wall which is painted upon must be continually wetted ; and the colours employed upon it must all be earths, and not

minerals, and the white must be calcined travertine. This kind of painting also requires a firm and quick hand, but above all a good and sound judgment, because while the wall is soft the colours appear quite different from what they do when the wall is dry. It is therefore necessary for the artist, while painting in fresco, to use his judgment more than his skill, and to be guided by experience. . . .'

" The subject naturally divides itself into four parts :—

" 1. Preparation of the wall—tools.
" 2. „ „ cartoons.
" 3. „ „ colours.
" 4. Laying on of colours—tools.

" PREPARATION OF WALL SURFACES

" In the preparation of the walls I have been obliged to base my practice altogether on the traditions handed down by old writers, as I have not had the good fortune to come across any masons who have had experience of that kind of work. These traditions apparently vary very considerably, but I gather that the disagreement lies mostly in the number of coats laid on rather than in the material. Wall plaster always seems to consist of slaked fat lime, with some gritty material which it binds together ; and a wall surface properly prepared for fresco, is composed of three different kinds of plaster which vary according to the kind of grit. There is (1) the Undercoat (Italian : *Trusilar*) of lime and pounded brick (size of peas) or baked pottery, laid on coarsely on laths or bundles of rushes carefully laid in place and left rough to serve as a base for the upper coats ; (2) the Lime and Sand Coats (*Arricciato*) ; (3) the Lime and Marble (*Intonaco*). The last one receives the painting.

201

MODERN METHODS

" According to Vitruvius, one coat of *Trusilar* was sufficient, whilst three of the *arricciato* or sand coats and the same number of *intonaco* or marble were necessary. Probably this very elaborate preparation was for surfaces which we associate with Pompeiian style, half of whose beauty is due to the fine texture of the plaster ; and which was made to be decorated in flat spaces of colour, as he speaks of burnishing and polishing the *intonaco*, in order to enrich the quality of the pigments. The instructions of Italian artists such as Alberti and Vasari, and of Guevara among the Spanish, are based mostly on Vitruvius, who, in Book VII, Chapter 3 (Gwilt's translation), gives a very detailed and practical account of preparing walls for painting in the manner of the ancients ; but they are content with three or four coats in all.

" The lime used is a putty made from freshly burnt lime[1] slaked in water, and allowed to rot for at least three months under cover in a damp cellar or disused well. When it is first slaked it should be sifted into the water and carefully stirred every day for some time, so as to make it fine and silky. Lime slaked roughly, in lumps, does not get properly soaked and is troublesome to break up, and not being homogeneous spoils the work. It should be passed afterwards through a wire sieve and left as stated till required. The sand must be pit sand quite free from dirt or mud, and gritty. The marble dust is broken white marble pounded in a mortar till it is fine enough to pass through a piece of close muslin. The marble must be of a sharp quality, and not rusty from open-air sawing. Chips from a sculptor's studio are good for this purpose, but a magnet should be passed through them to collect all the particles of steel.

[1] Opinions vary as to the superiority of chalk (fat) lime or grey limestone for this purpose.

MODERN METHODS

" If the wall of the building where the fresco is to go is of a porous, sandstone nature, it is well to have it cemented internally as a protection against damp drawing in from the outside.[1] From my own experiment in fresco the first coat was composed of brick and lime, the brick being pounded to about the coarseness of peas, well mixed with the lime, and laid on roughly about 1 in. thick, including thickness of laths between which it was finely keyed in.

" The second and third coats of sand and lime, about the coarseness of brown sugar, were laid on about ⅓ in. thick each, the first coat on the brick surface before the latter was dry, so as to amalgamate well together ; the second coat after the first sand one was well dried. This was of a finer texture than the first sand coat, and was finished off comparatively smoothly. These operations took about four months to complete, being carried out during the winter months.

" The fourth coat of marble and lime is laid on by the fresco painter piecemeal as his work proceeds. ' The *intonaco* is to be so prepared that it does not stick to the trowel, but easily comes away from the iron.' Sticking shows that it has not been sufficiently worked or beaten ; it should be pounded in a mortar (both lime and marble dust should have been previously strained separately), ground on slab, and, if at all uneven, crushed several times under edge of a strong palette-knife, which is the best method of detecting any dirt or grit. The proportions of the mixture of lime and marble dust should be equal by measure. It is fit for use when it is of the consistency of a thick paste. The best plan is to prepare a good quantity and place it in

[1] This was done to the wall of the school building upon which I am engaged at present and laths were stretched about two inches away from the wall to make the foundation upon which to place the layers of plaster.

a cool earthenware pot with a little water. This last coat should be laid on as thickly as possible, though I found that ⅛ in. was the limit of adhesion. In greater bulk the *intonaco* tended to crack and eventually peel off. Probably the thickness depends greatly on the greater or less smoothness of the sand coat beneath. Should any signs of cracks appear after laying on, tap the surface to find out by the hollow sound what is the condition of adhesion, and if unsound, cut out at once and relay. The presence of grease on the under-surface will prevent adhesion. The *intonaco* must be laid from the top, downwards, so as to avoid splashing finished work, which would inevitably happen if the lower part were completed first.

" Sufficient for the day's work should be placed on a board. Always remember to have the tools which come in contact with the plaster well moistened ; this prevents sticking, and keeps the plaster compact. The *arricciato* must, of course, be most thoroughly wetted ; it is advisable in warm weather to sprinkle the portion of wall over night and keep it moist with wetted rags.

" To lay on the *intonaco* satisfactorily it should be applied with steady pressure, spreading with the steel float and working from below upwards in the first laying on. After the principal mass of plaster has been applied the float can be used in all directions, so as to ensure its being even all over ; it must amalgamate with the under-coat, or it will show cracks and eventually peel off. I find floats of two sizes (adapted to the hand of the worker) necessary to get an even surface. The wooded float is indispensable to scour the wet plaster, so to speak ; where a large area is being laid, a large float is necessary.

" The plasterer's tools principally used for laying on the plaster are : (1) the float ; (2) the trowel ; (3) the

mortar board. Both wood and steel floats are used according to the nature of the work, but the former are best where the suction is strong. They are flat slabs, varying from 11 × 4 to 8 × 3, with a bridge-handle behind. Flat steel trowels of various sizes are used for pointing and filling in joins and crevices between the work of different days, and to give a finer finish to the surface. The mortar board, a square slab of wood, is the plasterer's palette. There are a variety of small tools for finishing edges—the most useful are slightly bent and spoon-shaped. A straight edge, for testing flatness of surface, and a plumb-line complete the outfit required.

" PAINTING IN FRESCO ON THE PREPARED WALLS

" A great deal of judgment is required in planning out the daily portion of work. I have not practically found it possible to hide the joins between different days' work, where these joins occur on plain colour surfaces. To begin with, it is difficult to lay the two edges together exactly in the same place. In the second place, it seems impossible to prevent streaking the colour. To get as exact a join as possible I have found it best at the beginning of the day to lay the plaster beyond the actual space marked, and at the close to cut back with a sharp scalpel to the desired area, cutting the edge obliquely and as cleanly as possible. In very hot weather it is advisable to leave the extra edge of plaster till the next morning, and then cut away, simply as a means of preserving the edges moister than if they were exposed by trimming.

" With regard to this difficulty, and I believe impossibility, of true joining in colour, it has to be realized that the same tone laid on in various coats lightens in value with each coat; so that where the edge of the second

day's work overlaps that of the first, streaks of a lighter value are apparent. Overlapping cannot be avoided, as the edge, requiring to be moistened, sucks in some of the fresh tone. The only solution of the difficulty lies in planning the joins to follow outlines in the design as far as possible, or wherever two colours or shades meeting make a natural variety in tone. This, of course, produces much longer lines of joins than if worked in rectangles, such an extensive boundary-line giving a sense of weakness. It also has the drawback of drying more quickly. However, I have found no ill effects result from these intricate junctures, and they most effectually conceal defects in plastering of edges, and in colour. The great drawback lies in the frequent difficulty of having to paint on separate days the object and its background. To obviate this it is often worth while putting in some of the background, in order to get the object in right relief, and next day cutting back to outline and replastering for the fresh work.

<center>" Use of Cartoons</center>

" Many directions are given by the old writers on the subject of the Preparation of Cartoons.

" With regard to the piecemeal transfer of the cartoon to the wall, I have found it less destructive to the cartoon to trace each portion on tracing paper and so transfer to wall, using a blunt wooden point for indenting the line as less apt to tear the paper than a metal one. The countersigning is very important for exactness, as in large surfaces one is apt towards the end to get some inches out in the design.

" Remember in planning out the transfer of design that the fresco must be worked horizontally, beginning at the top of wall surface. It can either be worked

<center>206</center>

from right to left or the reverse, according to the liking of the artist ; but, as has been said already, it must always be worked downwards as the splash of the material spots whatever is below.

" With regard to the material for the cartoon, I find most congenial to myself the Willesden waterproof paper prepared with a thin layer of gesso ground. This is convenient for large surfaces as it is wide, and is sold by the yard. It is not so woolly as most brown paper and stands transport well. The gesso ground is not thick enough to flake off seriously when rolled, and it receives both charcoal and brush work in egg tempera admirably. The colour also resembles that of a wall more closely than white paper, and is less dazzling to the eyes.

" In preparing the small-sized study of composition I find it invaluable to keep it always to scale ; that is, fix the size of the study to be $\frac{1}{4}$, $\frac{1}{8}$, or $\frac{1}{10}$ of the final design, so as to carry out the perspective to scale in all its details. But I need not dwell longer on these points, as all artists are equally well aware of the importance of exact preliminary studies for composition.

" The Colours for Fresco Painting

" A very limited range of colour is certainly the best safeguard of decorative harmony, as, the larger the masses of coloured surfaces, the simpler should be the colour scheme. I leave this part of my subject, only saying a word or two about the body-colour, white, which is made of the slaked lime used in preparing the plaster, purified by boiling and grinding and allowed to dry in the sun till it is in a caked condition. It is very fine and white, and is preferable to using the *intonaco*, which, containing marble dust, is sometimes gritty and leaves scratches on the coloured surface.

" With regard to the actual laying on of the colours, I am able to draw more upon my own experience. It is important to realize that fresco is practically water colour ; a stain rather than a paint, and it should be treated as a liquid body. The moist, ivory-like surface of the *intonaco* absorbs the colour, causing it to spread in soft gradations which no retouching can improve. The more transparent the pigment the better it is adapted to this surface ; and it is just this purity which gives such a brilliant softness to draperies whose folds are drawn in richer shades of the local colour of the stuff. It is for this reason also, I think, that Cennino's account of his master's method of painting flesh is so invaluable. Having first shown how to draw and model the outlines in some monotone, as a basis for the colouring, he says : ' Procure three small vases and make three shades of flesh colour ; that is, the darkest, and the other two each lighter than the other in regular gradation. Now take some colour from the little vase containing the lightest tint and with a very soft pencil of bristles, without a point, paint in the lights of the face ; then take the middle tints of the flesh colour and paint the middle tints of the face, hands, and body, when you paint a naked figure. Afterwards take the third vase of flesh colour and go to the edges of the shadows ; and in this manner, softening one tint into the other, until it is all covered as well and as evenly as the nature of the work will permit. But if you would have your work appear very brilliant, be careful to keep each tint of flesh colour in its place, and do not mix one with another.'[1]

" This is practically painting *au premier coup*, and I have tested the truth of it by having previously

[1] The correct translation of the last clause is " except that with skill you soften one delicately into the other." B.

Plate 40. FRESCO PAINTING. By GHIRLANDAIO.

Detail of fresco painting from the Church of S. Maria Novella, Florence
by Ghirlandaio.

Plate 41. A MAGNIFICENT FRESCO.

Detail of fresco painting by Benozzo Gozzoli in the Chapel of the Riccardi Palace, Florence.

worked on other lines. Of these other methods I must
mention one to caution you against it, as in theory it
sounds so very attractive and is also recommended by
an old writer (Armenino). First (just) let us suppose
that a head has to be painted. The modelling is put in
in semi-tones, which allows more time for intricate play
of light and shade than in Giotto's method ; then the
whole is pulled together by a wash of flesh tone laid
lightly over the surface. This looks fresh and forcible
whilst wet, but as it dries grows spotty and mealy-
looking, till at last there is scarcely a true colour left.
This is due to what I have already referred to as being
of such vital importance to realize, namely, that fresco
colours lose value in drying in proportion to the number
of washes laid on.

" On that account in work that is modelled by
hatching, the chief difficulty is to hit upon the right
hatching tone ; it must be darker on the palette than
the pure shadow tone, or, when laid in place, will become
either similar in value to the shadow or lighter. Much
of the chalky or troubled look of fresco is due to this ;
the shadows look hollow with cold reflected lights,
because the hatching strokes dry lighter than shadow
wash. It is a mistake to think that fresco must be
chalky ; the range of tones is cooler than in oils, but
not less pure, and they should not be opaque in quality
any more than in water colours. It is for this reason
that I do not understand the use of lime-water in pre-
paring colours being recommended by some old writers
in place of pure water. I have followed Professor
Church's advice to employ baryta water in moistening
the surface of the *intonaco* before laying on the colours,
to prevent efflorescence ; but have given up adding it
to the pigments, or moistening any coloured surface
with it on account of its clouding water as lime does.

I would advise anyone who is interested in this to con-sult Professor Church's *Chemistry of Paints and Painting*.

" In fresco, work for as direct and natural effects as possible ; you may rely on its drying harmoniously and, as it is called, decoratively. It takes a great deal to tire out the *intonaco* if it has been properly prepared ; should it begin to work up rough under your brush, it is only necessary to smooth it down with a wet trowel, being careful not to spread any of the plaster over the edges of the part in question. The best spirit in which to attack it is in that of the line of poetry :—

' A wet sheet and a flowing sea, and a wind that follows fast.'

" DIFFICULTY OF CORRECTION

" There is one more point in the actual handling of fresco which it is important to consider, indeed it is, I believe, one of its chief bugbears, namely, the difficulty of correction. There is really no great difficulty in it ; it is rather a question of patience. So long as there is plenty of time and daylight ahead of you, it is easy enough to correct on the plaster by going over the mistakes with a wet trowel and a little fresh *intonaco ;* but it is difficult if the day is drawing to a close or the mistakes are not noticed till the next morning. Then the only remedy is to cut out the offending piece, following outlines as much as possible. This is easily done, as the previous day's *intonaco* cuts like soap ; use a sharp scalpel, as thin-edged as possible, and cut slanting to make a better join eventually. Remove the old *intonaco* with trowel or palette-knife (or for a large surface a carpenter's scraper is most useful), wet the surface carefully so as to avoid splashing the surround-ing decoration, and lay on a fresh coat, joining thoroughly with the previous work. It is better worth

correcting in this manner immediately or the day following, than waiting to see the effect when dry, because to postpone means that your *intonaco* is harder to remove—the portion to patch will by that time have been surrounded by work liable to be easily damaged— and it will be much more difficult to match the neighbouring tones.

" It will be perceived that the actual fresco painting is not a lengthy process. The area one can cover satisfactorily depends, to a great extent, on the strength of the worker, also enormously on the importance of subject treated ; a head which covers, say, 1 ft. square, will probably take as long as 3 ft. square of background ; it also depends on the distance of the decoration from the eye of the spectator. Work at a height of 20 ft. from the ground requires free strong handling, which would appear insufferably coarse if on a level with the eye. There is no standard, though I think that a carefully finished life-sized head in one day's work is good average speed. The great thing to my mind to avoid is, accepting the rate of oil painting as a standard of speed. Fresco must be fresh and spontaneous. You must not ignore all the previous time in preparation of cartoons and drawings. Nevertheless, the novice is apt to be disheartened by the coarse look of the work, as seen close at hand on the scaffold, but this essential feature of the work must be accepted. One must be willing to sacrifice personal gratification in a beautifully finished portion for the general effect of the whole.

" With regard to style and the laying on of colours, the more individual the style the more likely fresco is to live again. Mannerisms should be avoided, such as that of the inevitable iron-drawn outline, probably only a tradition of renovators ; or the return to archaic forms which were simply a primitive style of drawing.

MODERN METHODS

Fresco is so essentially *plein-air* in its effects that it should be the medium in which modern thought in Art should express itself best.

" PREPARATION OF COLOURS

" We have now arrived at the last division of our subject; it is fully as important technically as the preparation of the wall; namely, the preparation of the colours. To anyone accustomed to palette and tubes of paint, the question of colours will not appear so very vital, but you who are accustomed to preparing powder colours for tempera work will understand if I go into some detail on the point.

" In the first place, we must make a small study in colour of the design, yet large enough to show gradations of tone. In preparing the design, keep in view the object for which it is being made, so that the scheme shall be suited to fresco, not to oil painting. Legros' favourite saying, ' *la belle et sainte simplicité,*' ought to reign here if anywhere; and as much *plein-air* effect of light as is compatible with the subject. Then, with the study hung up over the grinding slab and a full range of powder colours in glass bottles (so as to recognize each at a glance) within reach, set to work to determine what shades will be required, distinguishing between those which can be produced by more or less thinning and blending on the wall surface, and those which have their own individuality. I have found them divide into two classes, namely, the pure or unmixed colours, such as black, Venetian, light and Indian reds, ochres, etc., which are indispensable in each day's painting; of these, having always a supply in your bottles, you have a standard of colour to which they are bound to return when they are dry. The second class contains the mixed colours. These will, of course, produce unknown

tones when dry if you have only seen them mixed in the moist condition.

" This brings us face to face with one of the chief difficulties of fresco—the alteration of tone after it has been laid on the plaster and become dry. To the old Italian masters who had been trained to it from their youth and lived in the midst of tradition, this was not the difficulty it is to us ; but still, it is mentioned as a serious hindrance. They used the *pietra ombra* as the modern Italian workmen still do ; that is, a porous stone, which, absorbing moisture quickly, soon dries colours laid upon it and discloses its ultimate shade. But in England this stone is difficult to get, and it is besides a clumsy method where many shades are in use.

" It is also possible to have a comparative scale of values showing the same colour in its moist and, side by side, in its dry state ; but this is only approximate.

" I have employed another method suggested to me by a friend, accustomed to work in pottery, which is so simple, and I, at least, have found so satisfactory, that I am sure you will be glad to know of it. It is just simply to mix your powder colours dry, to the shade you wish to have. By very intimately blending the powders on the slab (being extremely careful that all the tools and the slab itself are absolutely dry) with a glass muller ; alternately crushing with the edge of the palette-knife, which is the best means of detecting impurities ; the different pigments used combine so closely that one can rely on the tone produced to remain true to itself, after being moistened, spread on the wall, and eventually dried out. Of course, this does not apply to artificial pigments, which, as shown above, can under no conditions keep their colour. In order to ensure matching work done on different days and in varying lights, compound a fair quantity of each shade, and

when quite satisfied that the tint has been mixed by mechanical combination as completely as possible, cork up in a clean test-tube with name of colour, and which shade it represents, with a note as to constituent pigments written on a strip of tracing paper gummed round the test-tube. Do not grudge devoting several days at the beginning of your work to this preparation. It will be time gained in the end if only that it has made you so acquainted with your colour scheme that you feel master of it when the time arrives for attacking it on a larger scale on the wall.

"Having got your stock of pigments in good order, it only remains to accustom yourself to a method for the day's work. The most excellent plan is to lay them out overnight, moistening the pans in which they stand, which should be well covered over with an oiled sheet of paper to prevent evaporation. It is always a pity to have to spend the fresh morning hours in mechanical grinding on the slab.

"First decide on your colour study, how large an area you are likely to cover in the day's work, and what colours will be required and approximately how much of each. Then take from each test-tube, in turn, some of its contents and grind with pure water on the marble slab, beginning with those lightest in tone, as the slab and muller are apt to get stained by each pigment in spite of constant washing. Lay each colour when ground to a paste in a little white saucer, and set the saucers side by side in any regular order you prefer, on a slab of wood or board of white wood, as you can then paint a streak of each colour close to its own saucer on the board, which drying, will be an index to the eventual tone of the moist pigment. A pipkin of clean water in the middle of the board completes an extempore palette, which placed on a high stool forms

a kind of table. The working palette on which the shades can be mixed is very good, made of aluminium with depressions to hold extra large quantities of paint; it is of the ordinary shape and is held on the thumb, completing with the brushes, trowel, and palette-knife the equipment of the artist."

A method which falls to be discussed here, and of which examples are to be seen in the House of Lords, is the use of silicate of potash as a binding material; it is known as the stereo-chrome process, and it was considered to be absolutely permanent. "The Meeting of Wellington and Blücher after Waterloo," and "The Death of Nelson," by Maclise, and "Moses Bringing the Tables of the Law," by Herbert, all in the House of Lords, were executed in this process. Within ten years Sir Arthur Church had to treat the decaying surface with paraffin wax. The process was afterwards improved by Keim.

The process consists essentially of painting on a dry surface with the pigments mixed with water, and then fixing with a solution of silicate of potash. The ground is also soaked with fluo-silicate before painting, the object being to try to convert the lime into insoluble fluo-silicate to form the binding material. The details are very complicated, and the pigments and solution require to be specially prepared. An example of the method in its final form, as improved by Keim, is to be seen in the fresco painted by Mrs. Lea Merritt at Wonersh, near Guildford.

While the method probably results in a more durable painted surface than *Buon-Fresco* under the conditions of our polluted air, it cannot be claimed as a solution of the problem of permanent wall decoration. A very large portion of the lime and marble dust remains unchanged

and will readily be attacked by sulphur acids, and with the formation and crystallization of sulphate of lime, it will break up the surface. For a full description of the process, see Papers read at the Society of Arts by the Rev. J. A. Rivington in 1884, and by Sir Robert Austen. The process is also described in Church's *Chemistry of Paints and Painting*, and in *Mural Painting*, by Hamilton Jackson.

In conclusion, the objection of chemists to the use of *Buon-Fresco* is due to the pollution of the air in this country with sulphur acids from the burning of the sulphur in coal. These acids are distributed in the air over the whole country, attacking and destroying limestone buildings in remote districts. The conversion of carbonate into sulphate of lime is not always equally destructive, and seems to depend on the aggregation and growth of the crystals in certain centres. When fairly equally distributed, a limestone can carry from 4–5 per cent of sulphate of lime with impunity. The conditions governing the distribution are very obscure, and it might well happen therefore that rapid decay might take place in one case by the sulphate of lime crystallizing in definite spots and breaking up the surface ; while in another case this local crystallization not taking place, the frescoes might last longer. Generally speaking, the danger of such local crystallization is very much diminished if the wall and building are dry.

CHAPTER XVIII

OTHER METHODS OF WALL PAINTING

WE shall next proceed to consider other methods of wall painting. Before doing so, a word or two is necessary on the æsthetic as well as the chemical aspects of the problem.

If the frescoes by Giotto and his disciples are examined, the decorative effect produced is essentially a part of the wall surface and is in no sense a picture painted on a wall. This is not entirely due to the method of painting adopted. The frescoes in the Church of Santa Croce in Florence are painted on a ground tone which matches the peculiar greyish yellow colour of the Florentine stone of which the church is built, and lights and shadows are a little above and below this, the colour being in the nature of a soft tinting of this fundamental tone. The whole effect is as if the stone itself had come to life, as if the natural varieties of tint of a stone had expressed itself in form and colour. Doubtless these frescoes have diminished in brightness, but I must believe that Giotto painted with this decorative object. The effect is enhanced by the fact that his treatment in the drawing, and his decorative conception, is the same as the sculpture done under his direction. Painting as an individual art with its own methods of expression had not asserted itself. When we compare with Giotto's work the somewhat garish frescoes in the Library of the Duomo at Siena, this conception of wall decoration has been departed from, the free introduction of gold leaf making

217

this departure obvious. The question naturally arises, how far the decorative aim of Giotto depends upon the skill of the artist rather than upon the method adopted.

Treatment with paraffin wax melted in, as carried out by Sir Arthur Church in the House of Lords, is, I admit, fatal. At certain angles the frescoes are invisible ; but flat painting in oil, even executed on canvas attached to the wall, is capable, I believe, of successful treatment, and in this direction I wish to direct artists to the possibilities of painting in Chinese wood or Tung oil. This oil, the drying oil of China, dries flat without any treatment with wax and is one of the most durable of drying oils. It also makes excellent emulsions, with size and water. Like all drying oils, it darkens with time, but if thinly painted on a pure white ground this danger is reduced to a minimum.

In order to be able to execute permanent wall painting in our modern cities, it is essential that the ground on which the fresco is painted must be secure from attack by the sulphur acids in the air. This is easily achieved by replacing lime plaster by plaster of Paris. Plaster of Paris alone produces a cold and uninteresting surface and is apt to crack ; but plaster of Paris with white sand produces an excellent painting surface. This should be made non-absorbent with size as directed by Cennino Cennini. The size, to protect it from change, should be lightly sprayed over with a dilute solution of formalin. On this the artist can paint with Tung oil in which the colours have been stiffly ground, thinned with a little turpentine.

There is another direction in which experiments require to be made, namely, the use of silicon ester as a fixative. This solution, which quickly evaporates after application, finally, by the action of the moisture in the

air, deposits a layer of hydrated silica which is in itself indestructible ; and the process has the advantage over methods depending on the use of soluble silicates that no soluble salts are formed at the same time, which may cause further trouble. It should prove very valuable to save and protect existing frescoes and remains of old colouring in our churches.

I shall now briefly describe other materials for wall painting.

On the whole, the evidence is in favour of the use of size in many cases for mediæval wall decorations. If size is used, the finished fresco should be sprayed with formalin. Casein dissolved in soda, or ammonia, or mixed with lime, can also be used, and Professor Oswald recommends pastel as a wall decoration, and fixing with casein. Emulsions can also be used. Of these, the best in my opinion is Chinese oil and size. A final spraying to fix the size with formalin is advisable.

The Gambier Parry medium, as modified by Sir Arthur Church, is a mixture of paraffin wax, 4 oz. (M.P. 58°—62° C.) copal oil varnish, 16 fluid ozs., and oil of spike, 12 fluid ozs. This medium was used by Madox Brown for the decoration of the Town Hall in Manchester. Half of the paintings are on plaster. They have stood well, but here and there the sulphur acids are attacking the plaster below, and crystals of sulphate of lime are forming and breaking up the paint in places where the paint is very thin. The other half are painted on canvas, and are on the whole in good condition ; but in some cases the paint is leaving the priming so that whole sheets could be ripped off with a knife blade inserted underneath. This seems to be a vice peculiar to copal varnish in emulsions. The frescoes in this medium on canvas in the McEwan Hall, Edinburgh, which are now some thirty years old, seem

in excellent condition. On the other hand, Lord Leighton's fresco in this medium at South Kensington was in a deplorable condition, but has been successfully restored.

This medium has two defects. It is apt to attract the growth of mould. This takes place on the organic pigments, like madder lake and Prussian blue, which should therefore be excluded. If the attack is superficial, it can be cured by several sprayings at intervals with formalin. If deep-seated, nothing can remove it, not even scraping off the paint and repainting. A damp wall or a cold wall, causing condensation of moisture, is the cause of this. For this reason an inner wall should be built, ventilated from inside the building.

If the fresco is painted on canvas which is to be attached to the wall by the usual process of cementing with stiff white lead, the canvas should be sprayed with formalin and then washed over the back with a very weak solution of corrosive sublimate.

Another objection to the medium is that, owing to its complex nature, it is difficult to clean it safely. Fuller's earth, breadcrumbs, or saponin and water are the safest.

It is evident that under the present unfortunate conditions of the air in our big cities it is very difficult to give a positive ruling as to the method of wall decoration which is likely to be most successful. The reasons against *Buon-Fresco* are, I think, sufficiently conclusive ; and the Gambier Parry medium has obvious defects. Probably, therefore, the safest thing to do is to accept the necessity of, at any rate, an egg-shell gloss and to paint very thinly in oil, preferably in Chinese wood oil instead of linseed oil, and to protect the surface by the double treatment used by Mrs. Traquair. It is also evident that where the use of lime is not necessitated

OTHER METHODS

by the process adopted—namely, *Buon-Fresco*—the painting should be executed on a surface of plaster of Paris and sand.

It is of some interest at this point to consider what the Northern tradition was in the matter of painting on walls. Mr. Noel Heaton found on certain remains of Roman villas in this country that, in order to carry out a fresh painting, a thin coat of plaster had been laid on the older painting, which makes it probable that the Roman method was *Buon-Fresco*. In some samples which I examined from the foundations of the new Post Office in London, in which the plaster was sound and the pigment firmly adhering, I could find no indications of any organic medium, which is a further confirmation of the view that the Roman method was some modification of *Buon-Fresco*. Mr. Cran, while of the opinion that size was largely used in England for wall decoration in the Middle Ages, mentions a similar case of new plaster laid over an old painting at Chichester, which again suggests *Buon-Fresco*.

That size was probably often used for temporary decorations of no great importance is quite probable, but it can hardly have been used for permanent and important works.

We possess in England a great number of accounts for painting of the thirteenth and fourteenth centuries. In the account rolls of Henry III, Edward I, and Edward II, oil is mentioned, and again in the accounts of Ely Cathedral from 1325 to 1352. The account for the decoration of St. Stephen's Chapel from 1352 to 1358, and in the account of Edward I, 1274 to 1277, relating to the painted chamber, white lead, oil, and varnish are mentioned. The varnish is sold by the pound, and may well therefore be, as Eastlake suggests, the resin, possibly sandarac, which was purchased and dissolved in oil to

make the varnish. Such a varnish would be very slow drying and explain the purchase of charcoal for drying the painting. Mr. Wilson, of the Office of Works, has written an interesting paper on the Westminster Accounts. The blues are indigo and azurite. This use of azurite is of interest, as the blue in illuminated manuscripts, with certain exceptions during the thirteenth and fourteenth centuries, is real ultramarine. I have found azurite only on certain Flemish manuscripts of this period. Evidently azurite was the common blue at this period of time, although not considered good enough for illuminated manuscripts. The large quantities of oil used seems to point to extensive wall surfaces having been covered with oil painting. That oil was not the universal vehicle in England is shown by another painting account, quoted by Eastlake, of 1274 to 1277, where eggs, honey, white wine, and size are the vehicles. Size is occasionally mentioned in the other accounts, but in very small quantities. The question arises whether the walls were sized and then painted in oil and varnish, or painted in size and then varnished, or whether oil alone was used both to prepare the ground and to paint with.

Cennino Cennini directs to size first and then paint in oil, but the practice of house-painters when painting on stone outside a building is to saturate the stone with oil first ; and Mrs. Traquair has adopted this method in her frescoes, presently to be described.

Judging by the small quantities of size mentioned and the large quantities of oil, it is most probable that the plaster was first saturated with oil and white lead ground in oil ; that then the painting was continued in oil, and was finally coated with varnish which required to be heated with charcoal as it was so slow in drying. As I have shown in the chapter on Oil, the mediæval recipes

would give an oil sufficiently quick in drying, and the charcoal would therefore only be required for drying the varnish.

The whole technique, judging by the accounts, is the same as that adopted by Mrs. Traquair for her frescoes in Edinburgh.

The cleaning of the painted tombs in Westminster has been carried out recently by Mr. Tristram, who is of opinion that the paintings were executed in size and then varnished with oil.

As there has been some discussion as to whether the wall paintings in this country were executed in oil or in size and afterwards varnished, it is of some interest to quote the following recipe from the Strasburg Manuscript :—

" I have now honestly, and to the attentive, amply taught how all colours are to be tempered, according to the Greek practice, with two aqueous vehicles ; also how the colours are to be mixed, and how each colour is to be shadowed ; (I have told) the whole truth. I will now teach how all colours may be tempered with size, on wood, on walls, or on cloth ; and in the first place, how the size is to be prepared for the purpose, so that it shall keep without spoiling, also without an unpleasant smell. Take parchment cuttings, and, after washing them well, boil them in water to a clear size, neither too strong nor too weak. When the size is sufficiently boiled, add to it a basinful of vinegar, and let the whole boil well. Then take it from the fire, strain it through a cloth into a clean earthenware vessel, and let it cool. Thus prepared, it keeps fresh and good for a long time. The size being like a jelly, when you wish to temper any colours, take as much size as you please, and an equal quantity of water ; mix the size and water

together, and likewise much honey with them. Warm the composition a little, and mix the honey thoroughly with the size. With this vehicle all colours are to be tempered, neither too thickly nor too thinly, like the other pigments of which I have already spoken. And these colours can all be coated with varnish ; thus they become glossy, and no water nor rain can then injure them, so as to cause them to lose either their tints or their shining appearance."

From this it is evident that painting in size and then varnishing was well known.

I obtained some tiny samples from the tomb at Westminster and found gold, vermilion, and azurite for the pigments, and was satisfied as to the presence of oil, though whether used in the way suggested by Mr. Tristram I could not say. Most of the azurite had turned quite black, just a few blue crystals still existing here and there. Whether this blackening was due to the conversion of the azurite into sulphide or oxide I do not know, as I had not sufficient for further experiments. Under the azurite a curious technique had been adopted : first a layer of white lead in oil next the stone, then a gesso containing fine fragments of fibre, and then the azurite in oil.

No such elaborate preparation is found under the vermilion.

As far as I am aware, no chemical examination has been made of the vehicle of the various remains of frescoes throughout England, so that any opinion as to the medium is guesswork. On the whole, the evidence from the numerous accounts is in favour of the view that wall painting in this country was executed in oil and varnish, thus producing a shiny surface, and that therefore, in trying to transplant *Buon-Fresco* to this country,

the modern artist is going directly against the Northern tradition.

As a modern example of the use of oil and oil varnish for wall decoration, the pictures carried out in Edinburgh in various public buildings some thirty years ago by Mrs. Traquair will now be described.

Among other places decorated by Mrs. Traquair is the Song Room of St. Mary's Cathedral. This is a stone building, lined inside with ordinary lime plaster, which has been laid directly on the stone, and the decorations were carried out some thirty-five years ago.

In the first place, five coats of zinc white in oil were laid upon the plaster without any previous sizing. The first coat was very thin, being highly diluted with turpentine. Each coat was allowed a week or two to dry, and then followed by another coat containing a little less turpentine, the final or fifth coat consisting of almost pure zinc white in oil. Six weeks were allowed for this final coat to dry. The designs were painted with ordinary oil colours, thinned down with turpentine, a piece of beeswax about the size of a hazel nut being dissolved in each half-pint of turpentine. The pigments used were light red, burnt sienna, yellow ochre, terre verte, cobalt blue, real ultramarine, and a very little Chinese vermilion, which when glazed with light red gives a rich and beautiful colour. No black, white, or brown was used, the whole of the light being obtained by the thin transparent washes of oil colour on the white ground.

In this matter Mrs. Traquair's technique is the same as that adopted in *Buon-Fresco*, and is of interest in connection with the whole theory of colour which I have developed in this book.

When the painting was dry it was varnished with an old carriage varnish, thinned down with turpentine.

Over this a flat varnish was laid, and this again, when dry, was polished with beeswax and turpentine.

The whole scheme having got very dirty, Mrs. Traquair washed the whole of it a short time ago with soft soap and water, and then repolished the beeswax with the palm of the hand. Here and there a crack has appeared in the plaster, and in one small portion some early cracking took place, but this cracking has gone no further.

In one place over a window, where the wall is very thin and exposed to the full blast of the east wind, which brings with it all the worst weather in Edinburgh, owing to damp getting through, the plaster became detached from the stone, but the pigment remained firmly attached to the plaster. These decorations have now got a mellow golden tint ; the surface has an egg-shell gloss, and the whole effect is very beautiful and satisfying. As Mrs. Traquair says, it is useless in our modern cities to do any wall painting which cannot be thoroughly well washed down, and for this a smooth surface, thoroughly protected by oil and varnish, is necessary.

I cannot help believing that in these Mrs. Traquair has got much nearer to the mediæval Northern technique than most modern efforts.

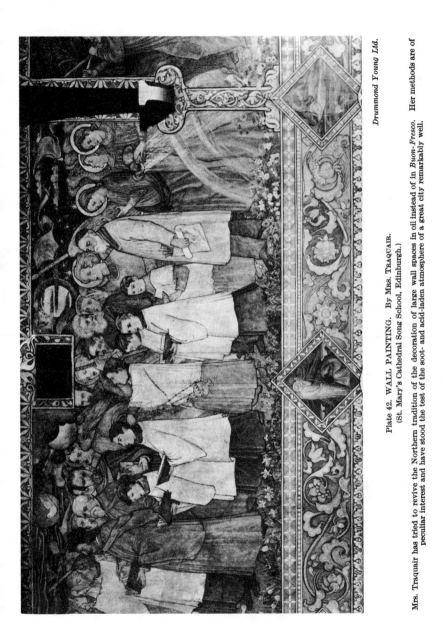

Drummond Young Ltd.

Plate 42. WALL PAINTING. By Mrs. Traquair.

(St. Mary's Cathedral Song School, Edinburgh.)

Mrs. Traquair has tried to revive the Northern tradition of the decoration of large wall spaces in oil instead of in *Buon-Fresco.* Her methods are of peculiar interest and have stood the test of the soot- and acid-laden atmosphere of a great city remarkably well.

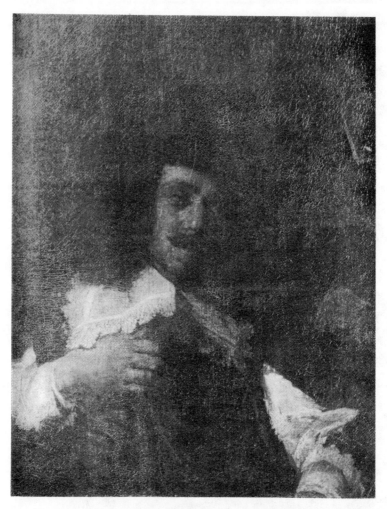

Plate 43. THE GOVERNORS OF THE ST. ELISABETH'S HOSPITAL AT HAARLEM.
BY FRANS HALS.

The three photographs, this and the two following it, illustrate the cleaning by Mr. A. M. de Wild of different parts of a picture by Hals. This photograph was taken before cleaning.

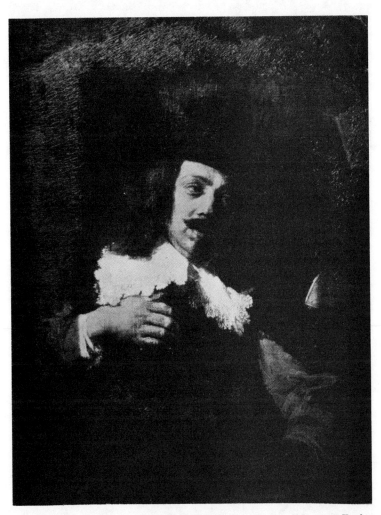

Plate 44. THE GOVERNORS OF THE ST. ELISABETH'S HOSPITAL AT HAARLEM.
By FRANS HALS.

Here the picture is partially cleaned. The cleaning gave rise to some controversy, until the materials used for the cleaning of a second picture by the same methods had been examined.

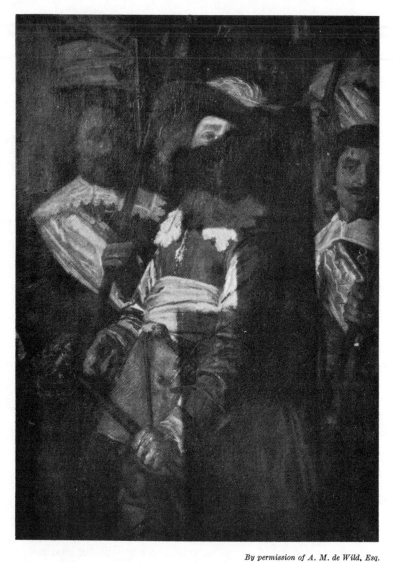

Plate 45. THE GOVERNORS OF THE ST. ELISABETH'S HOSPITAL AT HAARLEM.

Another portion of the same picture partially cleaned.

An analysis of a second picture cleaned by this method proved that the wads of cotton-wool used contained nothing but old varnish.

CHAPTER XIX

PRESERVATION AND CLEANING OF PICTURES

It is obvious from what has gone before that a picture
is a somewhat complex combination of substances with
different properties, and there are so many different
varieties of grounds, methods of painting, and varnish-
ing, that no one picture is exactly like another, and
consequently their preservation and cleaning and
restoring is no easy matter, and only broad general
instructions are possible.

For the art gallery itself certain general rules should
be followed. Freedom from injurious dust and soot
particles is evidently, from what we have learnt, essen-
tial. The soot of our big cities has a most corroding
property. If a surface of oil paint on a picture which
has been exposed to the London atmosphere for years
without protection is examined under the microscope
it is seen to be covered with little black particles. Wash-
ing with turpentine, or even with soap and water, re-
moves some superficial dirt, but does not remove the
ingrained tarry particles which seem to have eaten their
way into the oil surface. They can only be removed
with a solvent which at the same time removes some of
the paint of the picture. If the picture has not been
protected by a varnish, injury to the picture itself is
inevitable if an attempt is made to clean it.

If the varnish is easily removed without touching the
paint film, well and good. If, on the other hand, an oil

varnish has been used, in trying to remove it by solvent, we may well, if great care is not taken, remove some of the paint as well. All pictures in oil and tempera should be protected by an easily removed varnish or protective coat.

Of these varnishes, mastic is the one universally used. I should prefer a protective coat still more easily removed if possible ; beeswax and turpentine has been suggested in place of mastic varnish. I find that a polished film of beeswax is quite equal to the protective value of a film of mastic varnish. For the tempera pictures, a varnish readily soluble in alcohol would be better, as the tempera medium is quite insoluble in this solvent.

Protection by a removable varnish, and in addition protection by glass, is essential. The enclosing the picture in a glass frame is not so simple a matter as it seems. We wish to exclude dirt, but at the same time it is not safe to attempt hermetically to seal the picture, as in that case, under certain conditions of temperature, the moisture which the whole fabric of the picture contains may condense on the surface, encouraging the growth of mould spores.

The introduction of a thin strip of velvet against which the edge of the glass is pressed, with the usual method of pasting up the back with brown paper, is a sound practice. The picture can then breathe, and yet it would be dust-proof, the velvet acting as a dust filter.

In the case of pictures painted in tempera which show signs of crumbling, or oil pictures which seem to show signs of scaling off the ground, it is a good plan to arrange for a line of visible black just inside the glass along the bottom of the frame, so that any disintegrated particles which have fallen off can be seen. The attacks of the

wood-beetle can often be first detected in this way, a little wood dust revealing their presence.

Where pictures have been relined, the back may be regarded as well protected; but in the case of those which have not been so treated, Professor Oswald has made the excellent suggestion of covering the back with tinfoil.

This can be easily and cheaply done, but if the method of relining is adopted, which I shall describe presently, and which is the practice in the Amsterdam Museum, it seems to me better to reline a picture at once, whether ancient or modern, when purchased by the Gallery, rather than wait for injury to take place; and I have suggested in another place the coating of the back of the pictures with a layer of beeswax and resin, covered with a protective canvas, which is practically the Dutch method of relining.

Pictures, and more especially tempera pictures, are apt sometimes to show a tendency to scale. In the case of tempera pictures, a little size should be introduced with a hypodermic syringe under the scaling portion, which should then be gently pressed home. In the case of oil pictures, a little quick-drying linseed oil can be introduced in the same way.

Brittle blisters can be softened with chloroform, or a very, very thin solution of collodion spread over them, which will both soften the blister and at the same time protect them with an elastic film. A little linseed oil can then be introduced under the blister with a hypodermic syringe and the blister worked down with the fingers steeped in oil. Finally, all superfluous oil must be removed.

A tempera picture, if it has not been varnished, can be cleaned with alcohol; the loose pieces cemented down with size, and then a thin coat of size laid over the whole.

PRESERVATION OF PICTURES

Some people have stated that to varnish a cracked tempera picture with mastic is dangerous, as the mastic soaking in underneath the tempera will loosen it and cause it to come off. The custom of the best picture restorers in Florence is to lay over the picture a thin coat of size. This probably is all that is necessary in Italy. In this country it would be better to follow up the thin coating of size when quite dry with a layer of mastic varnish. The size will prevent the mastic varnish soaking in and doing any damage.

A similar objection has been raised to varnishing with mastic oil pictures which have become dry, the pigment no longer carrying sufficient oil to bind it together. In this case it would be safer to rub in gently a little oil, taking care that the minimum of oil is used ; give this some six months to dry and then varnish with mastic.

It is evident from what has been said as to the properties of wood and canvas that not only should the temperature of the room be kept as even as possible, but the percentage of moisture in the air should also be controlled, wet and dry bulb thermometers being used to measure this percentage of moisture. The air should be neither too dry nor too moist, a mean percentage of moisture being attained as far as possible. The pictures should never be exposed to direct sunlight.

The superficial cleaning of pictures which have not been varnished with mastic is probably best done by wiping with cotton-wool, moistened with well-rectified spirits of turpentine. In the case of a mastic-varnished picture, the surface can be dusted, but a solvent cannot very well be used which will not cause the mastic varnish to become sticky.

There has been much discussion as to whether water should be used in the cleaning of pictures. If water is

to be used, the cotton-wool should be nearly dry, and a little saponin can be mixed with the water. This is an excellent and harmless cleaning agent, being prepared from the bark of the soap tree. On no account should any kind of soap be used. The objection to the use of water is that soaking through cracks it may loosen the ground priming of the picture. If excessive water is avoided, and the picture placed in a warm dry place to dry, there should be no danger of this, but soap would remain in the fissures and would probably ultimately do harm.

A picture which has become low in tone can often be very much improved by placing it in a window looking north for a few months. Care should be taken that the direct rays of the sun do not fall on it.

We shall now discuss the cleaning of pictures from the picture restorer's point of view—that is, the actual removal of varnishes, which have become scaled, dark brown in colour, and full of particles of dirt. As has already been stated, an oil picture which has never been varnished and which has become ingrained with London soot, cannot be completely cleaned without injury to the paint. Where there is a protective varnish, the problem is not so insoluble. There are two types of varnishes—the spirit varnishes, in which the resin is dissolved in alcohol or oil of turpentine, and which are readily soluble in a similar medium; and the oil varnishes, in which the resin has been dissolved in linseed oil, and which dry in the same way as a drying oil, forming a film at least as insoluble as the paint of the picture itself. These obviously form the most difficult problems for the cleaner of pictures.

Mastic varnish is not only readily soluble, but can be removed by gentle friction. If the corner of the picture is very gently but persistently rubbed with the tips of

the fingers, presently a white powder is formed of the disintegrated varnish, and it is possible, starting from this corner, to work over the whole picture and remove the mastic varnish. Sometimes it is necessary to crush into powder a little bead of mastic resin in order to start the process. The powdered resin having been blown off, the cleaning process can be completed by rubbing lightly over with a piece of cotton-wool soaked in turpentine. It has been objected that even this method may result in injury to the surface of the picture, and in the case of very impasto paintings, it would not enable us to get into the hollows, and in that case we must trust to the solvent.

When cleaning a picture of a varnish other than mastic, the picture cleaner uses two liquids—one alcohol and the other turpentine; the alcohol being used as a solvent, and the turpentine as a restrainer. He has a dish filled with each beside him, a plentiful supply of cotton-wool, and taking some cotton-wool in each hand, he dips the one into the alcohol and the other into the turpentine, coming over the surface which he is cleaning with the turpentine, followed with the alcohol, thus alternatively dissolving and restraining and watching carefully the process of his work, he aims at the removal of the old varnish without injury to the paint below.

If the alcohol fails to dissolve the varnish, we must use more powerful solvents, such as amyl alcohol, chlorinated hydrocarbons, caustic potash, or ammonia. All these solvents will not only attack the varnish, but will also attack the paint layer, and therefore must be used with the greatest caution.

In the case of a painting in which the brush work shows ridges and furrows, the cleaning presents great difficulties, as the tops of the ridges are apt to be

to be used, the cotton-wool should be nearly dry, and a little saponin can be mixed with the water. This is an excellent and harmless cleaning agent, being prepared from the bark of the soap tree. On no account should any kind of soap be used. The objection to the use of water is that soaking through cracks it may loosen the ground priming of the picture. If excessive water is avoided, and the picture placed in a warm dry place to dry, there should be no danger of this, but soap would remain in the fissures and would probably ultimately do harm.

A picture which has become low in tone can often be very much improved by placing it in a window looking north for a few months. Care should be taken that the direct rays of the sun do not fall on it.

We shall now discuss the cleaning of pictures from the picture restorer's point of view—that is, the actual removal of varnishes, which have become scaled, dark brown in colour, and full of particles of dirt. As has already been stated, an oil picture which has never been varnished and which has become ingrained with London soot, cannot be completely cleaned without injury to the paint. Where there is a protective varnish, the problem is not so insoluble. There are two types of varnishes—the spirit varnishes, in which the resin is dissolved in alcohol or oil of turpentine, and which are readily soluble in a similar medium; and the oil varnishes, in which the resin has been dissolved in linseed oil, and which dry in the same way as a drying oil, forming a film at least as insoluble as the paint of the picture itself. These obviously form the most difficult problems for the cleaner of pictures.

Mastic varnish is not only readily soluble, but can be removed by gentle friction. If the corner of the picture is very gently but persistently rubbed with the tips of

the fingers, presently a white powder is formed of the disintegrated varnish, and it is possible, starting from this corner, to work over the whole picture and remove the mastic varnish. Sometimes it is necessary to crush into powder a little bead of mastic resin in order to start the process. The powdered resin having been blown off, the cleaning process can be completed by rubbing lightly over with a piece of cotton-wool soaked in turpentine. It has been objected that even this method may result in injury to the surface of the picture, and in the case of very impasto paintings, it would not enable us to get into the hollows, and in that case we must trust to the solvent.

When cleaning a picture of a varnish other than mastic, the picture cleaner uses two liquids—one alcohol and the other turpentine ; the alcohol being used as a solvent, and the turpentine as a restrainer. He has a dish filled with each beside him, a plentiful supply of cotton-wool, and taking some cotton-wool in each hand, he dips the one into the alcohol and the other into the turpentine, coming over the surface which he is cleaning with the turpentine, followed with the alcohol, thus alternatively dissolving and restraining and watching carefully the process of his work, he aims at the removal of the old varnish without injury to the paint below.

If the alcohol fails to dissolve the varnish, we must use more powerful solvents, such as amyl alcohol, chlorinated hydrocarbons, caustic potash, or ammonia. All these solvents will not only attack the varnish, but will also attack the paint layer, and therefore must be used with the greatest caution.

In the case of a painting in which the brush work shows ridges and furrows, the cleaning presents great difficulties, as the tops of the ridges are apt to be

over-cleaned, while the furrows still contain old yellow varnish.

These processes are in my opinion always dangerous, for the following reasons. In the first place turpentine is far from a perfect restrainer, it being quite possible to remove paint from the surface with cotton-wool steeped in turpentine.

The danger of using powerful alkalies like caustic potash, which will form soaps with the dried oil film, is obvious ; and I believe it is never used to-day by careful picture cleaners, but has been replaced by ammonia.

Ammonia is volatile, and therefore quickly evaporates ; but its volatile nature is a source of danger. Fragments of oil paint some twenty years old, enclosed in a covered vessel over ammonia liquor and exposed to the vapour of ammonia, are quickly softened right through, being converted into a soft sticky mass. On exposure to air the film hardens again, but must now consist largely of ammonia soaps and be no longer stable.

The vapour of ordinary alcohol and amyl alcohol also rapidly soften the film of dried oil. Therefore during treatment the film of dried oil must be absorbing these volatile substances with more or less injury to its stability. One paint layer may be more easily attacked than another, so that I have found after exposure to ammonia vapour a skin of paint floating on a semiliquid mass of the priming underneath.

The use of chlorinated hydrocarbons is also to be deprecated, as it is uncertain how far they are permanently absorbed by the film, and their stability is doubtful, with the possible release of chlorine, which will have disastrous effects.

The difficulty of cleansing a painted surface with ridges of paint are sufficiently obvious. I have examined

such a surface under the microscope after the picture cleaner had been at work, to find that the ridges of white lead were all torn and ploughed, while varnish was still lurking in the hollows.

In Florence the practice of the best picture cleaners is to rely very largely on the use of the knife. This is the only possible way of removing overpaintings in egg and is the safest way to remove old varnish. Among the delicate instruments of the surgeon, the necessary tools can be found. A skilled workman can remove thin layers of paint and varnish without any injury to the surface below. In this way all dangerous solvents are avoided.

If solvents are to be used, brushes instead of the harsh and wholesale cotton-wool should be adopted. As I have said, turpentine is itself a solvent, and a much more perfect restrainer is castor oil. This oil mixes with alcohol, and some of the pure oil having been laid on the surface about to be cleaned, a mixture of the oil with alcohol can be painted into the oil on the surface with a fine brush, and this process repeated until the varnish is removed. By using this mixture of alcohol and oil, the absorption of the alcohol by the film is diminished, and the solvent action of the alcohol is completely under control. The objection to this method is the leaving in cracks of a non-drying oil. The oil must therefore be washed off the picture with turpentine at the finish. Only pure alcohol should be used.

When the stronger solvent may be necessary, copaiba balsam is saponified with ammonia, by adding ammonia liquor drop by drop to the copaiba balsam, and shaking up until a clear solution with a very faint smell of ammonia is obtained. This is a powerful solvent, and will, of course, attack a paint layer if pushed too far; but diminishes the danger of the absorption by the film

Plate 46. A FLORENTINE PICTURE CLEANER'S METHOD.

The picture cleaners in Florence often resort to scraping to remove oil varnish and overpaintings. The process is tedious, but absolutely safe in the hands of an expert, the dangers from the use of powerful solvents being avoided. In the case of over-paintings in egg it is the only possible method, as the old egg film is insoluble.

Plate 47. MICRO-PHOTOGRAPH OF A TURNER.
(Tate Gallery.)

This photograph illustrates the damage done to impasto by the habit of the English reliners of pictures of using very heavy irons to drive the composition between the new and the old canvases through the old canvas.

The method of relining adopted in the Continental galleries, which is described in the text from the account of the Director of the Rijks Museum, is quite different, and preserves the impasto from injury. The flattening of Turner's beautiful impasto is quite obvious in this photograph.

of the free ammonia. At the finish the copaiba balsam must be washed off with turpentine.

These two recipes I owe to a well-known Dutch picture restorer, and I have tried them and found that they work excellently well. In careful hands, therefore, they seem fairly safe, but nothing can guard from the danger of overcleaning.

The aim of the cleaner should be to leave a thin layer of the old varnish, both on ridges and in hollows. Plenty of time and infinite skill and patience are necessary.

RELINING. Before cleaning a picture, if the paint shows signs of being detached from the canvas, it is relined. This does not mean the removal of the old canvas, which is seldom done ; but backing the old canvas with a new one, which is cemented on, the aim being to drive the cementing material through the old canvas to the back of the paint layer. In order to do this, sheet upon sheet of fine tissue paper is pasted on the front of the picture to protect it from injury, and the canvas is cemented on to new stretched canvas by ironing the back with hot irons. In this country a mixture of glue and resin is usually used, and very heavy irons, with the result that the brush work is sometimes flattened and ruined. The following method used in the Dutch Galleries should always be adopted, as being much safer and more satisfactory :

After a picture has been stretched on a frame and protected on the front by thin sheets of paper pasted on it by means of starch, the new canvas is applied to the back of the old one. The material that acts as the adhesive substance between the old and the new canvas is a mixture in equal parts of wax and resin, with the addition of a little oil of turpentine. I have already spoken of the high protective value of this mixture.

The new canvas is flattened with electric flat irons, and every care is taken that these irons are not too hot. The flattening itself is done on a table covered with soft paper on sheets of quilt, so that the impasto may not be crushed, and may remain undamaged. If the impastoes are very big, a blanket is put on the table. One of the advantages of the wax and resin mixture is the fact that if small portions of this material appear after the relining on the painted side of the canvas, it can easily be removed by using turpentine.

In the case of rents in the canvas, a fresh piece of canvas cut to fit the hole is carefully inserted before the relining is done. Afterwards it is filled up from the front with a little gesso. Where part of the painted surface has disappeared, the bare portion is filled in by stippling on colour ground in mastic varnish. It is usual before proceeding to this restoration to put a very thin film of mastic varnish over the whole picture. Finally, the picture is varnished with mastic.

In this treatment of mastic there is possible danger. If the pigment on the picture is too arid after the cleaning process it may mean the replacement of oil by mastic varnish as a medium, which is not advisable. In such a case a little oil should be rubbed in with the fingers, care being taken that the very minimum quantity is used, wiping off all excess, and this should be given a few months to dry before the final restoring and varnishing is done. It has been suggested by some authorities that where such restoration work is necessary, care should be taken that it should be slightly below the level of the surface of the paint, so that it is always possible to detect where this has been done. It is unnecessary to say that all such restoration should be confined to places where actual gaps in the paint surface

occur. A skilful restorer can do this without any need to come over any of the painted surface.

Finally, photographs should be taken both before and after cleaning and restoration, for the sake of comparison.

The bad appearance of a picture is sometimes due to the surface disintegration of the varnish, and, if this is a spirit varnish, the exposure of the picture to alcohol vapour redissolves the varnish and restores the surface.

This treatment with alcohol vapour is known as the Pettenkofer process, and has given rise to much discussion and controversy. It can sometimes be used with benefit if applied by those skilled and experienced in the process. It is evident from what I have already said about the powerful action of alcohol vapour on the dried oil film that unless used with the utmost caution it may completely destroy the picture.

One of the most difficult problems in the past has been how to destroy the wood beetle, when found to be attacking a panel, without doing any injury to the picture. It is necessary to find a vapour which, while destructive to the beetle, will not act on oil or varnish. Dr. Scott has solved this problem, as he finds the vapour of bisulphide of carbon can be safely used. To prevent a return of the beetle the holes should be filled up with beeswax mixed with sandalwood oil, as the female beetle dislikes the smell of the oil. The backs of panel pictures should occasionally be rubbed over with sandalwood oil for the same reason.

CHAPTER XX

CONCLUSION

I⊤ will be evident to a student reading this book that the craft of the painting of pictures has suffered a terrible loss from the perishing of studio traditions,handed down from age to age through the apprenticeship system.

The loss of the tradition is not entirely to be ascribed to the gradual disappearance of the teaching of painting as a craft and the separation of the painter from the artist colourman. It is also due to the wonderful flexibility of the oil medium in fulfilling the needs of every new type of artistic expression.

The early methods of painting in oil were, as we have seen, scientifically sound ; but, being merely the result of tradition without any scientific basis, proved useless as a guide to the painter when he abandoned the early methods because they no longer enabled him to produce what he wished to express.

I have dwelt at some length on what we know from MSS. as to the history of oil painting, as it seemed necessary to demonstrate that evidence is conclusive that we have no lost medium or special trick to look for in order to explain the durability of the early pictures.

Having got rid of this search for the philosopher's stone we have found that an examination of the early methods in the light of the optical principles involved, is quite sufficient to account for the excellent results obtained. We have seen how the early oil painting is really a combination of tempera with oil, and how old

National Gallery of Scotland

Plate 48. THE COMING OF ST. COLUMBA. By WILLIAM McTAGGART.

McTaggart's pictures are remarkable for their vivid feeling of sunshine and open air, and would therefore be peculiarly susceptible to degradation of tone. Owing to his method of painting they have shown no indications, up to the present, of such degradation.

An examination of this picture reveals the thin translucent painting on a very lightly tinted priming with stiff ground white lead for the highest lights, in fact, essentially the method of the Dutch School though applied to so different a technique.

CONCLUSION

traditions handed down enabled **Van Eyck** and his followers to adopt methods which we have found to be optically sound.

Later, when the tempera under-painting is abandoned and the oil paint is laid direct on the gesso, we still find the same reliance on the white gesso to correct the defects developed by the oil in time ; in fact, the use in oil of a water-colour technique. When later the practice of solid white for high lights becomes more universal, great care is taken to grind the white stiffly with a minimum of oil. But with the replacement of the white gesso panel by canvas, this gesso was, in course of time, replaced by an oil priming, and as the fundamental optical principles involved were not understood, the methods were not adapted to the new conditions. But even here we find that all through the history of painting, including many of our modern painters, sound optical principles have been followed, more perhaps by instinct than by reason.

In this gradual losing of sound tradition and sound scientific principles, the man of science has perhaps not been without blame. The variety of new pigments invented owing to the rapid development of chemistry in the last hundred and fifty years, naturally made him turn his attention to the examination of these pigments, in order to discover which were permanent and which fugitive, and the results of his experiments have been applied by the painter in oil without full understanding. The wrong and right uses of such pigments as cobalt blue when ground in oil is a striking instance.

I therefore attempt in this book to emphasize the other considerations due to changes not in the pigment, but in the oil itself, which must guide the painter in oils, if he is to produce a picture which will not rapidly lower in tone.

CONCLUSION

Of modern painters in oil, the Pre-Raphaelites alone seem to have thought out and adopted a definite technique with a view to obtaining permanent results, a technique, as we have seen, sound in principle but limited in power of expression. It is here that the difficulty lies to keep sound scientific principles in view, while obtaining full freedom of expression. The study of the problem seems to have been abandoned in despair by the painter in oil, and while the modern painters in tempera have been striving to be, above all, craftsmen with an accurate knowledge of the properties of their materials, the painter in oil seems, in too many cases, to have given up any attempt to master the scientific properties of his materials.

I have before me, as I write, a landscape painted by a famous French artist, in which he has deliberately prepared a priming of asphaltum on which he has painted his picture, with, it is unnecessary to say, appalling results.

In the book on oil painting in this series by Mr. Solomon, R.A., and the book written recently by Mr. Harold Speed, we find serious attempts to bring the oil painter back to the study of his art as a craftsman. He must not be satisfied merely with the knowledge of how to express himself in paint, but must also study the properties of his materials and their limitations, and so modify his methods as to produce not only a beautiful picture, but a good job which will stand up to the test of time.

In this book I have tried as far as possible to deal rather with methods than materials, only describing materials in so far as information will be of use to the artist, endeavouring to write something useful to the artist craftsman, and as far as I can to guide him as a craftsman to the proper use of his materials.

CONCLUSION

In order to do this I have had as far as possible to recover traditional methods, and combine them with modern practice. I have also avoided the description of new and untried materials. The slow chemical actions over long periods of time and exposure to light, moisture, and oxygen, and the gradual physical changes taking place, are so obscure that it is safer to rely on materials which have been tested and used throughout the centuries than to assume too quickly that new materials and new methods will stand the test of time.

Let the painter in oil study his medium by making simple experiments for himself on the amount of oil necessary, the effect of darkness on the ground, and of the thickness of the layer of oil paint and so on. By shutting up his experiments in a box together with a jug of water, he will be able in a few months to obtain results which will guide him in the choice of his palette and in the amount of oil advisable. The way in which he should lay on his paint will become more evident, and on these lines he should be able to obtain good craftsmanship without cramping his style. There is no universal method of overcoming the bad properties of the oil medium. It is a good servant, but a bad master.

It is evident that when we look at the whole history of painting in oil, the method which has proved most successful in avoiding lowering of tone throughout the centuries, has been the method in which the oil paint is translucent and is painted over a layer of white or bright light colour, whether in gesso, tempera, or oil, a method which differs widely from the method of using oil paint which is most universal to-day, in which solid opaque paint is aimed at. The artist, painting in this modern method, would be well advised, in my opinion, to limit his palette to the more opaque pigments as shown in the table given in Chapter IX. By doing this

CONCLUSION

and avoiding excess of oil he should be able to avoid serious lowering of tone.

The chapters on tempera, fresco, and wall painting I have tried to make useful by combining a description of the older methods with an account of modern practice from sound practitioners. Doubtless different painters have different methods, but in each case the method selected is that of a sound craftsman, which should therefore prove a useful guide.

The water-colour painter has three problems—the good and pure quality of his paper, the permanency of his pigments, and the absence of an excess of hygroscopic agents like honey and glycerin in his medium. He can obtain excellent and pure paper and select a list of reliable pigments, and his medium—gum-arabic—has also proved reliable under the test of time.

Unfortunately the demand for moist colours requires the loading of the medium with hygroscopic materials like glycerin. While this has not been proved to be injurious, it is at least probable that this practice will diminish the life of modern water-colour pictures as compared with the older ones that were painted with cake colours. It is a matter well worthy of the consideration of the Water-colour Society, whether a return to the old cake colours is not possible.

In the discussion of fresco and tempera, I have been much indebted to modern artists and to the publications of the Tempera Society. The test of centuries has proved egg to be an excellent and reliable medium, so that the question as to how far present-day methods of expression can be carried out in tempera is of profound interest to the artist.

In the course of this book I have here and there thrown out suggestions to the artists' colourman. On the subject of cracking, I have contented myself with

CONCLUSION

advice to the artist. The causes of cracking, from the point of view of the artists' colourman who grinds pigments in oil, are only beginning to be understood. The properties of the different drying oils, the proportion of pigment to oil, the laying of hard coats over soft coats, and the size and the grading of the pigment grains, all have their influence, and when thoroughly understood may result in profoundly modifying the methods of the preparation of colours for use. The diminution of the yellowing of the oil film by the selection of the most suitable oil, and the introduction of resin, is also worthy of very careful study. It would be a great gain if, with the object of reducing the yellowing of the medium, a highly resinous vehicle could be made which at the same time is workable under the brush.

In conclusion, I hope that this book will be a useful contribution towards the restoration of the painter in oil to the position he once held as a craftsman, thoroughly acquainted with the properties of his materials and with the right way to use them.

INDEX

INDEX

246

INDEX

INDEX

Mander, Van, 150
Manganese violet, 96
Mappæ Clavicula, 23
Marble for fresco, 196
Mars yellow, 86
Mastic varnish, 163, 167, 228–236
Massicot, 91
Materials for a History of Oil Painting, Eastlake, 26, 39
Mayerne, De, 69, 70
McEwan Hall, Edinburgh, frescoes in, 219
Merrifield, Mrs., 28, 37, 39, 191
Merritt, Lea, Mrs., frescoes at Wonersh, 215
Morrell, Dr., 136
Mount Athos MS., 37
Mural painting, 17, 29, 191–226

Naples yellow, 91

Oil, darkening of, 39, 40, 124, 129, 137, 142, 146, 241
— drying of a film of, 20, 24, 40, 156, 157
— medium, early methods and discovery, 19, 20, 22–48, 144, 148, 151
— optical properties of, 140–155
— poppy, 20, 76, 134, 151, 152, 157
— preparation of, 24, 25, 28, 32, 34, 40, 128
— priming for canvas, 68, 69, 70, 71, 73, 156
— spike of lavender
— Stand, 41, 42, 77, 137, 138, 187
— Tung, 134
— varnishes, 170
— walnut, 20, 133
Oleum Cicinum, 23
Olio d'abezzo, 35, 45, 164
Opacity of pigments, 119, 120

Optical principles, 102–127
Orange cadmium, 88–89
— chrome, 89
Orpiment, 90
Oswald, Professor, 219, 229
Oxide of chromium, 92

Palette for fresco painting, 215
Panels, 53, 54, 58, 60
— priming of, 59–65
Paper, 51, 52
Paraffin wax, 172
Parchment size, 174–175
Parry, Gambier, medium for fresco, 219, 220
Pentimento, 109. 152 (Illus.)
Permeation of moisture, 45, 55, 57
Petrie, Professor Flinders, 19
Petroleum, 171
Pigments, 80–101
— early, 46, 47
— effect of changes in linseed oil on (table), 124
— fresco, 197, 199, 207, 212, 216
— permanent, 98, 99, 161
Pigments and Mediums of the Old Masters, Professor A. P. Laurie
Pink, Dutch, 96
Pinus balsamea, 165
Pinus maritima, 166
Plaster (fresco), 193, 195, 197, 201, 202, 204
Pliny, 18, 23, 42, 80, 93, 177
Ply-wood, 54, 57, 58
Pompeiian frescoes, 17, 194
Poplar, white, for panels, 53
Poppy oil, 20, 76, 134, 151, 152, 157
Potash, silicate of, for fresco painting, 215
Practice of Oil Painting, S. J. Solomon, R.A., 151, 152
Pre-Raphaelite technique, 71, 72, 240

INDEX

INDEX

Umber, 85
Underpainting, in egg, 21
— in grey, 151, 152
— flesh, Michael Angelo, 147, 161, 184
— flesh, Velazquez, 150

Vandyke brown, 86
Varnish, 33, 35, 36, 164, 169, 170, 176
— addition of, to oil medium, 44, 45
— removal of, 231
— Tempera (Cennino Cennini), 180
Varnishes and their Components, Dr. Morrell, 171
Varnishing, the, of a picture, 163
Vasari, 20, 21, 34, 36, 40, 44, 67, 68, 133, 177, 186, 202
— on Van Eyck, 49
— *Life of Alessio Baldovinetti*, 36
Velazquez, Rokeby Venus, 150
Venetian red, 85
Venice turpentine, 36, 45, 164
Verdigris, 93
Vermilion, 87
Vernition, 25
Verte emeraude, 92
Vinci, Leonardo da, " Last Supper," 192
— use of massicot,
Violets, the, 96
Viridian, 92
Vitruvius, preparation of wall for fresco, 193, 202

Walls, preparation of, for fresco, 193, 195, 197, 201, 204, 205
Wall painting, 191–226
Walnut oil, 20, 133
Ward, James, *History and Methods of Ancient and Modern Painting*, 19
Warping of panels, 54, 58
Water colours, 173, 175, 242
Wax, beeswax, 171
— ceresin, 172
— medium, 18, 19
— medium for fresco, 215–219
Westminster, the painted tombs at, 223
White lead, 80, 82, 110, 161
— light, behaviour of, 102–110
— pigments, 80–84
Whites, transparency of the, 110
Wood-beetle, 228, 237
Wood panels, 53, 54, 58, 60

Yellow pigments, 88
— chrome, 89
— cobalt, 89
— Indian, 91
— Naples, 91
— ochre, 85
— oxide of lead, 91
Yellowing of oil, the, 122, 124, 129, 135, 136, 137, 143, 145, 149, 150, 156–159

Zinc chromate, 90
— white, optical properties of, 109, 110

A CATALOG OF SELECTED

DOVER BOOKS

IN ALL FIELDS OF INTEREST

A CATALOG OF SELECTED DOVER
BOOKS IN ALL FIELDS OF INTEREST

DRAWINGS OF REMBRANDT, edited by Seymour Slive. Updated Lippmann, Hofstede de Groot edition, with definitive scholarly apparatus. All portraits, biblical sketches, landscapes, nudes. Oriental figures, classical studies, together with selection of work by followers. 550 illustrations. Total of 630pp. 9⅛ × 12¼.
21485-0, 21486-9 Pa., Two-vol. set $25.00

GHOST AND HORROR STORIES OF AMBROSE BIERCE, Ambrose Bierce. 24 tales vividly imagined, strangely prophetic, and decades ahead of their time in technical skill: "The Damned Thing," "An Inhabitant of Carcosa," "The Eyes of the Panther," "Moxon's Master," and 20 more. 199pp. 5⅜ × 8½. 20767-6 Pa. $3.95

ETHICAL WRITINGS OF MAIMONIDES, Maimonides. Most significant ethical works of great medieval sage, newly translated for utmost precision, readability. Laws Concerning Character Traits, Eight Chapters, more. 192pp. 5⅜ × 8½.
24522-5 Pa. $4.50

THE EXPLORATION OF THE COLORADO RIVER AND ITS CANYONS, J. W. Powell. Full text of Powell's 1,000-mile expedition down the fabled Colorado in 1869. Superb account of terrain, geology, vegetation, Indians, famine, mutiny, treacherous rapids, mighty canyons, during exploration of last unknown part of continental U.S. 400pp. 5⅜ × 8½. 20094-9 Pa. $6.95

HISTORY OF PHILOSOPHY, Julián Marías. Clearest one-volume history on the market. Every major philosopher and dozens of others, to Existentialism and later. 505pp. 5⅜ × 8½. 21739-6 Pa. $8.50

ALL ABOUT LIGHTNING, Martin A. Uman. Highly readable non-technical survey of nature and causes of lightning, thunderstorms, ball lightning, St. Elmo's Fire, much more. Illustrated. 192pp. 5⅜ × 8½. 25237-X Pa. $5.95

SAILING ALONE AROUND THE WORLD, Captain Joshua Slocum. First man to sail around the world, alone, in small boat. One of great feats of seamanship told in delightful manner. 67 illustrations. 294pp. 5⅜ × 8½. 20326-3 Pa. $4.95

LETTERS AND NOTES ON THE MANNERS, CUSTOMS AND CONDITIONS OF THE NORTH AMERICAN INDIANS, George Catlin. Classic account of life among Plains Indians: ceremonies, hunt, warfare, etc. 312 plates. 572pp. of text. 6⅛ × 9¼. 22118-0, 22119-9 Pa. Two-vol. set $15.90

ALASKA: The Harriman Expedition, 1899, John Burroughs, John Muir, et al. Informative, engrossing accounts of two-month, 9,000-mile expedition. Native peoples, wildlife, forests, geography, salmon industry, glaciers, more. Profusely illustrated. 240 black-and-white line drawings. 124 black-and-white photographs. 3 maps. Index. 576pp. 5⅜ × 8½. 25109-8 Pa. $11.95

CATALOG OF DOVER BOOKS

THE BOOK OF BEASTS: Being a Translation from a Latin Bestiary of the Twelfth Century, T. H. White. Wonderful catalog real and fanciful beasts: manticore, griffin, phoenix, amphivius, jaculus, many more. White's witty erudite commentary on scientific, historical aspects. Fascinating glimpse of medieval mind. Illustrated. 296pp. 5⅜ × 8¼. (Available in U.S. only)　　24609-4 Pa. $5.95

FRANK LLOYD WRIGHT: ARCHITECTURE AND NATURE With 160 Illustrations, Donald Hoffmann. Profusely illustrated study of influence of nature—especially prairie—on Wright's designs for Fallingwater, Robie House, Guggenheim Museum, other masterpieces. 96pp. 9¼ × 10¾.　　25098-9 Pa. $7.95

FRANK LLOYD WRIGHT'S FALLINGWATER, Donald Hoffmann. Wright's famous waterfall house: planning and construction of organic idea. History of site, owners, Wright's personal involvement. Photographs of various stages of building. Preface by Edgar Kaufmann, Jr. 100 illustrations. 112pp. 9¼ × 10.
23671-4 Pa. $7.95

YEARS WITH FRANK LLOYD WRIGHT: Apprentice to Genius, Edgar Tafel. Insightful memoir by a former apprentice presents a revealing portrait of Wright the man, the inspired teacher, the greatest American architect. 372 black-and-white illustrations. Preface. Index. vi + 228pp. 8¼ × 11.　　24801-1 Pa. $9.95

THE STORY OF KING ARTHUR AND HIS KNIGHTS, Howard Pyle. Enchanting version of King Arthur fable has delighted generations with imaginative narratives of exciting adventures and unforgettable illustrations by the author. 41 illustrations. xviii + 313pp. 6⅛ × 9¼.　　21445-1 Pa. $5.95

THE GODS OF THE EGYPTIANS, E. A. Wallis Budge. Thorough coverage of numerous gods of ancient Egypt by foremost Egyptologist. Information on evolution of cults, rites and gods; the cult of Osiris; the Book of the Dead and its rites; the sacred animals and birds; Heaven and Hell; and more. 956pp. 6⅛ × 9¼.
22055-9, 22056-7 Pa., Two-vol. set $21.90

A THEOLOGICO-POLITICAL TREATISE, Benedict Spinoza. Also contains unfinished *Political Treatise*. Great classic on religious liberty, theory of government on common consent. R. Elwes translation. Total of 421pp. 5⅜ × 8½.
20249-6 Pa. $6.95

INCIDENTS OF TRAVEL IN CENTRAL AMERICA, CHIAPAS, AND YUCATAN, John L. Stephens. Almost single-handed discovery of Maya culture; exploration of ruined cities, monuments, temples; customs of Indians. 115 drawings. 892pp. 5⅜ × 8½.　　22404-X, 22405-8 Pa., Two-vol. set $15.90

LOS CAPRICHOS, Francisco Goya. 80 plates of wild, grotesque monsters and caricatures. Prado manuscript included. 183pp. 6⅞ × 9⅝.　　22384-1 Pa. $4.95

AUTOBIOGRAPHY: The Story of My Experiments with Truth, Mohandas K. Gandhi. Not hagiography, but Gandhi in his own words. Boyhood, legal studies, purification, the growth of the Satyagraha (nonviolent protest) movement. Critical, inspiring work of the man who freed India. 480pp. 5⅜ × 8½. (Available in U.S. only)
24593-4 Pa. $6.95

ILLUSTRATED DICTIONARY OF HISTORIC ARCHITECTURE, edited by Cyril M. Harris. Extraordinary compendium of clear, concise definitions for over 5,000 important architectural terms complemented by over 2,000 line drawings. Covers full spectrum of architecture from ancient ruins to 20th-century Modernism. Preface. 592pp. 7½ × 9¾. 24444-X Pa. $14.95

THE NIGHT BEFORE CHRISTMAS, Clement Moore. Full text, and woodcuts from original 1848 book. Also critical, historical material. 19 illustrations. 40pp. 4⅝ × 6. 22797-9 Pa. $2.50

THE LESSON OF JAPANESE ARCHITECTURE: 165 Photographs, Jiro Harada. Memorable gallery of 165 photographs taken in the 1930's of exquisite Japanese homes of the well-to-do and historic buildings. 13 line diagrams. 192pp. 8⅜ × 11¼. 24778-3 Pa. $8.95

THE AUTOBIOGRAPHY OF CHARLES DARWIN AND SELECTED LETTERS, edited by Francis Darwin. The fascinating life of eccentric genius composed of an intimate memoir by Darwin (intended for his children); commentary by his son, Francis; hundreds of fragments from notebooks, journals, papers; and letters to and from Lyell, Hooker, Huxley, Wallace and Henslow. xi + 365pp. 5⅜ × 8. 20479-0 Pa. $5.95

WONDERS OF THE SKY: Observing Rainbows, Comets, Eclipses, the Stars and Other Phenomena, Fred Schaaf. Charming, easy-to-read poetic guide to all manner of celestial events visible to the naked eye. Mock suns, glories, Belt of Venus, more. Illustrated. 299pp. 5¼ × 8¼. 24402-4 Pa. $7.95

BURNHAM'S CELESTIAL HANDBOOK, Robert Burnham, Jr. Thorough guide to the stars beyond our solar system. Exhaustive treatment. Alphabetical by constellation: Andromeda to Cetus in Vol. 1; Chamaeleon to Orion in Vol. 2; and Pavo to Vulpecula in Vol. 3. Hundreds of illustrations. Index in Vol. 3. 2,000pp. 6½ × 9¼. 23567-X, 23568-8, 23673-0 Pa., Three-vol. set $37.85

STAR NAMES: Their Lore and Meaning, Richard Hinckley Allen. Fascinating history of names various cultures have given to constellations and literary and folkloristic uses that have been made of stars. Indexes to subjects. Arabic and Greek names. Biblical references. Bibliography. 563pp. 5⅜ × 8½. 21079-0 Pa. $7.95

THIRTY YEARS THAT SHOOK PHYSICS: The Story of Quantum Theory, George Gamow. Lucid, accessible introduction to influential theory of energy and matter. Careful explanations of Dirac's anti-particles, Bohr's model of the atom, much more. 12 plates. Numerous drawings. 240pp. 5⅜ × 8½. 24895-X Pa. $4.95

CHINESE DOMESTIC FURNITURE IN PHOTOGRAPHS AND MEASURED DRAWINGS, Gustav Ecke. A rare volume, now affordably priced for antique collectors, furniture buffs and art historians. Detailed review of styles ranging from early Shang to late Ming. Unabridged republication. 161 black-and-white drawings, photos. Total of 224pp. 8⅜ × 11¼. (Available in U.S. only) 25171-3 Pa. $12.95

VINCENT VAN GOGH: A Biography, Julius Meier-Graefe. Dynamic, penetrating study of artist's life, relationship with brother, Theo, painting techniques, travels, more. Readable, engrossing. 160pp. 5⅜ × 8½. (Available in U.S. only) 25253-1 Pa. $3.95

HOW TO WRITE, Gertrude Stein. Gertrude Stein claimed anyone could understand her unconventional writing—here are clues to help. Fascinating improvisations, language experiments, explanations illuminate Stein's craft and the art of writing. Total of 414pp. 4⅝ × 6⅜. 23144-5 Pa. $5.95

ADVENTURES AT SEA IN THE GREAT AGE OF SAIL: Five Firsthand Narratives, edited by Elliot Snow. Rare true accounts of exploration, whaling, shipwreck, fierce natives, trade, shipboard life, more. 33 illustrations. Introduction. 353pp. 5⅜ × 8½. 25177-2 Pa. $7.95

THE HERBAL OR GENERAL HISTORY OF PLANTS, John Gerard. Classic descriptions of about 2,850 plants—with over 2,700 illustrations—includes Latin and English names, physical descriptions, varieties, time and place of growth, more. 2,706 illustrations. xlv + 1,678pp. 8½ × 12¼. 23147-X Cloth. $75.00

DOROTHY AND THE WIZARD IN OZ, L. Frank Baum. Dorothy and the Wizard visit the center of the Earth, where people are vegetables, glass houses grow and Oz characters reappear. Classic sequel to *Wizard of Oz*. 256pp. 5⅜ × 8.
24714-7 Pa. $4.95

SONGS OF EXPERIENCE: Facsimile Reproduction with 26 Plates in Full Color, William Blake. This facsimile of Blake's original "Illuminated Book" reproduces 26 full-color plates from a rare 1826 edition. Includes "The Tyger," "London," "Holy Thursday," and other immortal poems. 26 color plates. Printed text of poems. 48pp. 5¼ × 7. 24636-1 Pa. $3.50

SONGS OF INNOCENCE, William Blake. The first and most popular of Blake's famous "Illuminated Books," in a facsimile edition reproducing all 31 brightly colored plates. Additional printed text of each poem. 64pp. 5¼ × 7.
22764-2 Pa. $3.50

PRECIOUS STONES, Max Bauer. Classic, thorough study of diamonds, rubies, emeralds, garnets, etc.: physical character, occurrence, properties, use, similar topics. 20 plates, 8 in color. 94 figures. 659pp. 6⅛ × 9¼.
21910-0, 21911-9 Pa., Two-vol. set $15.90

ENCYCLOPEDIA OF VICTORIAN NEEDLEWORK, S. F. A. Caulfeild and Blanche Saward. Full, precise descriptions of stitches, techniques for dozens of needlecrafts—most exhaustive reference of its kind. Over 800 figures. Total of 679pp. 8¼ × 11. Two volumes. Vol. 1 22800-2 Pa. $11.95
Vol. 2 22801-0 Pa. $11.95

THE MARVELOUS LAND OF OZ, L. Frank Baum. Second Oz book, the Scarecrow and Tin Woodman are back with hero named Tip, Oz magic. 136 illustrations. 287pp. 5⅜ × 8½. 20692-0 Pa. $5.95

WILD FOWL DECOYS, Joel Barber. Basic book on the subject, by foremost authority and collector. Reveals history of decoy making and rigging, place in American culture, different kinds of decoys, how to make them, and how to use them. 140 plates. 156pp. 7⅞ × 10¾. 20011-6 Pa. $8.95

HISTORY OF LACE, Mrs. Bury Palliser. Definitive, profusely illustrated chronicle of lace from earliest times to late 19th century. Laces of Italy, Greece, England, France, Belgium, etc. Landmark of needlework scholarship. 266 illustrations. 672pp. 6⅛ × 9¼. 24742-2 Pa. $14.95

ILLUSTRATED GUIDE TO SHAKER FURNITURE, Robert Meader. All furniture and appurtenances, with much on unknown local styles. 235 photos. 146pp. 9 × 12.
22819-3 Pa. $7.95

WHALE SHIPS AND WHALING: A Pictorial Survey, George Francis Dow. Over 200 vintage engravings, drawings, photographs of barks, brigs, cutters, other vessels. Also harpoons, lances, whaling guns, many other artifacts. Comprehensive text by foremost authority. 207 black-and-white illustrations. 288pp. 6 × 9.
24808-9 Pa. $8.95

THE BERTRAMS, Anthony Trollope. Powerful portrayal of blind self-will and thwarted ambition includes one of Trollope's most heartrending love stories. 497pp. 5⅜ × 8½.
25119-5 Pa. $8.95

ADVENTURES WITH A HAND LENS, Richard Headstrom. Clearly written guide to observing and studying flowers and grasses, fish scales, moth and insect wings, egg cases, buds, feathers, seeds, leaf scars, moss, molds, ferns, common crystals, etc.—all with an ordinary, inexpensive magnifying glass. 209 exact line drawings aid in your discoveries. 220pp. 5⅜ × 8½.
23330-8 Pa. $4.50

RODIN ON ART AND ARTISTS, Auguste Rodin. Great sculptor's candid, wide-ranging comments on meaning of art; great artists; relation of sculpture to poetry, painting, music; philosophy of life, more. 76 superb black-and-white illustrations of Rodin's sculpture, drawings and prints. 119pp. 8⅝ × 11¼.
24487-3 Pa. $6.95

FIFTY CLASSIC FRENCH FILMS, 1912–1982: A Pictorial Record, Anthony Slide. Memorable stills from Grand Illusion, Beauty and the Beast, Hiroshima, Mon Amour, many more. Credits, plot synopses, reviews, etc. 160pp. 8¼ × 11.
25256-6 Pa. $11.95

THE PRINCIPLES OF PSYCHOLOGY, William James. Famous long course complete, unabridged. Stream of thought, time perception, memory, experimental methods; great work decades ahead of its time. 94 figures. 1,391pp. 5⅜ × 8½.
20381-6, 20382-4 Pa., Two-vol. set $19.90

BODIES IN A BOOKSHOP, R. T. Campbell. Challenging mystery of blackmail and murder with ingenious plot and superbly drawn characters. In the best tradition of British suspense fiction. 192pp. 5⅜ × 8½.
24720-1 Pa. $3.95

CALLAS: PORTRAIT OF A PRIMA DONNA, George Jellinek. Renowned commentator on the musical scene chronicles incredible career and life of the most controversial, fascinating, influential operatic personality of our time. 64 black-and-white photographs. 416pp. 5⅜ × 8¼.
25047-4 Pa. $7.95

GEOMETRY, RELATIVITY AND THE FOURTH DIMENSION, Rudolph Rucker. Exposition of fourth dimension, concepts of relativity as Flatland characters continue adventures. Popular, easily followed yet accurate, profound. 141 illustrations. 133pp. 5⅜ × 8½.
23400-2 Pa. $3.50

HOUSEHOLD STORIES BY THE BROTHERS GRIMM, with pictures by Walter Crane. 53 classic stories—Rumpelstiltskin, Rapunzel, Hansel and Gretel, the Fisherman and his Wife, Snow White, Tom Thumb, Sleeping Beauty, Cinderella, and so much more—lavishly illustrated with original 19th century drawings. 114 illustrations. x + 269pp. 5⅜ × 8½.
21080-4 Pa. $4.50

SUNDIALS, Albert Waugh. Far and away the best, most thorough coverage of ideas, mathematics concerned, types, construction, adjusting anywhere. Over 100 illustrations. 230pp. 5⅜ × 8½. 22947-5 Pa. $4.50

PICTURE HISTORY OF THE NORMANDIE: With 190 Illustrations, Frank O. Braynard. Full story of legendary French ocean liner: Art Deco interiors, design innovations, furnishings, celebrities, maiden voyage, tragic fire, much more. Extensive text. 144pp. 8⅜ × 11¼. 25257-4 Pa. $9.95

THE FIRST AMERICAN COOKBOOK: A Facsimile of "American Cookery," 1796, Amelia Simmons. Facsimile of the first American-written cookbook published in the United States contains authentic recipes for colonial favorites—pumpkin pudding, winter squash pudding, spruce beer, Indian slapjacks, and more. Introductory Essay and Glossary of colonial cooking terms. 80pp. 5⅜ × 8½. 24710-4 Pa. $3.50

101 PUZZLES IN THOUGHT AND LOGIC, C. R. Wylie, Jr. Solve murders and robberies, find out which fishermen are liars, how a blind man could possibly identify a color—purely by your own reasoning! 107pp. 5⅜ × 8½. 20367-0 Pa. $2.50

THE BOOK OF WORLD-FAMOUS MUSIC—CLASSICAL, POPULAR AND FOLK, James J. Fuld. Revised and enlarged republication of landmark work in musico-bibliography. Full information about nearly 1,000 songs and compositions including first lines of music and lyrics. New supplement. Index. 800pp. 5⅜ × 8¼. 24857-7 Pa. $14.95

ANTHROPOLOGY AND MODERN LIFE, Franz Boas. Great anthropologist's classic treatise on race and culture. Introduction by Ruth Bunzel. Only inexpensive paperback edition. 255pp. 5⅜ × 8½. 25245-0 Pa. $5.95

THE TALE OF PETER RABBIT, Beatrix Potter. The inimitable Peter's terrifying adventure in Mr. McGregor's garden, with all 27 wonderful, full-color Potter illustrations. 55pp. 4¼ × 5½. (Available in U.S. only) 22827-4 Pa. $1.75

THREE PROPHETIC SCIENCE FICTION NOVELS, H. G. Wells. *When the Sleeper Wakes, A Story of the Days to Come* and *The Time Machine* (full version). 335pp. 5⅜ × 8½. (Available in U.S. only) 20605-X Pa. $5.95

APICIUS COOKERY AND DINING IN IMPERIAL ROME, edited and translated by Joseph Dommers Vehling. Oldest known cookbook in existence offers readers a clear picture of what foods Romans ate, how they prepared them, etc. 49 illustrations. 301pp. 6⅛ × 9¼. 23563-7 Pa. $6.50

SHAKESPEARE LEXICON AND QUOTATION DICTIONARY, Alexander Schmidt. Full definitions, locations, shades of meaning of every word in plays and poems. More than 50,000 exact quotations. 1,485pp. 6½ × 9¼. 22726-X, 22727-8 Pa., Two-vol. set $27.90

THE WORLD'S GREAT SPEECHES, edited by Lewis Copeland and Lawrence W. Lamm. Vast collection of 278 speeches from Greeks to 1970. Powerful and effective models; unique look at history. 842pp. 5⅜ × 8½. 20468-5 Pa. $11.95

SIR HARRY HOTSPUR OF HUMBLETHWAITE, Anthony Trollope. Incisive, unconventional psychological study of a conflict between a wealthy baronet, his idealistic daughter, and their scapegrace cousin. The 1870 novel in its first inexpensive edition in years. 250pp. 5⅜ × 8½. 24953-0 Pa. $5.95

LASERS AND HOLOGRAPHY, Winston E. Kock. Sound introduction to burgeoning field, expanded (1981) for second edition. Wave patterns, coherence, lasers, diffraction, zone plates, properties of holograms, recent advances. 84 illustrations. 160pp. 5⅜ × 8¼. (Except in United Kingdom) 24041-X Pa. $3.50

INTRODUCTION TO ARTIFICIAL INTELLIGENCE: SECOND, EN-LARGED EDITION, Philip C. Jackson, Jr. Comprehensive survey of artificial intelligence—the study of how machines (computers) can be made to act intelligently. Includes introductory and advanced material. Extensive notes updating the main text. 132 black-and-white illustrations. 512pp. 5⅜ × 8½. 24864-X Pa. $8.95

HISTORY OF INDIAN AND INDONESIAN ART, Ananda K. Coomaraswamy. Over 400 illustrations illuminate classic study of Indian art from earliest Harappa finds to early 20th century. Provides philosophical, religious and social insights. 304pp. 6⅜ × 9⅜. 25005-9 Pa. $8.95

THE GOLEM, Gustav Meyrink. Most famous supernatural novel in modern European literature, set in Ghetto of Old Prague around 1890. Compelling story of mystical experiences, strange transformations, profound terror. 13 black-and-white illustrations. 224pp. 5⅜ × 8½. (Available in U.S. only) 25025-3 Pa. $5.95

ARMADALE, Wilkie Collins. Third great mystery novel by the author of *The Woman in White* and *The Moonstone*. Original magazine version with 40 illustrations. 597pp. 5⅜ × 8½. 23429-0 Pa. $9.95

PICTORIAL ENCYCLOPEDIA OF HISTORIC ARCHITECTURAL PLANS, DETAILS AND ELEMENTS: With 1,880 Line Drawings of Arches, Domes, Doorways, Facades, Gables, Windows, etc., John Theodore Haneman. Sourcebook of inspiration for architects, designers, others. Bibliography. Captions. 141pp. 9 × 12. 24605-1 Pa. $6.95

BENCHLEY LOST AND FOUND, Robert Benchley. Finest humor from early 30's, about pet peeves, child psychologists, post office and others. Mostly unavailable elsewhere. 73 illustrations by Peter Arno and others. 183pp. 5⅜ × 8½. 22410-4 Pa. $3.95

ERTÉ GRAPHICS, Erté. Collection of striking color graphics: *Seasons, Alphabet, Numerals, Aces* and *Precious Stones*. 50 plates, including 4 on covers. 48pp. 9⅜ × 12¼. 23580-7 Pa. $6.95

THE JOURNAL OF HENRY D. THOREAU, edited by Bradford Torrey, F. H. Allen. Complete reprinting of 14 volumes, 1837–61, over two million words; the sourcebooks for *Walden*, etc. Definitive. All original sketches, plus 75 photographs. 1,804pp. 8½ × 12¼. 20312-3, 20313-1 Cloth., Two-vol. set $80.00

CASTLES: THEIR CONSTRUCTION AND HISTORY, Sidney Toy. Traces castle development from ancient roots. Nearly 200 photographs and drawings illustrate moats, keeps, baileys, many other features. Caernarvon, Dover Castles, Hadrian's Wall, Tower of London, dozens more. 256pp. 5⅜ × 8¼. 24898-4 Pa. $5.95

CATALOG OF DOVER BOOKS

AMERICAN CLIPPER SHIPS: 1833–1858, Octavius T. Howe & Frederick C. Matthews. Fully-illustrated, encyclopedic review of 352 clipper ships from the period of America's greatest maritime supremacy. Introduction. 109 halftones. 5 black-and-white line illustrations. Index. Total of 928pp. 5⅜ × 8½.
25115-2, 25116-0 Pa., Two-vol. set $17.90

TOWARDS A NEW ARCHITECTURE, Le Corbusier. Pioneering manifesto by great architect, near legendary founder of "International School." Technical and aesthetic theories, views on industry, economics, relation of form to function, "mass-production spirit," much more. Profusely illustrated. Unabridged translation of 13th French edition. Introduction by Frederick Etchells. 320pp. 6⅛ × 9¼. (Available in U.S. only)
25023-7 Pa. $8.95

THE BOOK OF KELLS, edited by Blanche Cirker. Inexpensive collection of 32 full-color, full-page plates from the greatest illuminated manuscript of the Middle Ages, painstakingly reproduced from rare facsimile edition. Publisher's Note. Captions. 32pp. 9⅜ × 12¼.
24345-1 Pa. $4.95

BEST SCIENCE FICTION STORIES OF H. G. WELLS, H. G. Wells. Full novel *The Invisible Man*, plus 17 short stories: "The Crystal Egg," "Aepyornis Island," "The Strange Orchid," etc. 303pp. 5⅜ × 8½. (Available in U.S. only)
21531-8 Pa. $4.95

AMERICAN SAILING SHIPS: Their Plans and History, Charles G. Davis. Photos, construction details of schooners, frigates, clippers, other sailcraft of 18th to early 20th centuries—plus entertaining discourse on design, rigging, nautical lore, much more. 137 black-and-white illustrations. 240pp. 6⅛ × 9¼.
24658-2 Pa. $5.95

ENTERTAINING MATHEMATICAL PUZZLES, Martin Gardner. Selection of author's favorite conundrums involving arithmetic, money, speed, etc., with lively commentary. Complete solutions. 112pp. 5⅜ × 8½.
25211-6 Pa. $2.95

THE WILL TO BELIEVE, HUMAN IMMORTALITY, William James. Two books bound together. Effect of irrational on logical, and arguments for human immortality. 402pp. 5⅜ × 8½.
20291-7 Pa. $7.50

THE HAUNTED MONASTERY and THE CHINESE MAZE MURDERS, Robert Van Gulik. 2 full novels by Van Gulik continue adventures of Judge Dee and his companions. An evil Taoist monastery, seemingly supernatural events; overgrown topiary maze that hides strange crimes. Set in 7th-century China. 27 illustrations. 328pp. 5⅜ × 8½.
23502-5 Pa. $5.95

CELEBRATED CASES OF JUDGE DEE (DEE GOONG AN), translated by Robert Van Gulik. Authentic 18th-century Chinese detective novel; Dee and associates solve three interlocked cases. Led to Van Gulik's own stories with same characters. Extensive introduction. 9 illustrations. 237pp. 5⅜ × 8½.
23337-5 Pa. $4.95

Prices subject to change without notice.

Available at your book dealer or write for free catalog to Dept. GI, Dover Publications, Inc., 31 East 2nd St., Mineola, N.Y. 11501. Dover publishes more than 175 books each year on science, elementary and advanced mathematics, biology, music, art, literary history, social sciences and other areas.